The National Gallery of Art is most grateful for the support of Goldman Sachs, Bank Austria, Creditanstalt, the Austrian Federal Ministry for Foreign Affairs, the Austrian Cultural Institute of New York, The City of Vienna, and Joan and David Maxwell to make this exhibition possible.

Egon Schiele

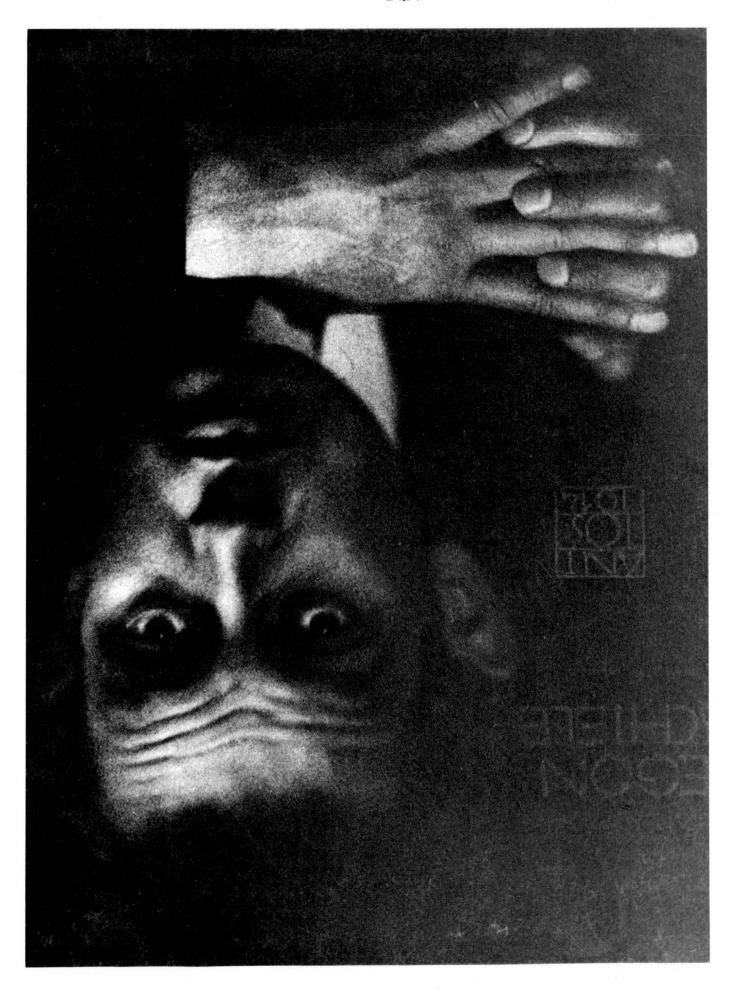

Egon Schiele

By Jane Kallir

With an essay by Alessandra Comini

Harry N. Abrams, Inc., Publishers
Art Services International

27704

Published on the occasion of the exhibition *Egon Schiele*, which has been organized and circulated by Art Services International, Alexandria, Virginia, and curated by Jane Kallir.

Support for the national tour has been provided by the Austrian National Bank, the Austrian Ministry for Foreign Affairs, The City of Vienna, the Austrian Cultural Institute of New York, and Austrian Airlines, and by an indemnity from the Federal Council on the Arts and the Humanities.

Exhibition schedule:

National Gallery of Art, Washington; February 6–April 24, 1994

The National Gallery of Art is most grateful for the support of Goldman Sachs, Bank Austria, Creditanstalt, the Austrian Federal Ministry for Foreign Affairs, the Austrian Cultural Institute of New York, The City of Vienna, and Joan and David Maxwell to make this exhibition possible.

Indianapolis Museum of Art, Indianapolis; May 28–August 7, 1994

San Diego Museum of Art, San Diego; August 27–October 30, 1994

The exhibition at the San Diego Museum of Art has been made possible by Mrs. Philip L. Gildred, Jr., Walter Fitch III, Mrs. George Gafford, Joseph W. Hibben, Mrs. George Pardee, Paul F. Mosher, Maurice C. Kaplan, Frank Russell, Jr., and Mrs. Michael Dessent.

Front Cover: *Female Nude on Checkered Cloth.* 1911.
Watercolor and pencil on Strathmore Japan paper, 18⅞ × 12⅜"
Neue Galerie am Landesmuseum Joanneum, Graz

Back Cover: *Self-Portrait, Bust.* 1912.
Watercolor and pencil on paper, 13¾ × 10"
Private collection, courtesy Galerie St. Etienne, New York

Frontispiece: Egon Schiele in 1914.
Photograph by Anton Josef Trčka, Vienna

For Harry N. Abrams, Inc.:
Project Director: Margaret L. Kaplan
Editor: Lory Frankel
Designer: Judith Michael
For Art Services International:
Editorial Supervision: Nancy Eickel

Library of Congress Cataloging-in-Publication Data

Kallir, Jane.
Egon Schiele / Jane Kallir.
p. cm.
Exhibition catalog.
Includes bibliographical references and index.
ISBN 0–8109–3845–6 (Abrams : hardcover). — ISBN 0–8109–2552–4 (museum : paperback)
1. Schiele, Egon, 1890–1918—Exhibitions. I. Title.
N6811.5.S34A4 1994
759.36—dc20 93—26840

Contents

Egon Schiele

Preface and Acknowledgments

Egon Schiele, like his compatriot and mentor Gustav Klimt, has become increasingly well known in America during the past two decades. Yet, with the notable exception of the Museum of Modern Art's vast anthology exhibition "Vienna 1900" (New York, 1986), major works by both artists have rarely been seen here in the original. The last significant American showing of the two (who are often paired) was held at the Solomon R. Guggenheim Museum, New York, in 1965, and the only comprehensive Schiele exhibition ever to travel to a group of American museums took place back in 1960.[1] To the extent—and it is not great—that American museums have acquired works by Schiele, only the few oil paintings are regularly displayed, for the preponderant works on paper are subject to stringent restrictions regarding exposure to light.[2]

Certainly, since 1965 there have been numerous small-scale American Schiele exhibitions, mostly in New York City and its environs and largely drawn from local collections.[3] But the artist's signature works, the majority of which remain in his native Austria, are known in the United States chiefly through reproductions. Even those who make the necessary pilgrimage to Vienna will find many key pieces sequestered in virtually inaccessible private collections. The Graphische Sammlung Albertina—which houses the most complete public collection of Schiele's works on paper—almost never exhibits its holdings, again due to the dangers of light damage. Only the oils at the Österreichische Galerie and the Historisches Museum der Stadt Wien can be viewed with comparative ease.

The present exhibition thus represents a very necessary attempt to deepen the American public's direct understanding of Schiele's art. The artist's growing stature in recent years has heightened the need for such an exhibition but has not entirely facilitated its accomplishment. Due to rising art values and the uncontrolled borrowing frenzy of the 1980s, major loans are far harder to come by than they would have been twenty or even ten years ago. On the other hand, a burst of scholarly activity—including Jane Kallir's recent catalogue raisonné—has mapped out Schiele's oeuvre with an unprecedented degree of completeness, so that it is now possible to plot a retrospective exhibition with a precision heretofore impossible.[4]

The organizers of this exhibition have been extremely fortunate in obtaining full participation from the key Austrian museums. The Österreichische Galerie generously made available six of its most important Schiele paintings, the Albertina over two dozen pivotal watercolors and drawings, and the Historisches Museum der Stadt Wien four oils and three works on paper. The contributions of the Neue Galerie der Stadt Linz and the Neue Galerie am Landesmuseum Joanneum, Graz, whose holdings by the artist are somewhat smaller, have been proportionately no less significant.

From the start, this project was favored with support at the highest levels of the Austrian government, above all that of Vice-Chancellor and Minister for Science and Research Dr. Erhard Busek, who greatly expedited the approval process obligatory for the export of so many national treasures. We extend to him our most heartfelt appreciation. It is an exceptional privilege that His Excellency Helmut Tuerk, Austrian Ambassador to the United States, has agreed to serve as honorary patron of the exhibition. His willingness to participate in this way is a reflection of the importance of this international project, and with warm regards, we thank him for his confidence. We are also extremely grateful to Dr. Ursula Pasterk, Cultural Commissioner of the City of Vienna, and her able adviser, Dr. Gerald Matt, for their dedicated assistance. Within the Austrian Ministry for Foreign Affairs, Dr. Peter Marboe and Dr. Georg Jankovic expressed enthusiasm for our undertaking from its inception, and we deeply appreciate their sustained encouragement.

Of course, any systematic attempt to investigate Schiele's achievement would have been impossible without the magnanimous contributions of the more than fifty international lenders, both public and private, who allowed their prized possessions to travel with this exhibition. We would like, first of all, to convey our profound thanks to Dr. Gerbert Frodl, Director of the Österreichische Galerie, Dr. Konrad Oberhuber, Director of the Graphische Sammlung Albertina, and Dr. Günter Düriegl, Director of the Historisches Museum der Stadt Wien, whose participation has been crucial to the success of our endeavor. We are likewise extremely grateful for the cooperation of the Harvard University Art Museums, Cambridge, Massachusetts; the Neue Galerie am Landesmuseum Joanneum, Graz; the Neue Galerie der Stadt Linz; the Pierre Gianadda Foundation, Martigny, Switzerland; McMaster University, Hamilton, Ontario; the Minneapolis Institute of Arts; the Galerie St. Etienne, New York; the Solomon R. Guggenheim Museum, New York; The Metropolitan Museum of Art, New York; The Museum of Modern Art, New York; the Národní Galerie, Prague; the Staatsgalerie, Stuttgart; the National Gallery of Art, Washington, D.C.; and the Kunsthaus Zug; as well as Fred Elghanayan, Fernande Elkon, Byron Goldman, Klaus Hegewisch, Alice M. Kaplan, Richard Nagy, Serge Sabarsky, Wolfgang Werner, and numerous private collectors who have requested anonymity. Because of their generosity, Schiele's accomplishment can now be shared with viewers in the United States and Canada.

As with any endeavor of such complexity, the efforts of a host of individuals have made this project a reality. Foremost among these is Dr. Alessandra Comini, who has added a highly personal dimension to the investigation of Schiele's lifelong passion for art. The interviews she conducted with those of the artist's family members and sitters who were still alive in the 1960s offer a wealth of information and insight into his relationships as well as into his sense of self, and we are pleased to acknowledge her contribution to the scholarship surrounding the artist. We convey a special note of gratitude to Hildegard Bachert, co-director of the Galerie St. Etienne, for her steadfast dedication to this exhibition and for her cheerful collaboration.

We are also deeply grateful to the many additional people who have endorsed and fostered this exhibition. With the greatest pleasure, we recognize the Austrian National Bank, the central bank of Austria, for its help in underwriting this international venture. The support of the bank's Governor, Dr. Maria Schaumayer, its Chief Executive Director Adolf Wala, and Werner Studener, the bank's able Representative in New York City, has been instrumental to the success of this project. In addition, we wish to thank Dr. Wolfgang Waldner, Director of the Austrian Cultural Institute in New York City, for his dedication to this project from the outset and his continued enthusiasm as the exhibition developed. His ongoing backing of our various Austrian interests is, as always, deeply appreciated. We warmly thank Austrian Airlines, and specifically

Monika Paulus, for serving as the official carrier of the exhibition. Dr. Denise von Quistorp-Rejc, Cultural Attaché of the Embassy of Austria, has given this exhibition her dedicated energies, and we send her our personal thanks. We are also indebted to Alice Whelihan, Indemnity Administrator, Museum Program, National Endowment for the Arts, for her continued assistance.

From the outset, the museum community has responded to this endeavor with enthusiasm, and we cherished the opportunity to work again with our colleagues at the three prestigious museums on the tour. In particular, we acknowledge Dr. Earl A. Powell III of the National Gallery of Art in Washington, D.C., Bret Waller of the Indianapolis Museum of Art in Indiana, and Steven Brezzo of the San Diego Museum of Art, San Diego. Central to the genesis of the exhibition were Ellen Lee, of the Indianapolis Museum, who remained committed to the project through its long development, and Andrew Robison of the National Gallery, whose advice and encouragement were crucial in shaping the final selection of loans. We are also grateful for the collaboration of the staff at each museum.

It has been a pleasure to work once again with Harry N. Abrams, Inc. In particular, we send our thanks to Paul Gottlieb and Margaret Kaplan, for their enduring commitment to the art of Egon Schiele and to this publication. We are grateful as well to Lory Frankel, whose astute editing added both clarity and polish to the catalogue manuscript, and to Judith Michael, who as usual came up with a beautiful design. They all worked closely with Art Services International's editor, Nancy Eickel, to create both a significant and an attractive volume.

Working diligently behind the scenes have been the dedicated staffs of Art Services International and Galerie St. Etienne. Our thanks are extended to Ana Maria Lim, Douglas Shawn, Anne Breckenridge, Joy Spicer, Kirsten Simmons, and Patti Bruch in Alexandria, and Beth Harris, Maura Heffner, Elizabeth Marcus, Irene Stapleford, and Roberta Waterstone in New York. Their orchestration of diverse aspects of *Egon Schiele* is worthy of praise, and it is our pleasure to thank them for their efforts.

Lynn Kahler Berg, Director, Art Services International
Jane Kallir, Co-director, Galerie St. Etienne
Joseph W. Saunders, Chief Executive Officer, Art Services International

[1] "Egon Schiele," Institute of Contemporary Art, Boston, October 6–November 6, 1960 (traveled to Galerie St. Etienne, New York, November 15–December 15; J. B. Speed Art Museum, Louisville, Ky., January 3–31, 1961; Carnegie Institute, Pittsburgh, March 2–April 2; Minneapolis Institute of Arts, April 19–May 21). "Gustav Klimt and Egon Schiele," Solomon R. Guggenheim Museum, New York, February–April 1965. "Egon Schiele and the Human Form," a smaller show comprising only works on paper, traveled to the Des Moines Art Center, the Columbus Gallery of Fine Arts, and the Art Institute of Chicago in 1971–72.

[2] The number of Schiele oils in American museum collections can easily be counted on the fingers of one hand: there is one painting each in the Minneapolis Institute of Arts, the Solomon R. Guggenheim Museum, and the Museum of Modern Art, New York. A fourth major work, technically a study in mixed mediums, is presently on extended loan to the Busch-Reisinger Museum in Cambridge, Massachusetts. Works on paper are more widely represented, but few museums have collected them in great quantity. Only the Museum of Modern Art and the Metropolitan Museum of Art, both in New York, have significant holdings.

[3] In New York, Schiele exhibitions were mounted by the Galerie St. Etienne in 1968, 1970, 1980, and 1990; by La Boetie in 1971; and by the Serge Sabarsky Gallery in 1974, 1978, 1982, and 1985. The only recent museum exhibition was presented by the Nassau County Museum of Fine Art in Roslyn Harbor, New York, in 1990.

[4] See, for example: Alessandra Comini, *Egon Schiele's Portraits* (Berkeley, 1974); Jane Kallir, *Egon Schiele: The Complete Works* (New York, 1990); and Christian M. Nebehay, *Egon Schiele, 1890–1918: Leben, Briefe, Gedichte* (Salzburg, 1979).

Egon Schiele: An Introduction

In recent years, a broader, more all-encompassing appreciation of the modernist tradition has brought increased attention to the Austrian artist Egon Schiele. The French orientation that long skewed America's perception of modern art has now been partially corrected by the recognition and investigation of the ancillary (and in many cases equally significant) contributions made by other European nations. Austria's status, in particular, has benefited from a proliferation of interdisciplinary studies stressing the almost miraculous confluence of great personalities in Vienna on the eve of World War I.[1] Vienna was then still the prosperous capital of an empire that stretched from present-day Hungary through the recently divided Czechoslovak republic and included as well territory in the Balkans and lands now incorporated in northern Italy. Among the many pioneering visionaries drawn to this hub were the composers Gustav Mahler and Arnold Schönberg, the writers Hugo von Hofmannsthal, Karl Kraus, and Arthur Schnitzler, the architects Otto Wagner, Adolf Loos, and Josef Hoffmann, the philosopher Ludwig Wittgenstein, and Sigmund Freud.

Nonetheless, Austria's contribution to modern art was somewhat anomalous, for a number of reasons. First of all, the avant-garde was dominated by the applied arts, and even the highly successful painter Gustav Klimt allied himself with this trend. The Vienna Secession, founded in 1897 as a forum for the latest in foreign and domestic art of all kinds, was soon torn by a conflict between the conventional easel painters and the so-called *Klimtgruppe*, which sought to combine the fine and applied arts in a total aesthetic environment, or *Gesamtkunstwerk*. The establishment of an independent crafts collective, the Wiener Werkstätte (Vienna Workshops), in 1903 only served to heighten tensions at the Secession, and in 1905 Klimt's more progressive faction resigned. Though the Secession in its early years had mounted some impressive exhibitions of modern European art, the Austrian art scene remained comparatively provincial. Cultural innovations from the West filtered through the nation's borders in a haphazard and often incomplete manner: the British Arts and Crafts movement and the German Jugendstil (both of which concentrated on the decorative arts) as well as the Belgian Symbolists were much in favor, while the French Impressionists and Fauves were far less well known. Unlike its German counterpart, Austrian Expressionism (which emerged between 1909 and 1910) was not the product of cohesive artistic groups but of relatively isolated individuals.

It is telling that Austria's two principal Expressionists, Egon Schiele and Oskar Kokoschka, not only had virtually no personal contact but were also divided by a one-

sided enmity.[2] Whereas Kokoschka quickly rejected the Wiener Werkstätte (for which he had once worked) to evolve an essentially self-taught, primitivistic painting style (see fig. 61), Schiele's entire career was to some extent shaped by the example of the Werkstätte and of Gustav Klimt, who personified his ideal of the artistic life. By their precedent, Schiele was led to believe that artists are exalted creatures whose gifts entitle them automatically to societal support while simultaneously granting them immunity from the strictures and standards of normal bourgeois life. Klimt and the Wiener Werkstätte taught him that artists likewise owe one another support, and he was therefore unusually generous in his dealings with colleagues. Above all, however, Klimt was Schiele's aesthetic role model: from him he learned the value of sinuous, evocative lines and of spare compositions incorporating monumental iconic figures. Schiele in his mature years was not especially dazzled by the glitter of Klimt's brief (albeit famous) "gold" period, but rather looked to the darker side of the master's allegorical compositions (see figs. 76 and 78). Schiele's brand of Expressionism is therefore unique, bearing the indelible legacy of Klimtian Symbolism while achieving its greatest heights not on canvas but on paper.

Schiele's painted oeuvre, like that of Klimt, may be divided into three broad categories: portraits, figural/allegorical work, and landscapes. However, the three groups are by no means equal. Portraits—more numerous in the first and last years of Schiele's professional life (1910 and 1918; see plates 26–35 and 89–101)—while certainly the most lucrative component of his output were clearly not his favorite. Allegory was what he considered of supreme importance (see plates 53, 62, 69, 85, and 86), and, in truth, this attitude extended to every branch of his production. Even his landscapes were on the whole an outgrowth of the allegories: his multitudinous Dead Cities (see plates 38, 40, and 51) emblematic of the emptiness and moral bankruptcy of human civilization, his frail, anthropomorphic trees (see plates 46 and 47) stand-ins for man's existential isolation.

Schiele's near obsession with allegory derives from the tradition that shaped Klimt's career but that was, by the turn of the century, no longer fully operative. Klimt, reared during a widespread Austrian building boom, had initially made his mark by painting allegorical murals for public structures such as theaters. However, under the influence of Symbolism, he soon began to render more comprehensive statements about human existence, in the process transcending the parameters of his specific commissions and alienating his official sponsors.[3] As public patronage dried up, he turned increasingly to smaller, more personal allegories that had no clear audience. Even for so well-established an artist as Klimt, such works proved difficult to market; for Schiele, they were virtually unsalable.[4] Nonetheless, the younger artist persisted in following in his mentor's footsteps, never relinquishing the belief that the highest goal of art is to explicate the meaning of life and death.

Schiele's allegorical cosmology is rendered most explicitly in his oil paintings, and those who are familiar chiefly with the more plentiful works on paper are therefore likely to come away with a skewed impression of his artistic goals. Like Klimt, Schiele created relatively few studies for his landscapes and almost no drawings with overtly allegorical content. Most of Schiele's works on paper are straightforward depictions of the human figure: self-portraits, drawings from the model, or portrait studies. Only in the last instance is there commonly a direct relationship between drawing and painting. Such ties as exist between the nudes or self-portraits and the allegorical oils are usually oblique, and those few drawings that did serve as studies tended to undergo marked changes by the time they reached the canvas. It may, in the end, be just a bit of a pose—the crook of a knee, say—that Schiele patched into his final composition. There was an aura of alchemy to the way the drawings were transformed

in the oils, and usually elements without precedent in any known studies were added.[5]

Nevertheless, a profound contextual link exists between Schiele's works on paper and the allegorical oils. It is the vision contained in the latter—the bittersweet, eternally insoluble duality of life and death—that forms the backbone of Schiele's entire achievement and gives meaning also to the watercolors and drawings. The same forces, fear and passion, are expressed in the works on paper, but in raw, unresolved form. All the confused emotions of adolescent sexuality are exposed in Schiele's nude studies. Sex is seen to be painful and tortured, but also wondrous and enticing. Pubescent children are as baffled by their emergent sexuality as was Schiele himself (see plates 12–16). Grown women are sometimes projections of the artist's fantasies but, more often, quirky, elusive creatures who inhabit a mysterious and inaccessible sexual realm all their own (see plates 3–11). Ambivalence and ambiguity haunt Schiele's famous self-portraits as well (see plates 17 and 20–25). He is a self-confident dandy one day and a confused boy-man the next. Schiele's works on paper constitute an ongoing search for meaning, and it is their questioning, exploratory stance that has struck such a responsive chord within the modern world.

Technique, as well as content, binds Schiele's drawings to his paintings. His view of composition—shaped not only by Klimt's decorative approach but also by the flat, posterlike images of the Austrian and German Jugendstil—was inherently two-dimensional. Perhaps because he dropped out of the Vienna Academy of Fine Arts after the third term, Schiele never learned to formulate elaborate compositions. The introductory curriculum did not include painting lessons, and most of his surviving student works are drawings of single objects: plaster casts, nudes, and portraits.[6] It is therefore not surprising that his mature drawings tend to depict single objects on a blank ground. With the notable exception of his landscapes (see plates 37–40 and 46–51)—where Schiele deployed an edge-to-edge geometric structure reminiscent of Klimt's work in the same genre—the compositions of his oils are scarcely more elaborate than those of his works on paper. Yet to say that the artist simply plopped his subject in the middle of the sheet or canvas is not entirely fair, for his blank backgrounds are never truly empty. He had an acutely developed sense of negative space and knew how to exploit every angle and bit of tension between the contours of his image and the edges of the picture plane. Not even the placement of his signature—much less that of his figures—is ever random.

Schiele's application of paint on canvas likewise followed the example set in his works on paper. Here he experimented freely with various chromatic devices: pushing granules of pigment through limpid pools of watercolor or molding denser swaths of gouache with his brush. An early attempt to translate these methods into oil may be seen in his great 1910 figure paintings, which not only were structured like large drawings (with muted, pale backgrounds) but also were limned in thin washes of bright paint that approximated as closely as possible the appearance of the preliminary studies (see plates 3, 4, 18, and 19). While Schiele was clearly interested in the expressive potential of color, the rhythms of his brushstrokes were always held in check by the contours of the surrounding drawing and in this sense were subordinate to the power of his line. He must, however, have felt that this essentially linear approach was not fully effective on canvas, for by 1911 he had embarked on a protracted attempt to articulate the backgrounds of his oils more completely—through denser impasto, or interlocking geometric veils of color, or looser, more painterly handling. He came to be increasingly concerned with coaxing volume out of his brushstrokes, and in tandem with this development, his lines became smoother, more evocative of underlying bone and muscle. Even as the paint handling in his oils grew looser and more typically Expressionistic (see plate 100), the coloring of his last drawings became spare, and eventually

almost entirely monochromatic (see plates 84 and 96). It was as if the artist had finally succeeded in isolating the two components of his work—color and line—and assigning each its proper place.

Perhaps the most vexing question in evaluating Egon Schiele's achievement is that of how much priority to assign his oils. It is commonly presumed that the most important artists of this century were painters and their most important works oils on canvas. Not so with Schiele. If one discounts his sizable body of juvenilia, Schiele executed easily ten times as many works on paper as on canvas or panel.[7] Such a proportionate discrepancy may in itself be fairly common, but Schiele's case is unusual in that most of the drawings and watercolors are not studies but fully conceived, independent works of art. In fact, scholars as well as collectors have long accorded equal, if not greater esteem to the watercolors than to the oils. Schiele is, quite simply, one of the foremost draftsmen of all time, and though his oils are surely as integral as his drawings to his artistic vision, on a global scale they do not hold the same claim to preeminence.

Like the late medieval German artists Hans Holbein and Albrecht Dürer—with whom he merits comparison—Schiele was a consummate master of line. Early on, he learned to work fast. His hated master at the academy, Christian Griepenkerl, gave timed exercises, and Schiele of his own volition often drew with a stopwatch in hand. His entire life was a search for the perfect line: the line that hits the target every time; the line that knows no eraser. This, however, does not mean that Schiele's approach was doctrinaire or monolithic. Flexibility and spontaneity were essential to his quest. His contours could be flowing and elegant in the Jugendstil manner, primitive in the Expressionistic mode, clipped and jagged, spare and sensual, or intertwined with curlicues and scarlike hatchings. The best of Schiele's drawings demonstrate a perfect accord among the artist's hand, his perceptions of his subject, and the subject's physical appearance.

The primacy of line in Schiele's oeuvre is the principal reason that his reputation rests so heavily on the watercolors and drawings, but in fairness to the oils it must be said that this is not the only reason. It is, unfortunately, today virtually impossible to reconstruct Schiele's accomplishments in oil with any accuracy. For one thing, several groups of crucial paintings have been largely lost or destroyed: of five breakthrough nudes executed in 1910, one survives (see plates 3, 4, 18, and 19); only four out of seven allegorical self-portraits from late 1910–11 can be found (see plate 53); and all the large allegorical canvases of 1913 are presently unaccounted for (see plate 62).[8] To a lesser degree, Schiele's very last paintings have also been compromised: many of them were completed by another hand, and their authenticity has become a subject of ongoing dispute.[9] A considerable number of Schiele oils, in fact, no longer look as they did when first painted. The artist's predilection for porous grounds made his canvases particularly vulnerable to the overzealous restorer's most common methods, varnishing and lining.[10] As a result, if one wants to experience the lambent color effects that are his forte, one is often better off sticking to the works on paper, whose original paint surface has been less frequently tampered with.[11]

The allegorical overtones of Schiele's most important oils also present problems for contemporary viewers, who tend to have little patience with such ponderous and relatively arcane statements. Unlike his paintings, the artist's drawings and watercolors do not attempt to reach sweeping conclusions, and for this reason they are perceived as being fresher and more spontaneous. Schiele drew almost every day, so there is a constant flow and connection among the works on paper that are lacking in the oils, which required much more time for completion. The paintings—sometimes reworked over a period of years—are more episodic, encapsulating a culmination of thought processes whose progressive evolution is traceable in the drawings.

Schiele's oils punctuate the oeuvre at crucial points rather than constituting its primary substance, and the present publication mirrors this phenomenon. A concerted effort has been made to follow as closely as possible the artist's development, illustrating at each point the strongest available representative pieces. The selection of subjects reflects the entire oeuvre, with oils and works on paper weighed and evaluated simultaneously. The overall organization is both chronological and thematic, making it possible to study and compare Schiele's handling of similar subjects over the course of his career. The colorplates are subdivided into groupings of loosely related items, often accompanied by black-and-white illustrations of lost paintings or works by other artists that provide insight into the original context of Schiele's creations. Brief descriptive essays accompany most of the individual plates.

Note: Throughout this book, Schiele's work is identified with the numbers used in Jane Kallir's catalogue raisonné *Egon Schiele: The Complete Works*, in which P. stands for painting, D. for drawing, and G. for graphic art.

[1] The best known of these are probably *Wittgenstein's Vienna* by Allan Janik and Stephen Toulmin (New York, 1973) and Carl E. Schorske's *Fin-de-Siècle Vienna* (New York, 1980).

[2] Kokoschka, who survived Schiele by over sixty years, seems to have felt particularly threatened by the latter artist's posthumous fame. He derided him as a "pornographer" and claimed that the two never met (see J. P. Hodun, "Kokoschka und Schiele, eine Streitfrage," in *Alte und moderne Kunst* 29, nos. 192–93 [1984]: 46–47). It is true that the two artists were seldom in Vienna at the same time after 1910. In 1918, Schiele wrote Kokoschka (then in Germany) inviting him to participate in a Viennese exhibition. Kokoschka refused—not, it seems, because he at that point felt any resentment toward his colleague, but rather because he did not want his work shown in Vienna (see Nebehay, *Egon Schiele, 1890–1918*, no. 1335).

[3] The famous turning point in Klimt's career as a public artist came in 1900, when he exhibited the first of a series of three canvases commissioned for the great hall at the University of Vienna. The assignment had been to depict the faculties of Medicine, Jurisprudence, and Philosophy. Klimt, instead of selecting illustrative examples from history or mythology, as was traditional, chose to evoke the human dilemma by painting masses of entangled nudes. This triggered a five-year-long scandal that eventually prompted the artist to renounce the commission.

[4] Schiele himself was aware of the aversion prospective customers had to his allegories, writing to one collector, "I *must* paint such pictures, [though] they have value only for me." His most famous painting, *The Hermits* (Kallir P. 229), failed to find a buyer during his lifetime, and in 1913 he was informed by his Munich dealer, Hans Goltz, that his oils were unsalable. Nonetheless, Schiele managed to persuade some of his private patrons to buy his allegories.

[5] Schiele's compositional process was not quite so mysterious as one might assume from the full-size drawings and watercolors. The missing link may be found in his sketchbooks, which contain thumbnail sketches of most of his major canvases.

[6] Since painting was not part of the academy's introductory curriculum, it is believed that Schiele's many small oils of 1907 and 1908 were done independently.

[7] The exact numbers, based on Kallir, *Egon Schiele: The Complete Works*, are 222 oils and 2,122 watercolors and drawings from the years 1910 through 1918. However, the count of the oils includes 47 works that are probably irretrievably lost or destroyed, while it is believed that the count of works on paper may be underestimated by 15 to 20 percent.

[8] The following key paintings are presently unaccounted for: *Male Nude Kneeling, with Raised Hands* (Kallir P. 168), *Standing Female Nude with Crossed Arms* (Kallir P. 169), *Seated Female Nude with an Outstretched Arm* (Kallir P. 170), *Standing Male Nude with Hands on Hips* (Kallir P. 171), *The Self Seers I* (Kallir P. 174), *Melancholia* (Kallir P. 175), *Delirium* (Kallir P. 190), *Vision and Destiny* (Kallir P. 194), *Resurrection* (Kallir P. 251), *Encounter* (Kallir P. 259), and *Conversion* (Kallir P. XLVIII). Numerous additional works (e.g., Kallir P. 195, 196, 197, and 200)—equally significant, though not part of larger thematic cycles—are also missing.

[9] The painting *Cityscape* (Kallir P. 334) was in all likelihood heavily reworked following Schiele's death, and it is generally believed that *Portrait of a Boy II* (Kallir P. 318), *Two Squatting Men* (Kallir P. 328), and *Mödling II* (Kallir P. 333) contain less significant additions by another hand. There is a difference of opinion as to whether *Squatting Women* (Kallir P. 327) and *Three Standing Women* (Kallir P. 330) were similarly altered.

[10] Both varnish and the adhesives used to affix a new lining to an original canvas penetrate the ground and distort its ability to refract light, hence altering the color of any pigments that may have been absorbed into the ground. When, as is often the case with Schiele's oils, the ground is porous and the paint has been thinned with solvent, the two become inextricably linked. Varnish and adhesives in such circumstances become virtually impossible to remove, and the discoloration they cause is therefore often irreversible. Conservation issues are discussed at great length in Appendix C of Kallir, *Egon Schiele: The Complete Works*, pp. 661–62.

[11] Specifically excluded from this statement, of course, are those cases in which coloring has been added by another hand to an originally uncolored drawing. Works on paper are vulnerable to damage chiefly by light, which can alter the color of both the paint and the sheet. However, the number of works that have been severely afflicted by such problems constitutes a relatively small percentage of Schiele's vast production on paper.

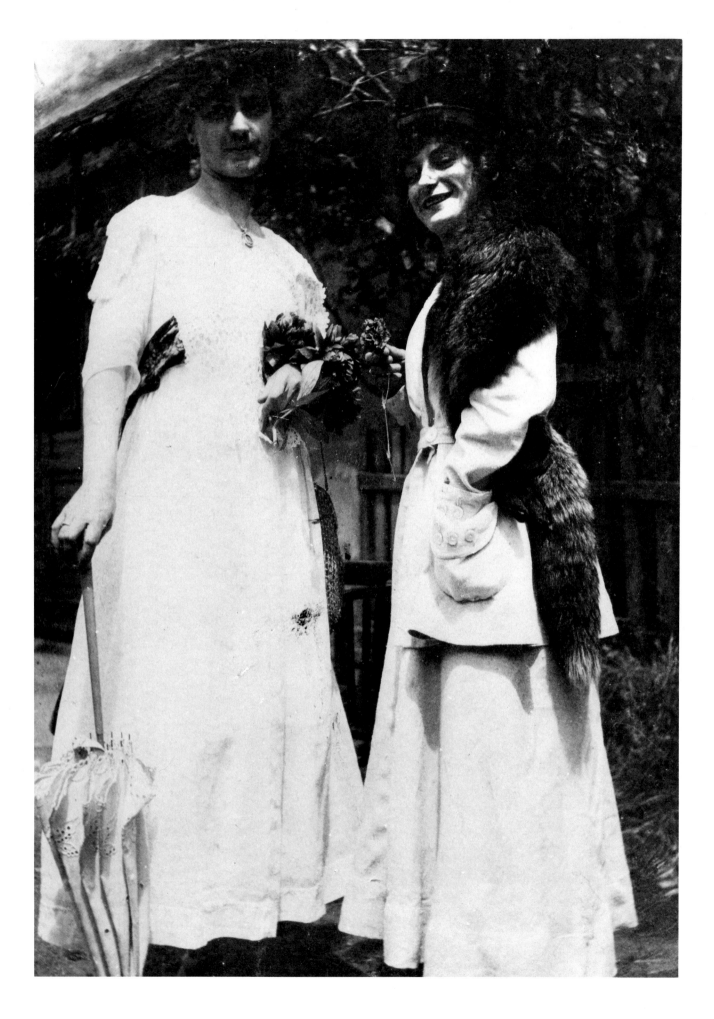

Alessandra Comini

In Search of Schiele

Seeking Out the Sitters and Sites of Egon Schiele

Adventures and Reminiscences of an American Scholar

For Egga

Three-quarters of a century have now elapsed since the tragically short-lived Viennese Expressionist artist Egon Schiele (1890–1918) created the compelling portraiture that exposed a collective cultural anxiety that haunted, and continues to haunt, the twentieth century. And yet some of his most important sitters—including his sisters, Melanie and Gertrude—were still alive when, in the summer of 1963, I began the research for a doctoral dissertation that would later flow into three monographs on the artist, published in the 1970s: a slim volume, *Schiele in Prison* (1973), about the twenty-four days the artist spent in a prison cell in 1912, during which time he produced some of his most eloquent self-portraits (see plates 55 and 56); a hefty 350-page tome, *Egon Schiele's Portraits* (1974; reissued 1990); and a medium-size book addressing the artist's poignant landscapes as well as his portraits, *Egon Schiele* (1976). In light of all the enthusiastic Schiele scholarship that has occurred since, it would seem unlikely that I, as an art historian whose newer interests have taken her away from the city of Vienna, would have anything more to add to the bulky bibliographic coffers of Schiele research.

And yet, just because so much time has passed since Schiele's sitters and sites were gazed upon by the artist himself, it could be argued that the original research notes, as well as the sometimes thorny conditions surrounding them, might conceivably be of interest and merit entry into the official historical record. The organizers of "Egon Schiele," the exhibition represented by this catalogue, have persuaded me that such is indeed the case, in spite of the autobiographical mold into which such reminiscences of reminiscences must necessarily be cast. Certainly the vivid recollections so forthcomingly provided by Schiele's sitters—his two sisters, his sister-in-law, his nephew, his friends, and his clients—were intertwined with anecdotal circumstances and intimate observations. If readers can, then, forgive the personal tone of this essay, I should like to invite them to share the adventures that awaited me when I entered the intriguing realm of Egon Schiele and his Vienna.

fig. 1. Melanie Schiele and Gertrude Peschka Schiele. 1919. Photograph courtesy Alessandra Comini

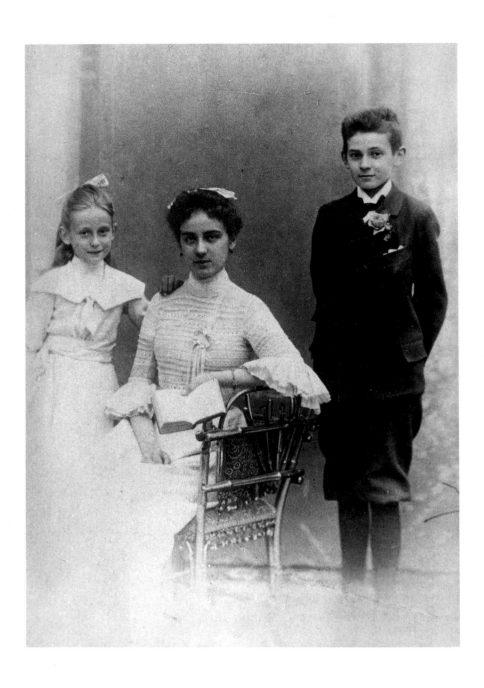

fig. 2. Gertrude, Melanie, and Egon Schiele. c. 1903.
Photograph courtesy Alessandra Comini

Vienna was not new to me when I arrived in the city to begin research in June 1963, but Schiele was. Seven years earlier, upon graduating from Barnard College, I had moved to the fabled, if still somewhat postwar (Russian sector signs were still on the walls of buildings), shabby City of Dreams to follow my own dream of continuing art history studies at the University of Vienna. However, no sooner had I begun attending the rather recondite classes on the artifacts of vanished civilizations offered by the university than the Hungarian Revolution of October 1956 broke out, forever changing my life and that of so many of my fellow students. This encounter with "real life" altered my opinion of the merits of dwelling in academia, and it was several years before the halls of academe looked attractive again. But in 1963, as a graduate student at the University of California at Berkeley hard at work on a medieval topic, I chanced upon a small campus exhibition of Viennese Expressionist drawings and was spellbound by the extraordinary draftsmanship and exploration of psyche revealed in the work of Egon Schiele. I became an instant convert to modern art and, simultaneously, a vicarious Viennese—greedily absorbing the unique cultural atmosphere of turn-of-the-century Vienna.

fig. 3. Egon Schiele. *Study of the Artist's Sister.* 1910. Charcoal on paper. 17¾ × 13" (45.1 × 32.9 cm). Kallir D. 489. Graphische Sammlung Albertina, Vienna

fig. 4. Egon Schiele. *Portrait of Gerti Schiele Looking at the Viewer.* 1911. Pencil on paper. 18⅞ × 12⅝" (48.1 × 32 cm). Kallir D. 893. Graphische Sammlung Albertina, Vienna

All that remained was to get to Vienna in body as well as spirit, and this was accomplished that fateful summer of 1963. For the first several months I worked daily in the Albertina museum, which not only possessed the world's greatest collection of Schiele drawings and watercolors, thanks largely to the efforts of one of Schiele's then still-living sitters, Otto Benesch, who had reigned for several decades as the museum's director, but also housed a unique Egon Schiele Archive of sketchbooks, photographs, letters, and newspaper articles donated by Max Wagner in 1954. Several helpful Viennese Schiele cognoscenti in the Albertina's Studiensaal took an interest in my work, and, uniformly, all counseled me not to bother interviewing the artist's still-living sisters, as they were both confirmed recluses and quite crazy—"verrückt." Nothing could have been more of a challenge than such advice, and soon I mailed off two carefully composed letters of self-introduction to Melanie and Gertrude, whom I already felt I had gotten to know from family photographs (figs. 1 and 2) and Schiele's portraits of them (figs. 3 and 4; see plates 3, 4, and 7), begging for the privilege of an interview. The labored awkwardness of my German prose apparently was not held against me, and my boldness was rewarded by responses from both sisters.

Melanie's came first, in the form of a postcard dated Wednesday, 4 September 1963 (fig. 5). In a very legible hand and using an old-fashioned ink pen, the seventy-seven-year-old widow of a civil servant with the state railroad ("Oberrevidentenswitwe," her calling card read) informed me:

Liebes Fräulein!
Da ich sehe, Ihr grosses Interesse für meinen armen verstorbenen Bruder und dessen Werke, bin ich gerne bereit, noch vieles Ihnen zu erzählen. Ich bin Freitag 6/9 ab 3ʰ Kaffee Zögernitz Döblinger Hauptstr. ich glaube 80? im Garten oder Kaffeehaus. Also komme[n] Sie dorthin. Mit herzliche[n] Grüssen

Mela Schuster Schiele

Dear Miss!
Since I see your great interest in my poor dead brother and his work, I am gladly ready to tell you much more. On Friday 6/9 from 3 o'clock on I will be at the Café Zögernitz Döblinger Hauptstr. I think [number] 80? in the garden or inside the café house. So come there. With cordial greetings

Mela Schuster Schiele

I was excited beyond words and showed up at the café at the appointed time. From the photographs and portraits of a young Melanie I knew to expect a tall, rather plain-looking woman, but one who was by now probably shrunk with age, stoop-shouldered, and white-haired. How surprised I was to see a still tall, straight-backed woman with bright red hair energetically beckon to me. Being quite naive about the existence of hair dyes at that time, I marveled out loud at Melanie's youthfulness, and we got on quite well—so well, in fact, that after three hours' conversation at the café, she spontaneously invited me to come to her house, then and there. We spent the next five and a half hours, with a break for dinner at a local restaurant, in the nearby rear ground-floor apartment at Döblinger Hauptstrasse 77/2, a humble, two-room abode looking out on a back courtyard, which she shared with an elderly dachshund called Waldi. The living room contained one large object that absolutely sent thrills through me—the great, black-framed standing mirror Schiele had used for his many self-portraits (fig. 6; see plates 1, 17, 20–25, 52–54, 57–59, 61, 63–65, 77, and 86–88). With trepidation I asked whether I might photograph Melanie in front of it; she obliged (fig. 7), then asked whether I might not like to photograph myself before this major bit of Schiele lore (fig. 8). I learned much about Schiele's childhood that evening,

fig. 5. Postcard from Melanie Schuster Schiele to the author. 4 September 1963. Photograph courtesy Alessandra Comini

and before I left at 11:30 P.M., I had been given a toy wooden soldier that used to belong to "Egon" and a cordial, insistent invitation to return. In my diary that night I wrote: "[Melanie is] a powerful, lively, alert, tall woman . . . she loved my photos and was pleased at my knowledge of her family. She talked readily and long and for the first time I realized that Egon had really been a child genius."

The next day I typed up five pages of notes summarizing what we had talked about. The "photos" mentioned in the diary entry quoted above refer to pictures I had taken eleven days earlier at a pivotal Schiele site—the prison in which he had been confined on a charge of immorality. Melanie had never been to the prison—nor, it turned out, had any Schiele relative or scholar. In the Albertina archives I had come across a letter—apparently unanswered—asking for the exact location of the building in which the artist had been incarcerated. Most of the watercolors Schiele had created while in prison belonged to the Albertina holdings (see plates 55 and 56), and I had studied them long and lovingly in the dim light of the Studiensaal, taking notes and drawing small replicas (fig. 9). This habit of quickly sketching the artworks under study (a necessary tool before the age of photocopy machines) fortuitously served as a crucial factor enabling me to identify with absolute certainty which of the look-alike cells had contained Schiele when I visited the prison—a building still functioning as the district courthouse (see fig. 48) in the village of Neulengbach, some twenty miles from Vienna. Instinct led me downstairs to the damp cellar, where, with a pounding heart, I "recognized"—and that is the only word applicable—the long corridor Schiele had depicted in his watercolor of 20 April 1912 that he defiantly entitled *I Feel Not Punished but Cleansed!* (fig. 10). There was the same dismal band of gray paint running along the bottom of the limy whitewashed walls on both sides of the narrow passageway; there to the right were the rough, heavy cell doors of thick wood; there to the left the same sort of long-handled mop propped up on end to dry; and there, wedged above my head, was the same wooden support beam Schiele had drawn, only now, fifty-one years later, it was sagging precariously at the center (fig. 11). Which of the six cells had been Schiele's? I opened the first door at the end of the corridor, appropriately still labeled "No. 1," then the door to "No. 2"—and knew instantly that this one had been Schiele's cell. How? In a watercolor depicting his surroundings, *The Single Orange Was the Only Light* (fig. 12), executed on the first day he was allowed to have drawing materials, 19 April 1912, the artist had recorded not only his narrow bunk bed and lumpy blanket, cheered by the orange he had placed on top, but he had also, with ravenous eyes, portrayed every detail of his cell door, including the initials M H carved by some former prisoner on the upper horizontal band of wood that crossed the door, and those initials (fig. 13) are what I saw! These, then, were the photographs I was able to show Melanie and with which my sincerity as a Schiele researcher was established in her eyes.

Earlier that day I had also visited Schiele's birthplace, the small railroad stop of Tulln on the Danube where his father, Adolf, had been stationmaster. I eagerly photographed the station building that had housed, on its upper floor, the family's living quarters overlooking the railroad tracks. When Melanie saw these mementos of her youth she pulled out a cache of old photographs, one of which showed a dress parade in front of the station honoring her father's twenty-fifth year of service (see fig. 40). She told me that the first objects of Egon's incessant craving to draw were the passing trains, and that before he was five he began—to their mother's horror—crawling out of the dining room window and onto the slanting porch roof facing the tracks to get a better view for his amazingly detailed images (fig. 14). If his pencil and paper were confiscated by his parents he would then make trains on the floor out of bed sheets—one sheet for each wagon.

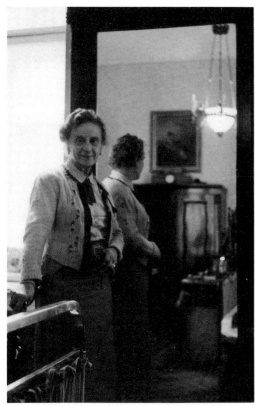

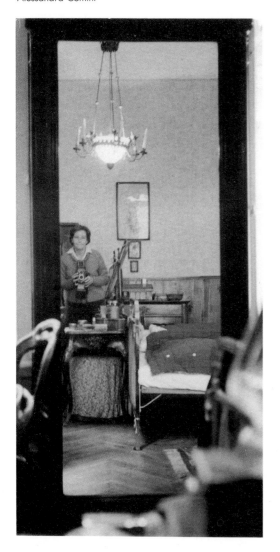

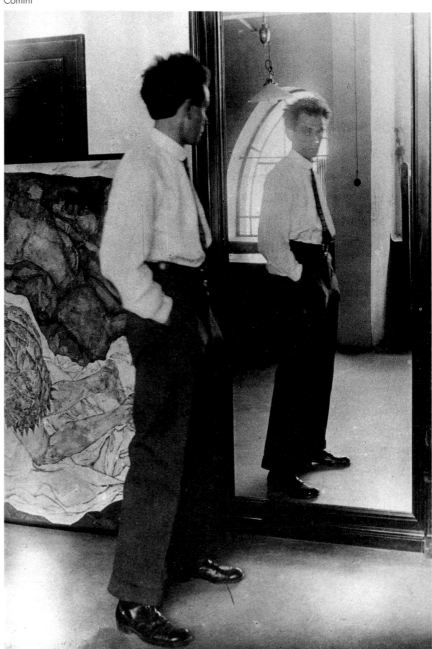

fig. 9. Alessandra Comini's 1963 notes and sketch of Schiele's prison drawing *Hindering the Artist Is a Crime, It Is Murdering Life in the Bud!* (see plate 55)

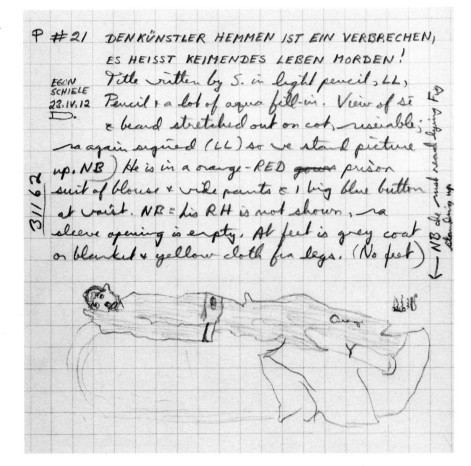

below left
fig. 10. Egon Schiele. *I Feel Not Punished but Cleansed!* 1912. Gouache, watercolor, and pencil on paper. 19 × 12½" (48.4 × 31.6 cm). Kallir D. 1180. Graphische Sammlung Albertina, Vienna

below right
fig. 11. The basement corridor outside Schiele's prison cell at Neulengbach. 27 August 1963. Photograph by Alessandra Comini

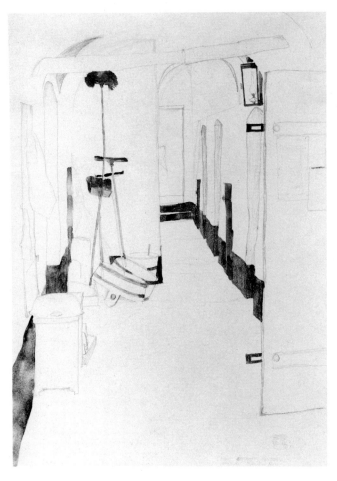

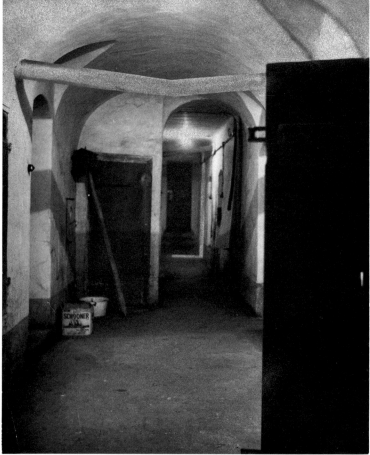

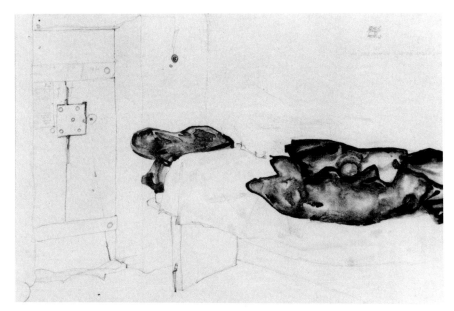

fig. 12. Egon Schiele. *The Single Orange Was the Only Light*. 1912. Gouache, watercolor, and pencil on paper. 12½ × 18⅞″ (31.9 × 48 cm). Kallir D. 1179. Graphische Sammlung Albertina, Vienna

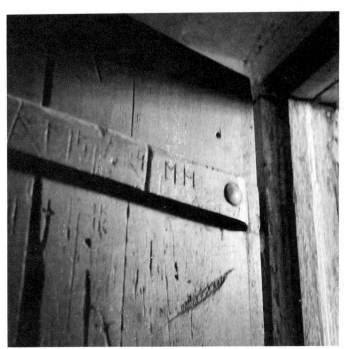

fig. 13. The door of Schiele's prison cell with the carved initials MH, Neulengbach. 27 August 1963. Photograph by Alessandra Comini

fig. 14. Egon Schiele. *Through Europe by Night*. c. 1906. Watercolor and ink on paper. 3¾ × 15⅜″ (9.4 × 39.2 cm). Kallir D. 76. Niederösterreichisches Landesmuseum, Vienna (formerly Collection Gertrude Peschka Schiele)

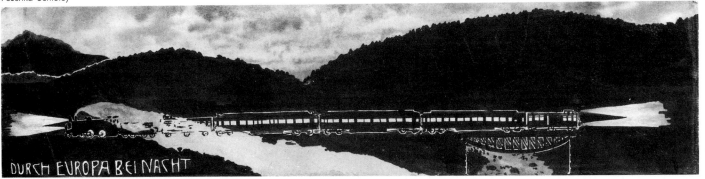

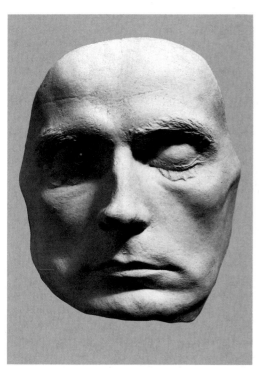

Most of the details about Schiele's childhood and early adult years reported in my books were related to me by Melanie over a period of many visits: for the next three months I visited her regularly on Wednesdays and Sundays, arriving for lunch and staying until two or three in the morning. The same routine was followed during a sabbatical I spent in Vienna during the winter of 1966–67, and I saw her each summer for eleven years until her death in October 1974. As our friendship developed, Melanie entrusted me with the task of putting in order the photographs and many letters and postcards to Schiele in her possession—the artist's legacy had been equally divided among Schiele's mother and sisters—and she lent me numerous Schiele objects (the drawing triangle he used as a student at Vienna's Academy of Fine Arts, for example), drawings, and watercolors to have photographed professionally. One of the most unusual and moving items she loaned me was Schiele's death mask (fig. 15)—that sad last portrait of the artist in which one side of the face is still taut from suffering, while the other side has relaxed in death. The plaster cast was taken by the sculptor Gustinus Ambrosi, who had come at the artist's request to make a cast of the hands of Schiele's wife Edith; she had just died of the influenza that would, three days later, claim Egon. I shall never forget the feeling of reverence that overtook me as I threaded my way carefully through the drifting snow toward a distant taxi stand at two in the morning that cold November day with my precious cargo.

Melanie had several favorite stories about her brother's early experiences in the art world, and they were tales she never tired of repeating for me. She acted them all out, as though she had been there, and so it is in her emphatic voice that I can still hear the ringing answer of Gustav Klimt, Vienna's greatest painter of the Art Nouveau generation, when Schiele courageously thrust a portfolio of his drawings into the older artist's hands and asked whether he had talent. "Viel zu viel!" (Much too much!) exclaimed Klimt. And how intrigued Melanie was to hear about my discoveries at the Vienna Academy of Fine Arts, where I had gone to examine the work of Schiele's teacher, Christian Griepenkerl—a conservative practitioner of the lofty stage realism to be found in the history murals decorating the great public buildings of Vienna's Ringstrasse. Quite by chance, while searching for the actual room in which Schiele's life-drawing class had been held and guided by a photograph showing the sixteen-year-old artist in that class with his fellow students, I came across not the room but the closet in which were stored the wooden boxes with hand grips carved in the sides that had served as stools for Schiele and his school comrades (fig. 16). I had seen these very same uncomfortable seats before, in a painting of 1787 by Martin Ferdinand Quadal, showing the life-drawing class at the Vienna Academy (fig. 17). To think that 120 years later nothing had changed, that the boxes were still in use, confirmed for me as nothing else had the validity of Schiele's increasingly bitter complaints about the academy's antiquated curriculum—complaints that led him and a small group of like-minded rebels to withdraw from the academy in the spring of 1909 and form their own Neukunstgruppe (New Art Group). The other academy find I was able to report to Melanie was that in the same book of academy entrance examination records where Schiele's test drawings had been marked "satisfactory," there was, a few pages earlier, the notation "unsatisfactory" entered against the name of another youthful applicant—Adolf Hitler. "At least the academy had high standards," joked Melanie ruefully.

We often took long walks, accompanied by a panting but joyous Waldi, and when Melanie heard that my next book was going to be about images of Beethoven, she triumphantly led me to the Robert Weigl effigy of him in the Heiligenstadt Park. Proud as I was that she entrusted me with Schiele items and information, I was even prouder when, just before I was to return to America, she afforded me the Du form of address

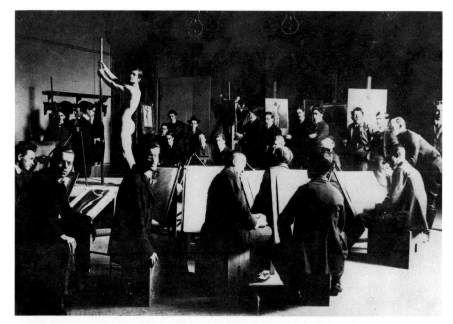

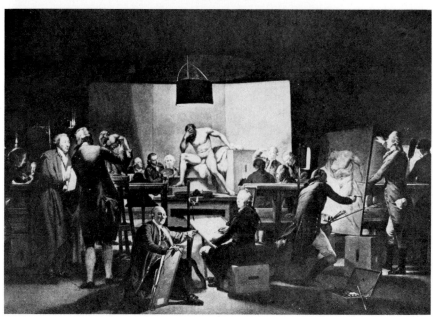

fig. 16. Photograph of the life-drawing class at the Vienna Academy of Fine Arts, with Egon Schiele standing in the background, far left. 1907. Photograph courtesy Galerie St. Etienne, New York

fig. 17. Martin Ferdinand Quadal. *The Life-Drawing Class at the Vienna Academy of Fine Arts*. 1787. Oil on canvas. From E. Pirchan, *Künstlerbrevier*, Vienna, 1939

reserved for intimates: my diary entry for 26 September 1963 records that moment: "showed Melanie all my new photographs, then we drank Brüderschaft, pledged the 'Du,' and she gave me my choice of an early Schiele drawing, plus a letter written by him, and a photo. She had also baked me a Gugelhupf cake. Sad farewell at midnight."

Perhaps the most important piece of information Melanie gave me about her family was one that shed new light upon Schiele's dual obsession with death (see plates 53 and 69) and sexuality. In terse terms I summed it up in the diary entry for that date, 12 January 1967: "[We went through] four of her mother's diaries. Then she told me the syphilis secret of the family!" Melanie stated that her parents married when Adolf was twenty-six and Marie was seventeen, against the wishes of her maternal grandfather, and that immediately afterward the couple took a wedding trip to Trieste (the itinerary of which Egon would repeat with his younger sister, Gertrude, in 1906), where, for the first three nights they did not sleep together. Instead, Adolf relieved himself at a local brothel and contracted syphilis, infecting his young bride shortly thereafter. He denied that he had the disease and would not have it treated. Marie was still so naive about

fig. 18. Exterior of Schiele's studio (top floor) at Hietzinger Hauptstrasse 101. 25 August 1963. Photograph by Alessandra Comini

fig. 19. Interior of Schiele's studio at Hietzinger Hauptstrasse 101. 25 August 1963. Photograph by Alessandra Comini

sexual matters that when she became pregnant for the first time she thought she was sick from eating apples. Three stillborn boys arrived in yearly succession, then came a girl, Elvira, who lived to the age of ten before she died from this lethal legacy. Egon and his two surviving sisters, Melanie, born four years before him, and Gertrude ("Gerti"), born four years after him, were all unwilling witnesses to their father's slow mental deterioration. Adolf played card games with imaginary partners and would insist on donning his dress uniform to greet numerous unseen visitors. After the family's move to Klosterneuburg, near Vienna, Adolf's fits of insanity came more frequently and he lay raving in bed most of the time. He died quite insane when Egon was fourteen. Awareness of his father's venereal affliction undoubtedly contributed to the preoccupation with sexual exploration, which was to become the subject matter of so many of Schiele's drawings: furious sexual activity in his private life seemed to be the artist's way of exorcising any threat of insanity.

Not all of Melanie's revelations were this dramatic, but over the years I was impressed by the consistency of her stories, related good-naturedly yet once again for the benefit of the tape recorder I now brought along with me. "Aber ich sprech' so ordinär" (But I speak so commonly) was her disappointed reaction to hearing her voice for the first time on tape. She was my enthusiastic companion on two "Schiele site" excursions. The first took us, after some persuasive talking, inside her brother's studio—still rented by artists—on the top floor of Hietzinger Hauptstrasse 101 (figs. 18 and 19; compare with fig. 6), where we stood at the windows from which Schiele had flapped outrageous self-portraits (similar to plate 65) to attract the attention of the two Harms sisters, Adele and Edith, who lived across the street at Hietzinger Hauptstrasse 114. It was there, in his mother-in-law's house, that both Edith and Egon Schiele would die; Melanie recalled that visitors were allowed to see her brother only from a mirror that had been placed in the doorway of his bedroom, so contagious was the raging influenza.

We also resolved to penetrate Schiele's final dwelling—the garden house with a two-story studio at Wattmanngasse 6, near the Schönbrunn zoological garden. After four years of trying in vain to find someone home we were successful: "Luck had it that the owner, Herr Forster, was there (he'd remodeled the house in 1960), and he showed us all around, the cellar, Edith's room, great!" reads my victorious diary entry for 17 December 1966. Herr Forster mentioned that there were some old unframed canvases in the basement, and for a few suspenseful moments Melanie and I nursed the silent hope that we were about to discover some missing Schiele paintings. However, here our luck ran out; the pictures were of quite recent vintage and very amateurish. But how she loved telling this story to her cronies at the neighborhood restaurant where we often ate dinner!

Someone who did not number among Melanie's friends, unfortunately, was her own sister, Gerti. They had had a falling out not over the Schiele estate but over a tomato, stolen, Melanie freely admitted, from Gerti's garden shortly after the end of World War II, when food was still scarce, following a visit to Gerti. Melanie "just couldn't help" herself, and anyway, she didn't think Gerti was watching. But Gerti was indeed watching, observing her older sister's departure from behind a curtained window. I heard Gerti's version when I visited her for the first time on 25 September 1963. She lived with more of the essentials of life than did poor Melanie and could afford to keep up the cottage house at Maygasse 37, where, since the death of her husband, Schiele's friend and colleague the painter Anton Peschka, she had lived with her unmarried son Anton Peschka, Jr. The two-story cottage was cozily atmospheric, with peasant furniture and, of much greater interest to me, Schiele's elegant wood and glass display cabinets (painted black, at his instructions, so as to resemble the designs of the Wiener

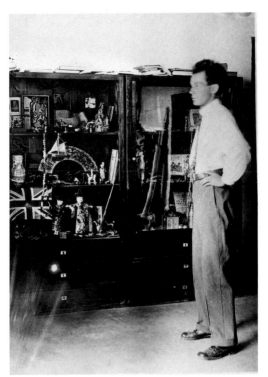

fig. 20. Schiele before his display cabinets. 1916. Photograph by Johannes Fischer; courtesy Alessandra Comini

fig. 21. Gertrude Peschka Schiele standing before her brother's display cabinets. Schiele's 1914 painting *Young Mother* (Kallir P. 273) hangs on the wall behind the cabinets. 18 February 1967. Photograph by Alessandra Comini

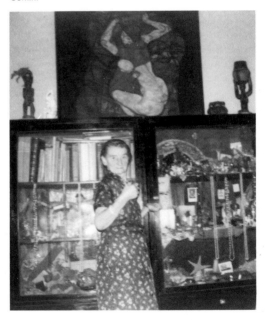

Werkstätte). The cabinets still contained many of the Oriental, Gothic, primitive, and folk art objects Schiele had collected with such enthusiasm, including a Chinese fan and a Japanese wooden doll complete with kimono, as well as a Union Jack flag and a rare copy of the Blaue Reiter *Almanach* of 1912—all of which can be seen in a photograph for which the artist somewhat self-consciously posed in 1916 (fig. 20). On a later visit Gerti obliged me by posing for the camera in front of the treasure cabinets of which she had been such a faithful guardian (fig. 21). But my first meeting with her was taken up largely by answering the many questions put to me as to why I visited Melanie first ("Because you took so long to answer my letter," I was tempted to reply), how often I saw her, and what Schiele drawings she still owned. Apparently I passed this inquisition satisfactorily, because I was then regaled with the tomato-theft story and how, because of this regrettable incident, the two sisters had not spoken to each other for some eighteen years. As I listened to the lively sixty-nine-year-old Gerti (also with dyed reddish hair) recount this litany of woes, accompanied by dramatic gestures, I could not help thinking how true to type—as manifest in their photograph of 1919 (see fig. 1)—these two very different sisters were: Melanie, tall, awkward, and serious, Gerti, petite, self-confident, and still the coquette. Anton, Jr. ("Toni"), who had been painted by Schiele as a child (see plate 94), was very much the solicitous cavalier to his mother and obviously adored her.

Over the years the Peschkas became less jealous of my visits to Melanie and more willing to cooperate with my Schiele research. It was, in fact, because of this research that the sisters began to communicate with each other again, and finally, after a nine-hour session on 18 February 1967 with mother and son looking through the first half of my Schiele book layout, I was able to engineer an invitation for Melanie to join us at the Maygasse cottage house. Like Melanie, Gerti was a night person, and, in fact, the later the hour the livelier she became. On 20 February I visited Melanie again and, according to my diary, "we sat in her heated bedroom and she glowed as I gave her a four-hour description of the Peschka visit." Now the stage was set for a face-to-face reunion of the two sisters, scheduled for Saturday, the twenty-fifth of February:

Taxi out to Peschkas at 2. . . . Melanie also came, and a funny time addressing each other as "Sie,"—she forgot once and said "Du." Gerti had put photos in order and we looked through the rest of my book layout. Toni brought sandwiches now and then . . . they showed me their holdings, some exciting Klimtish drawings and *Vorstudien* [preliminary studies] for the *Eremiten* [*The Hermits* of 1912, Kallir P. 229, Schiele's great double portrait of himself with Klimt] . . . we exchanged first names and kisses, left at 3 am!

How happy I was that the researches of an American art historian had been the instrument for reuniting the Schiele sisters, even if each still remained rather suspicious of the other. On the evening of 3 March 1967, the day before I was to fly back to America, I returned to the Peschkas with a tape recorder and, as my diary reveals, was able to conduct "an excellent tape recording session with Gerti and Toni from 8 till 2 am." It was during this last visit that I was allowed to photograph the Schiele objects and paintings in the Peschka collection—two major paintings were on the wall, *Young Mother* (Kallir P. 273) of 1914 (above Schiele's display cabinets; see fig. 21) and *Cityscape (Mödling III)* (Kallir P. 334) of 1918 (fig. 22). One of the most interesting objects was a multiprofile Janus head ceramic vase (fig. 23) Schiele had particularly treasured and which he incorporated as quixotic foil and frame for his own head in the 1911 oil *Self-Portrait with Black Clay Vase and Spread Fingers* (see plate 54). It was on this farewell occasion that Gerti and Toni playfully got into the Schiele spirit, dusting off the straight-backed, black Wiener Werkstätte—style armchair used by Schiele for his sitters (fig. 24), then disappearing upstairs to change clothes in order to pose for me in

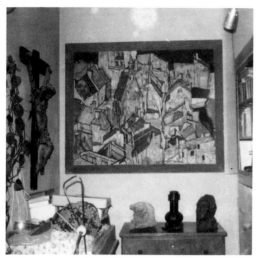

fig. 22. Schiele's 1918 painting *Cityscape (Mödling III)* (Kallir P. 334) and the sculptures *Female Torso* (Kallir S. 3) and *Self-Portrait* (Kallir S. 4) at the home of Gertrude Peschka Schiele. 3 March 1967. Photograph by Alessandra Comini

fig. 23. Schiele's black clay Janus head vase. Formerly Collection Gertrude Peschka Schiele. 3 March 1967. Photograph by Alessandra Comini

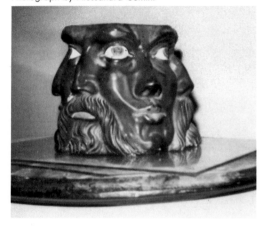

opposite, above to below

fig. 24. Gertrude Peschka Schiele dusting off Schiele's sitter's chair. 3 March 1967. Photograph by Alessandra Comini

fig. 25. Anton Peschka, Jr., sitting in Schiele's sitter's chair and posing as Karl Grünwald, whose 1917 oil portrait by Schiele (Kallir P. 307) is reproduced in the open book at the left. 3 March 1967. Photograph by Alessandra Comini

fig. 26. Gertrude Peschka Schiele sitting in Schiele's sitter's chair and posing as her sister-in-law Edith in Schiele's 1918 oil *Portrait of the Artist's Wife, Seated* (see plate 95). 3 March 1967. Photograph by Alessandra Comini

the chair as though they were two of Schiele's sitters — Toni, in shirtsleeves with a bow tie, assuming the identity of Karl Grünwald, Schiele's commanding officer in the army (fig. 25), and Gerti, in a dirndl, taking the role of her sister-in-law Edith (fig. 26; see plate 95).

"But why did Schiele always have to paint Edith looking so dumb!" exclaimed her sister Adele Harms (see plate 89) to me about the artist's passive, doll-like depiction of his wife (see fig. 82). This bitter complaint was hurled out during a tape-recording session with Schiele's sister-in-law on 24 January 1967. Adele was seventy-six when I first met her in November 1966, and she eked out a meager living as the *Hauswart* (concierge) of the gloomy apartment building in which she lived at Daungasse 3 — where the tarnished shield on her door read grandiosely, "Ada Del Harms." Our first interview lasted six hours, and she progressed from polite cordiality to agitated reflections on the fact that her mother, and Schiele, and "everyone" had preferred her beautiful younger sister Edith to her. She stressed how talented Edith was, that she spoke English and French and had a much superior education to that of Egon, and she confirmed Melanie's and Gertrude's tales of Schiele's "waving" his self-portraits out his studio window at the two Harms girls across the street. In general he acted "like an Apache," suddenly jumping out from bushes at them and bombarding them with notes and letters until they agreed to go to the cinema with him. When Edith married Egon she became his model (see plates 80, 90 and 91) until she got "too fat," but, Adele allowed, she, too, had served frequently as a model for her brother-in-law, posing not only for intimate drawings (fig. 27; see plate 81) but also for "naughty" photographs taken by him, for which occasion she had peeled down to her underclothes. "And I also sat for him in the nude," she volunteered in hushed tones, producing two provocative photographs taken in Schiele's Hietzinger Hauptstrasse 101 atelier in front of the great standing mirror. Before I could get up the nerve to ask whether she might allow me to reproduce one of the latter items in my book, she slowly tore them up in front of me, announcing in a dramatic stage whisper, "But you are the only person who shall ever see these." As consolation she handed me two of her "naughty" photographs (fig. 28). Painfully conscious of how much her appearance had altered with the passage of time, however, she would not grant my request to photograph her. Like Schiele, Adele seemed to have an obsession with erotica — she frequently and abruptly brought the discussion round to sex, as, for example, when starting to tell me about her father, whom Schiele had portrayed so sympathetically a year before the old man's death (see plates 92 and 93), commenting matter-of-factly, "My father, like all Germans, was bisexual" (Mein Vater, wie alle Deutschen, war bisexual) — a sweeping assessment noted down verbatim in my diary entry for that day. I also wrote: "She is a bit crazy, but her single cot touches my heart and I feel sorry for her. She even cried when recalling her mother's preference for Edith."

As we got to know each other better it became Adele's self-imposed mission to ensure that all her sister's personality traits be emphasized in any future scholarship concerning Schiele. She began calling me early in the morning at my pension with additional vital facts that had come to her during the night: Edith was "affectionate," "jealous," "quite willful," and "extremely thirsty for knowledge." One Sunday morning she telephoned at 6 A.M. (my landlord was none too happy) and with rolling rs and long, drawn-out tones shouted excitedly into the phone, "Fräu-lein Co-mi-ni! Hö-ren Sie gut zu! Ich hab' Ih-nen was Wich-ti-ges zu er-zäh-len." (Miss Co-mi-ni! Lis-ten care-fully! I have something im-por-tant to tell you.") "Ja, ja?" I said sleepily. "E-dith warrrrrrrr *früh reif!*" "Was? Was?" I answered, not comprehending a term that translated literally as "early ripe." As do so many people when they are not under-stood, Adele repeated her words, only more loudly. I still did not catch on. Exasper-

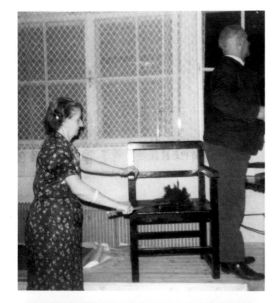

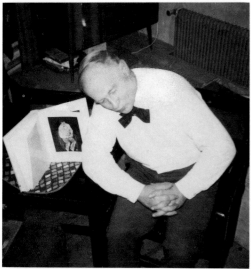

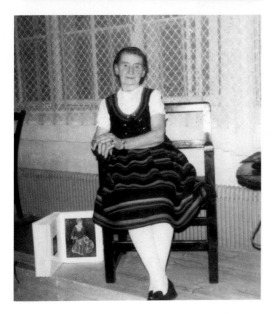

ated, Adele screamed into my ear, "Die E-dith hat, mit zwölf Jah-ren an-ge-fang-en zu men-stru-ie-ren!!!" Although I at last understood that Edith had begun to menstruate at the age of twelve, this gripping fact did not, somehow, appear in any of my books on Schiele. A few years later, "Ada del Harms" was forced to move into the Steinhof sanatorium ("Pavilion 25, for ever," she wrote me), where the ephemeral fame she had acquired as Schiele's sister-in-law hardly helped to allay her loneliness.

Back at the Albertina, due to a little article I had published in the museum's journal, *Albertina Studien*, concerning the discovery of Schiele's prison cell, my status with the guards had advanced from being referred to as "das Schiele Fräulein" to "die Schiele Frau," although this new rank carried absolutely no influence as far as getting the electric lights turned on during overcast days in the Studiensaal. But the dark halls of the Albertina did provide me encounters and interviews with two of Schiele's sitters. The first was with the art historian Otto Benesch, who had just retired as director the summer I arrived in 1963. He still had a small office in the building and was to be seen at all hours of the day prowling down the corridors with stacks of books under his arms. I had met his painted visage as the seventeen-year-old son figure in Schiele's great statement on tensions within a father-son relationship, *Double Portrait (Chief Inspector Heinrich Benesch and His Son Otto)* of 1913 (see fig. 64). I was eager to meet the real-life figure whose father — a civil servant with only a modest income who was nevertheless an avid art collector — had been such a close, loyal friend of the artist, and this was accomplished shortly after my arrival. We sat in Otto's modest office, and I noticed that he had lost none of the slender height indicated in Schiele's portrayals. To my eager question concerning what sort of man Schiele really was, he had a ready answer: "He was shy and quiet, but not close-mouthed or locked up in himself. He expressed his own opinions frankly and in fact was known for doing so. For example, the first time he visited my father he was shown the Benesch collection — at that time Romantic paintings — and when asked what he thought of it, Schiele answered, 'Well, yes, a few of the works are not too bad.'" Otto laughed at the memory of this exchange and admitted that later on his father came to agree with Schiele and changed the direction of his collecting. I asked him if Schiele were religious: "No, not particularly. He was like all the Expressionist painters, he believed in himself, his mission, that some power above had bestowed a particular talent upon him." To my query as to whether or not Schiele was political, he responded: "No, none of the artists of that time were seriously interested in politics — with the exception of Kokoschka, who was really serious and acted with extreme courage during the war. Schiele was not a socialist; he sometimes depicted [see plate 12] but did not crusade for the poor." Patiently Dr. Benesch answered these and many other questions, pausing considerately for me to write down his abundant answers, so filled with wisdom and a knowledge of that distant period. Only in one area did I later disagree with this distinguished scholar who had through his writings introduced Schiele to an international public, and that was concerning the possible influence of modern dance on Schiele's pantomime-like gesticulation in his photographs and self-portraits. Dr. Benesch, thinking perhaps of the flowing Art Nouveau lines of the waltzing Wiesenthal Sisters, who were all the rage in turn-of-the-century Vienna, said no; I was to discover a convincing parallel between the angular movements of Schiele's self-portraits and those of the contemporary Expressionist dancers Harald Kreutzberg and Mary Wigman.

A few years later, also in the halls of the Albertina, I met a second Schiele sitter, Eva Steiner, the wife and now widow of Otto Benesch. As a little girl she had been sketched by Schiele, but she was not particularly interested in recalling the experience. She did invite me to her apartment, which was nearby, and spoke animatedly to me about the psychological riddles with which Schiele's double portrait of her husband and father-

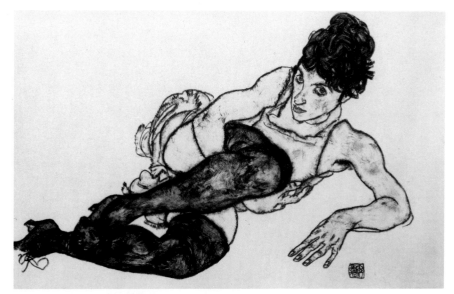

fig. 27. Egon Schiele. *Reclining Woman with Green Stockings*. 1917. Gouache and black crayon on paper. 11⅝ × 18⅛" (29.4 × 46 cm). Kallir D. 1995. Private collection, courtesy Galerie St. Etienne, New York

fig. 28. Adele Harms. c. 1917. Photograph by Egon Schiele; courtesy Alessandra Comini

in-law had first presented viewers, and how Schiele had intuitively divined the authoritative Heinrich's lack of understanding for the spiritual world toward which his son's thoughts and glance were directed. After a great deal of imploring on my part she produced a photograph of Otto as a young man (fig. 29)—an image that compellingly matches the serious, sensitive Otto Benesch of Schiele's creation. My original impression that the artist had very much identified with Heinrich Benesch's artistic son was reinforced.

It was equally difficult to obtain, at first, a photograph of the next person I met, who in his youth had been the subject of an oil portrait by Schiele—Erich Lederer (fig. 30). Erich (who insisted I call him thus) was the son of an important patron of the arts, the

fig. **29.** Otto Benesch. 1915. Photograph courtesy
Alessandra Comini

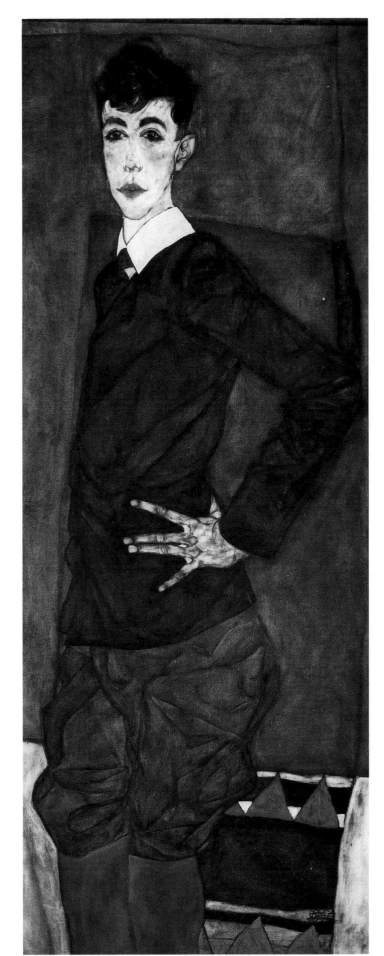

fig. **30.** Egon Schiele. *Portrait of Erich Lederer.* 1912.
Oil and gouache on canvas. 54¾ × 21⅝" (180 ×
119.5 cm). Kallir P. 235. Öffentliche Kunstsammlung,
Basel

fig. 31. The sixty-nine-year-old Erich Lederer looking at a reproduction of Schiele's portrait study of him as a young man (Kallir D. 1221), Geneva. 27 November 1966. Photograph by Alessandra Comini

fig. 32. Erich Lederer as a young man. Photograph courtesy Alessandra Comini

wealthy industrialist August Lederer, who maintained residences in Györ, Hungary, where his distillery factory was located, and in Vienna. Erich's mother, an amateur painter, had been a close friend of Klimt, and the family owned the largest private collection of Klimt's oils and drawings. Erich was fifteen when Schiele arrived in Györ in December 1912 with a commission (arranged by Klimt) to spend the Christmas holidays painting him. Schiele himself referred to Erich as a "Beardsley," and I had already found ample evidence of this in the letters he had written Schiele that were in Melanie's possession: they were the boastful outbursts of a high-spirited adolescent, devoted almost exclusively to detailed accounts of bizarre sexual adventures, written obviously to impress a confidant with a reputed penchant for things erotic. Now, as I flew to Geneva in November 1966 to meet the author of these letters, I wondered how much affinity he would still bear to the young man of 1912, so familiar to me through Schiele's many preparatory sketches (over a dozen in all) for the penetrating oil portrait completed in that year.

Swiss chocolates and a note of welcome were waiting in the room reserved for me at the Hotel Bristol, where Erich had lived with his wife Lisl for the past several decades. The couple arrived at 7:30 to take me to dinner, and I met a tall, elegant, soft-spoken woman and a short, portly old man who moved with deliberate slowness and whose heavy black glasses contrasted insistently with his silver-white hair. The only physical resemblance to the Erich of Schiele portraiture was the "long, aristocratic face" described by the artist in a letter. But the psychic similarity to the prurient "Beardsley" of former times was revealed almost immediately. No sooner had Erich ordered dinner (without consulting us) than he turned to me and demanded in a loud, imperious voice, "Tell me, young lady, do you shave under your arms?" Only later that evening, when Erich settled down to examine the visual material assembled in the layout for my book, did he abandon his storytelling and concentrate on Schiele. I photographed him as— entranced and silent for once—he held up a reproduction of one of the artist's exquisite portrait studies of him (fig. 31).

In the next few days a pattern was established: we would meet after breakfast and walk to the hotellike bank where his vast collection of Schiele and Klimt drawings was kept in a vault and spend the day looking at them. There was very little Erich could or would tell me about Schiele's personality, or what it was like to be his sitter, but certainly this unparalleled opportunity to study and take notes on so many Schiele drawings—the "*crème de la crème*," as Erich called them—was well worth the trip to Switzerland. Erich did indeed have a connoisseur's eye for art. As a young man he had assembled an impressive collection of bronzes—and it was just such an image of the young Erich at his best, proudly displaying one of his bronze statuettes (fig. 32), that Lisl thoughtfully slipped to me as I left Geneva to return to Schiele's Vienna.

Before long, however, another Schiele site lured me away from the city. I visited the picturesque village on the bend of the river Moldau in Czechoslovakia that had been one of the artist's favorite motifs, Krumau (see plates 38–40 and 51). Krumau, then in Austrian Bohemia, was Schiele's mother's hometown, and the initial summer visit made in 1904 during Schiele's boyhood had inspired the adult artist to return with regularity. The stillness of the square old buildings on the blue river (quite brownish in color and polluted by factory discharges when I saw it in 1966) appealed to Schiele's sense of ironic allegory, and he titled some of his completed oil views of the town *Dead City*. When I showed my new photographs of Krumau to Melanie she remembered that she had several picture postcards originally belonging to Schiele with views of the town. We looked at them and made the interesting discovery that Schiele had drawn a grid with his pencil over the lower right half of one town view that showed his beloved "crescent" of buildings at the bend of the river (fig. 33; compare with plate 51). This

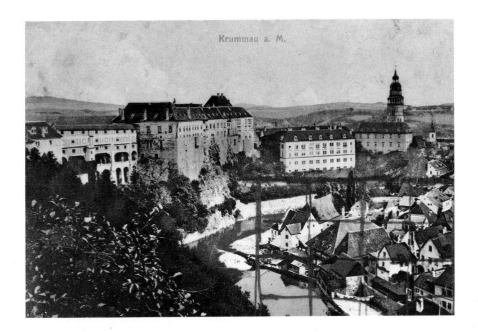

squaring off of a landscape motif agreed with the artist's characteristic preference for trenchant reduction, with its pristine emphasis on stacked planes and compressed volumes.

Second only to Melanie, the most informative of Schiele's sitters by far was Friederike Maria Beer, whose life-size oil portrait had been painted by both Schiele (fig. 34) and Klimt—and in that order, as she emphasized to me when I first met her in August 1963. Daughter of the prosperous owner of two stylish nightclubs, she had been schooled in Belgium and England and raised as a member of Vienna's young artistic elite. She had maintained a lifelong close friendship with one of Schiele's Neukunstgruppe colleagues, the painter Hans Böhler. Our initial interview took place in her large apartment at Krugerstrasse 3/8, which her family had owned since 1904. "Fritzi," as I was soon instructed to address her, was only twenty-three years old, just a few months younger than the artist himself, when Schiele painted her in 1914. A photograph she later sent me of herself (fig. 35) confirms the charming word portrait she gave me that day when I asked her what she was like at that age:

I was good-looking, young, and interested in music and art. What was I doing at twenty-three? Nothing! Just living—going to the theater, to art exhibitions, to the opera. In those days I was so wild about the Wiener Werkstätte that every single stitch of clothing I owned was designed by them.

This preference for the geometrical Wiener Werkstätte style, which would provide such motivic foil in both Schiele's and Klimt's portrayals of her, endured for life: my final visit to Frau Fritzi—after years of living in New York, she had moved to Honolulu to be with relatives—found her happily dressed in a Hawaiian muumuu of appropriately "Viennese" design and elegant as ever (fig. 36).

To my question, during our first meeting on 23 August 1963, as to what Schiele was like, she answered readily, "He was tall, thin, shy, and quiet. He spoke with the Viennese intonation but not in heavy dialect. [Melanie had mentioned to me that Schiele had such a good ear he was able to imitate the variation of dialect spoken in each district of the city of Vienna.] He dressed normally [Melanie had stressed this as well, but said he was so vain that he refused to be seen carrying a package in public], but even so he stood out in a crowd. One could tell there was something unusual about him: that fantastic head of hair! Those outspread ears! He really appeared rather spectacular."

opposite

fig. 34. Egon Schiele. *Portrait of Friederike Maria Beer.*
1914. Oil on canvas. 74¾ × 47½″ (190 × 120.5 cm).
Kallir P. 276. Private collection

fig. 35. Friederike Maria Beer, Vienna. 1916.
Photograph courtesy Alessandra Comini

fig. 36. Friederike Beer-Monti, Honolulu. 1970.
Photograph courtesy Alessandra Comini

Frau Fritzi explained how the commission to have her portrait painted by Schiele came about and what the sessions were like:

I had often seen Schiele at art exhibitions in the company of my friend Hans Böhler. I decided I wanted Schiele to paint my portrait but I was too shy to ask him, so I got Hans to ask him for me. Both Schiele and I were embarrassed and quiet during the sittings. I didn't want him to think that I was a society lady after all! I went out to his atelier at 101 Hietzinger Hauptstrasse every morning. I wore a Wiener Werkstätte handprinted dress that was black, white, and green; Schiele changed the colors, as you know. He liked the dress very much. He was very polite and always accompanied me back to the tram station. There was a railroad crossing before it and once we had to wait for a train to cross and I said to Schiele: "I'm always so impressed when I see a train, I feel as though all the places it has been can impart themselves a little bit to me as it goes whizzing by." And Schiele answered: "I must think about that when I paint you."

The previous summer my family and the Böhlers had been in South America and I had bought some of the little Indian dolls made by the natives in La Paz. One day I brought some of these little dolls with me to Schiele because I thought they would please him. He was delighted with them and strewed them over me, one here at the crook of my arm, one there, on a shoulder, just as you can see in my painting, and he included them in the final picture. No, I didn't give him one of the dolls, but I did leave the dress I wore in the painting for Wally [Valerie Neuzil, Schiele's companion and model at that time]. Schiele suggested, when the painting was finished, that I hang it on the ceiling, and indeed I did for a while. But our maid went to market a few days later and told everybody: "Just look! My mistress has been painted and she looks as though she lies in her tomb!"

It was the deliberate layering of Expressionist angst into Schiele's portrait of Fritzi—her figure suspended in space, with flailing fingers, wrenched head, and plummeting feet—that gave the picture such a "tomblike" aspect. The inexplicable and disquieting ambiguity of the unsupported, upright pose was further accentuated by the placement of the artist's signature at the lower left, thus enforcing a vertical reading to what had originally been a horizontal pose—Schiele's sketchbook notations show Fritzi's figure stretched out on his low studio mattress, her upraised arms wrapped around a pillow. By depriving his model of any explanatory environment—even the sophistication of the Wiener Werkstätte silk dress has been altered, almost attacked, by the dartlike intrusions of rag dolls from a primitive culture—Schiele created an existential as well as compositional void. Perhaps the good-natured Fritzi nourished a secret disappointment at the gaunt outcome; it was certainly with pride that she quoted to me what Klimt said to her after he finished his portrait of her (complete with a reassuring and highly decorative "environment") in 1916: "Now people can no longer say that I only paint hysterical women."

Fritzi also explained to me that although Schiele liked and admired Klimt he did not socialize with him:

When I think back on it now I can see that the artists of the time clearly fell into two different "camps." You might call them the "intellectuals" versus the "hedonists." . . . Klimt and [Josef] Hoffmann were the hedonists—living the high life, always going out with lots of girls at night to Grinzing, holding what we thought of as bacchanals—while the other faction, which included the "wild" painter Oskar Kokoschka as well, was considered the intellectual group, not so pleasure-loving, not so pleasure-seeking.

The division about which Fritzi was speaking paralleled, I realized, the difference in attitude that characterized Vienna's artists and styles at the beginning of our century: the older Art Nouveau or Jugendstil generation—Klimt and Hoffmann included—was involved in a last nostalgic preoccupation with beauty and the facade; the younger

Expressionist generation—represented by Schiele and Kokoschka—found itself gripped by the anxiety and self-concern that a compulsive confrontation with ugly truths, such as the state of society or of an individual psyche, had forced into the open.

And it was that raw confrontation with self—the most persistent theme of Schiele's art—that inevitably made available to me the most important of Schiele's sitters: himself (fig. 37). The tortured image reflected in that great standing mirror before which the artist had posed so often was released in the torrent of self-portraits that span the creative years of Schiele's brief life. They document a passage from trauma to healing in the series of assumed identities that progresses from lonely exhibitionist, acting out sexual compulsions and longings (see plates 21–25), to—after the Neulengbach imprisonment—self-pitying recluse, garbed as monk, hermit, and martyred saint (see plates 53, 58, 59, and 63) to, in the last year of World War I, hopeful founder of a young family (see plate 86)—a vision that would indeed have been realized, for Edith was six months' pregnant with their first child when influenza carried her off. For all those who would embark on their own search of Schiele, the way is still clear, the discoveries still exciting, because of the extraordinary talent for drawing of an artist who was able to make the sitters and sites of long ago so immediately accessible to future generations.

fig. 37. Alessandra Comini studying a Schiele *Self-Portrait* (Kallir D. 714) in the collection of Viktor Fogarassy, Graz. 15 September 1963. Photograph by Dollie Fogarassy

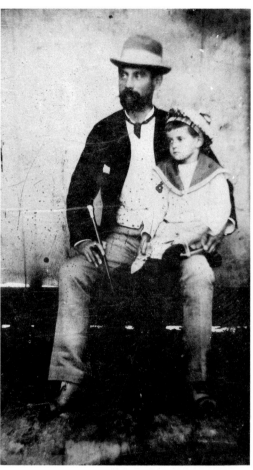

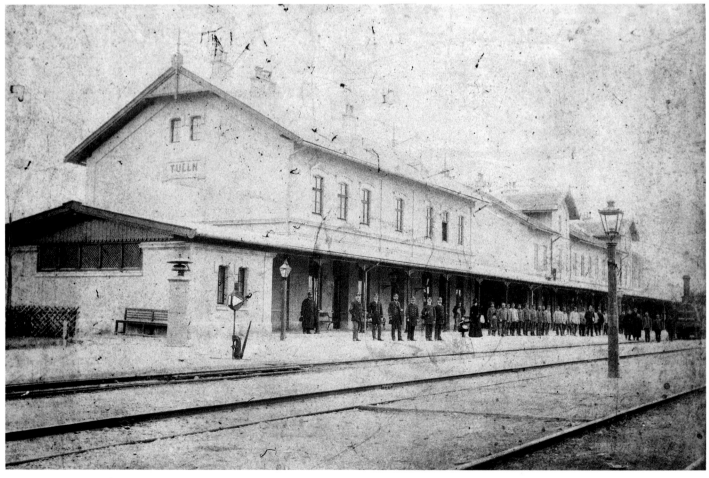

Egon Schiele Biographical Chronology

fig. 41. Melanie, Gerti, and Egon Schiele. 1894. Photograph courtesy Alessandra Comini

1890: On June 12, Egon Schiele is born, the first and only surviving son of Adolf and Marie (née Soukup) Schiele. Egon's childhood is blackened by illness, supposedly attributable to his father's untreated syphilis. Marie had previously given birth to three stillborn infants and a daughter, Elvira, who would die at the age of ten in 1893. Egon grows up in the company of an older and a younger sister, Melanie (born 1886) and Gertrude (known as Gerti; born 1894).

At the time of Egon's birth, Adolf Schiele is employed as stationmaster in Tulln, a small town on the Danube River about eighteen miles west of Vienna. From a very early age, Egon is enthralled by two things: drawing and the railroad. His remarkably precocious drawings of trains encourage his parents to conclude that he will follow in the family tradition and pursue a railroad career, possibly becoming an engineer like his paternal grandfather.

1897: Led by Gustav Klimt, a group of young artists dissatisfied with the conservative policies of the Künstlerhaus (then Vienna's sole venue for exhibitions of contemporary art) founds the Secession. Other than the philosophy embodied in its forward-thinking motto, "To the age its art, to art its freedom," the Secession espouses no set aesthetic program. It shows the latest in foreign and domestic art and makes a concerted effort to unify the applied and fine arts. To this end, the architect Josef Hoffmann and the designer Koloman Moser craft elaborate customized exhibition installations.

1901: In the hope of preparing Egon for a university education, his parents send him to a *Realgymnasium* in the town of Krems, about twenty-five miles from Tulln. The strategy proves a failure: Egon must board with an unsympathetic widow and does poorly in school. At midterm, he is brought back to Tulln, where he finishes the school year with the aid of a private tutor.

1902: The Schieles decide to try a *Gymnasium* closer to Tulln, in Klosterneuburg. Though Egon's uncle Leopold Czihaczek maintains a vacation home in the latter town, the boy must again board with strangers, and his schoolwork evidences little improvement.

Adolf Schiele's syphilis enters its terminal phase, and he begins to show signs of mental impairment.

1903: Josef Hoffmann and Koloman Moser cofound the Wiener Werkstätte (Vienna Workshops), a crafts collective intended to explore more intensively the union of the fine and applied arts previously essayed via the Secession's program.

1904: The Schieles join Egon in Klosterneuburg after Adolf is officially removed from his post in Tulln. On a summer outing to Marie's birthplace, Krumau (now Český Krumlov, in the Bohemian region of the Czech Republic), the critically ill father attempts suicide. He is thwarted in this endeavor but dies months later, on New Year's Eve.

1905: Dependent on Adolf Schiele's meager pension, the family's financial circumstances decline precipitously, and Melanie helps out by taking a job with the railroad. Leopold Czihaczek becomes guardian, together with Marie Schiele, of the two minor children, Egon and Gerti. Egon, increasingly immersed in his art, continues to flounder in school. He is befriended by a local painter some twelve years his senior, Max Kahrer, as well as by the *Gymnasium's* art teacher, Ludwig Karl Strauch, who gives him private instruction.

In Vienna, the Secession is split by a rift between the traditional easel painters and those who, like Klimt, Hoffmann, and Moser, favor a more unconventional union of the fine and applied arts. When the latter group walks out, the Secession effectively abandons its progressive program, and the local avant-garde is left without a steady exhibition venue.

1906: Already two or three years behind most of his classmates, Egon fails the spring term, and his mother is politely told to remove him from school. Against the protests of his uncle Czihaczek, the boy takes and passes the rigorous entrance exam for Vienna's Academy of Fine Arts. At sixteen the youngest of his fellow students, Egon enters the nation's foremost art school that autumn. His mother and sisters move to Vienna to be with him, and he also comes under closer scrutiny by his uncle.

1908: Having completed the introductory curriculum at the academy, Schiele advances to the General Painting class of Christian Griepenkerl, a notoriously harsh and conservative painter of the old school. The mutual antipathy that exists between the two prompts the young artist regularly to skip class.

Schiele has his first small exhibition, organized by his former teacher Strauch, in Klosterneuburg. He is increasingly influenced by Gustav Klimt, whom he has reportedly met the previous year. Klimt's work is prominently displayed at the 1908 "Kunstschau," the first exhibition organized by the Viennese avant-garde since the Secession split. Early work by Oskar Kokoschka, who will later take the lead in the development of Austrian Expressionism, is also to be seen at that exhibition.

1909: Klimt invites Schiele to participate in a second, international "Kunstschau." Perhaps emboldened by this encouragement, Schiele unites with a group of like-minded classmates to form the Neukunstgruppe (New Art Group), which submits a formal letter of protest to Griepenkerl. Consequently threatened with expulsion, he and many of his friends withdraw from the academy.

In December, the Neukunstgruppe has its first public exhibition at the Kunstsalon Pisko. Here Schiele meets the critic Arthur Roessler, soon to become one of his most ardent champions and patrons.

1910: In his first full year of artistic independence, Schiele achieves stylistic and professional breakthroughs with remarkable speed. Early in the year, he develops a

fig. 42. Egon Schiele as a first-year student at the Vienna Academy of Fine Arts. 1906

personal variant of Expressionism that seemingly owes little to the precedent of Kokoschka or Kokoschka's chief competitor, Max Oppenheimer (Mopp). Schiele also quickly gathers around him a small but loyal group of patrons, among them Roessler, the industrialist Carl Reininghaus, the wealthy physician Oskar Reichel, and Heinrich Benesch, a railroad inspector of modest means who has been following Schiele's career since the 1908 Klosterneuburg exhibition. He enjoys the continuing support of Klimt's circle, including Josef Hoffmann and the prominent elderly architect Otto Wagner. The Wiener Werkstätte publishes three postcards reproducing Schiele watercolors.

Despite his apparent success, Schiele grows increasingly disgusted with Vienna. Rivalries within the Neukunstgruppe, romantic problems, and an abortive attempt by his uncle to enlist him for military service prompt him to flee to Krumau in early May. This move, coupled with the artist's constant requests for money, brings to a head the brewing conflict with Czihaczek, who now renounces his guardianship and all financial responsibility for Egon.

Throughout most of the summer, Schiele remains in Krumau, where he is joined by the artist Anton Peschka and Erwin Osen, a mime, sometime painter, and avant-garde poseur who emulates the antics of the French poet Arthur Rimbaud. Before settling into Vienna for the winter, Schiele makes a brief return trip to Krumau in October. The medieval river town, which he calls the "dead city," becomes his most important landscape subject.

fig. 43. Egon and his uncle Leopold Czihaczek on a summer outing in Neulengbach. July 1908. Photograph courtesy Alessandra Comini

fig. 44. The Kunstsalon Pisko, Vienna, site of the first exhibition of the Neukunstgruppe. c. 1909. Photograph courtesy Alessandra Comini

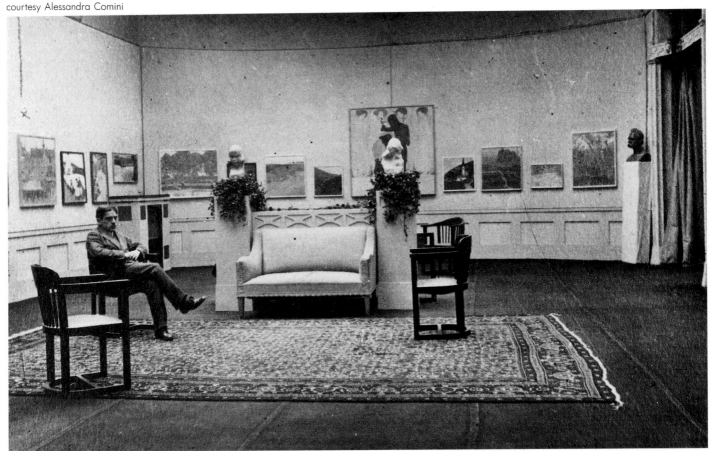

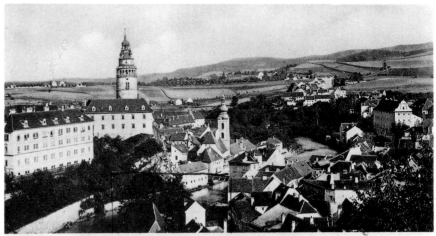

fig. 45. Photograph of Krumau, inscribed by Egon Schiele: "Das Eingerandete ist der obere Teil der 'Toten Stadt'" (The outlined area is the upper part of the "Dead City"). May 1911. Wiener Stadtbibliothek

fig. 46. The "garden house" in Krumau, used as a studio by Schiele in 1911

1911: Schiele continues to feel uneasy in Vienna, moving first to one of the city's outlying districts and then resolving to relocate permanently in Krumau. He returns in May accompanied by Valerie ("Wally") Neuzil, his lover and foremost model until the time of his marriage.

The next months are productive and happy for Schiele, but his unorthodox behavior—particularly his openly conducted affair with Wally—alienates the conservative townspeople. The situation erupts when a nude model is observed posing in his garden, and the artist is forced to leave Krumau in August. After a brief sojourn with his mother, Schiele moves to Neulengbach, a town some twenty miles west of Vienna previously known to him as the site of one of Czihaczek's vacation homes.

Schiele's remove from Vienna makes it difficult for him to sustain direct contact with his patrons, and he begins to seek broader exposure. His first solo exhibition in Vienna, arranged via Roessler, takes place at the Galerie Miethke in April. In October, again under Roessler's auspices, Schiele enters into his first sustained relationship with an art dealer, Hans Goltz in Munich.

fig. 47. The house at Au 48, Neulengbach, rented by Schiele in 1911–12

fig. 48. The district jail, Neulengbach. Photograph by Alessandra Comini

1912: Just as he did in Krumau, Schiele soon runs afoul of the small-town social mores of Neulengbach. It has long been his practice to use local children as models, and one of these proves his undoing. Tatjana Georgette Anna von Mossig, a retired naval officer's daughter approximately thirteen years of age, decides to run away from home and seeks refuge with Egon and Wally. Though she returns to her family unharmed several days later, her father accuses Schiele of kidnapping, and this in turn prompts the authorities to launch a full-scale investigation. On April 13, the artist is jailed on counts of kidnapping, statutory rape, and public immorality. The first two charges are eventually dropped, but Schiele is convicted of the third, on the premise that minors have seen indecent works in his studio.

Schiele spends a total of twenty-four days in jail, first in Neulengbach and then at the larger district prison in Sankt Pölten. Finding it pointless to return to Neulengbach following his release on May 7, the artist retreats once more to Vienna. In October, after a succession of makeshift living arrangements, he rents a studio at Hietzinger Hauptstrasse 101, which he will retain for the rest of his life.

Emotionally scarred by his prison ordeal and financially strapped by the attendant expenses, Schiele grows increasingly despondent. However, while he claims repeatedly that he cannot work, his professional opportunities actually appear to be improving. He exhibits alongside the radical Blaue Reiter (Blue Rider) group at Goltz's Munich gallery, with the Sonderbund in Cologne, at the Hagenbund in Vienna, and he also participates in a two-person show at the prestigious Folkwang Museum in Hagen. Additionally, he acquires two important new patrons, the Viennese innkeeper Franz Hauer and the wealthy industrialist August Lederer. He spends Christmas at the Lederer estate in Györ, Hungary, and paints a portrait of August's son Erich, who will later become an important collector of the artist's work.

1913: Despite his increasing professional contacts and exposure, Schiele continues to live a hand-to-mouth existence. His relationships with his original patrons—Reichel, Reininghaus, Roessler, and Benesch—are becoming strained, and the artist's financial position is not improved by his growing penchant for painting large, difficult allegories. A one-man show at Goltz's gallery proves a failure, and in the fall the dealer severs his ties with Schiele.

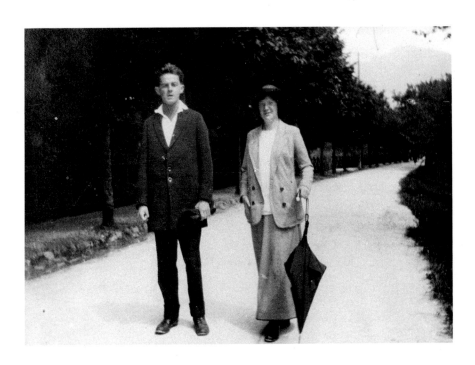

fig. 49. Egon Schiele and Wally Neuzil. 1913. Photograph courtesy Alessandra Comini

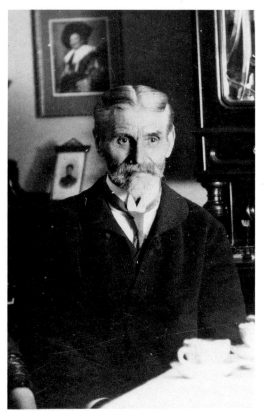

fig. 50. Johann Harms, Schiele's father-in-law. Photograph courtesy Alessandra Comini

fig. 51. Edith Harms Schiele, passport photograph. c. 1915. Photograph courtesy Alessandra Comini

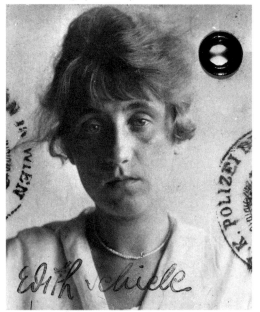

1914: Schiele's financial plight worsens. He fails to win any sort of prize in a competition sponsored by Reininghaus, and in April his landlord threatens him with eviction. Casting about for additional sources of income, he begins an abortive experiment with etching. Not until the fall does he find himself on sounder footing, largely due to the assistance of a new patron, Heinrich Böhler. Böhler is not only a collector but also Schiele's first regular student, and he helps the artist buy paints and canvas. In December, Schiele has his second one-man show in Vienna, at the gallery of Guido Arnot.

World War I has so far had little immediate impact on Schiele. A greater upheaval in his personal life is caused by the marriage, in November, of his favorite sister, Gerti, to his friend Anton Peschka. Under this impetus, Schiele intensifies an ongoing flirtation with two sisters, Adele and Edith Harms, who live across from his studio on the Hietzinger Hauptstrasse.

1915: Schiele's thoughts turn increasingly to marriage. He rejects the faithful but socially inferior Wally in favor of Edith, the younger of the two Harms sisters. Informally engaged in the early months of the year, the couple rushes to marry after Schiele is drafted into the army. The wedding takes place on June 17, and three days later the artist reports for basic training in Prague.

After a brief stint in Czech Bohemia, Schiele is assigned duty closer to Vienna, where he is frequently able to sleep at home. Many Austrian artists are shielded from active military service by remarkably lenient regulations and special arrangements, but Schiele's initial attempts to wangle a similar sinecure prove unsuccessful. He spends his days digging trenches or guarding Russian prisoners of war. Although he tries to pursue his art, his production in the second half of the year plummets.

1916: In May, Schiele is transferred to a prisoner-of-war camp at Mühling, a rural hamlet some three hours from Vienna. As Mühling is not in a war zone, Edith can accompany him. Egon's job is not taxing (he works in an office), and his superiors make an effort to accommodate his artistic proclivities. He is even given an empty storeroom to use as a studio. Nonetheless, his output continues to dwindle; this is his least productive year.

Though the war has greatly reduced exhibition and sales opportunities, the artist gets some exposure when the left-wing Berlin periodical *Die Aktion* publishes a special Egon Schiele issue. A planned second exhibition at Arnot's gallery falls through but helps reawaken Schiele's professional ambitions. Toward the end of the year, he launches a campaign to get reassigned to Vienna.

1917: Under the sponsorship of a sympathetic young art dealer, Karl Grünwald, Schiele is transferred to the Military Supply Depot in Vienna. His duties are relatively light, and the commanding officer, Hans Rosé, indulges his talents by assigning him to create a pictorial documentation of supply depots throughout the Austro-Hungarian Empire. In June, the artist travels with Grünwald (his immediate superior) to the Tirol researching this project.

Despite wartime restrictions, Schiele's career suddenly seems to be taking off. He cements his relationship with Franz Martin Haberditzl, the director of the Staatsgalerie (today Österreichische Galerie), who buys three drawings early in the year and in September sits for a portrait. The bookseller Richard Lanyi publishes the first portfolio of Schiele reproductions in July. Schiele's plans to establish a *Kunsthalle* for the promotion of contemporary culture run aground, but he nonetheless becomes increasingly active as an organizer of exhibitions. He gathers contributions for a "War

fig. 52. Egon Schiele (top row, second from left) with his army platoon. c. 1916. Photograph courtesy Alessandra Comini

fig. 53. Edith Schiele and her dog Lord in the artist's studio. c. 1917. Photograph courtesy Alessandra Comini

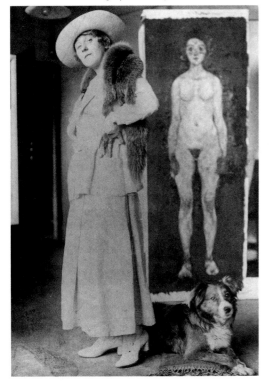

Exhibition," which opens at the Heeresmuseum (Army Museum) in Vienna and subsequently travels in modified form to Holland, Sweden, and Denmark. His inclusion in an exhibition at the Munich Secession rekindles the interest of his former dealer, Hans Goltz.

1918: Following the death of Gustav Klimt in February, Schiele is generally recognized as Austria's leading artist. (Kokoschka has temporarily settled in Dresden.) Schiele's new stature is confirmed by a sellout exhibition at the Vienna Secession in March. He is kept busy organizing exhibitions at home and abroad and maintains a full calendar of portrait sittings and modeling appointments. In June, he succeeds in getting himself transferred to the Army Museum, where he is effectively given free reign to pursue his artistic activities.

Schiele's newfound financial success permits him to rent a larger studio on the Wattmanngasse, though he retains his old space with the thought of establishing an art school there. The big studio, however, proves difficult to heat, and in the autumn Vienna is plagued by shortages of fuel and food. Edith, six months' pregnant, contracts the deadly Spanish flu in October and dies on the twenty-eighth. Egon, already ill, lasts scarcely three days longer, succumbing early the morning of October 31.

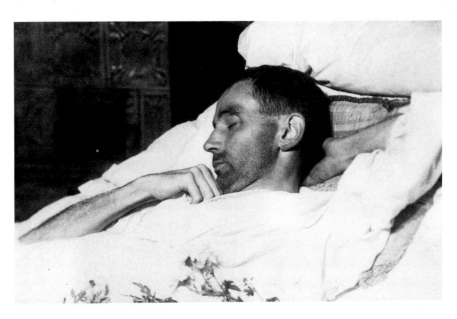

fig. 54. Egon Schiele on his deathbed. November 1918. Photograph by Martha Fein

The Plates

I. Schiele and His Models, 1909–11

plate 1. *Schiele, Drawing a Nude Model before a Mirror.* 1910. Pencil on paper. Initialed "S" and dated, lower right. 21¾ × 13⅞" (55.2 × 35.3 cm). Kallir D. 737. Graphische Sammlung Albertina, Vienna; Inv. 26.276

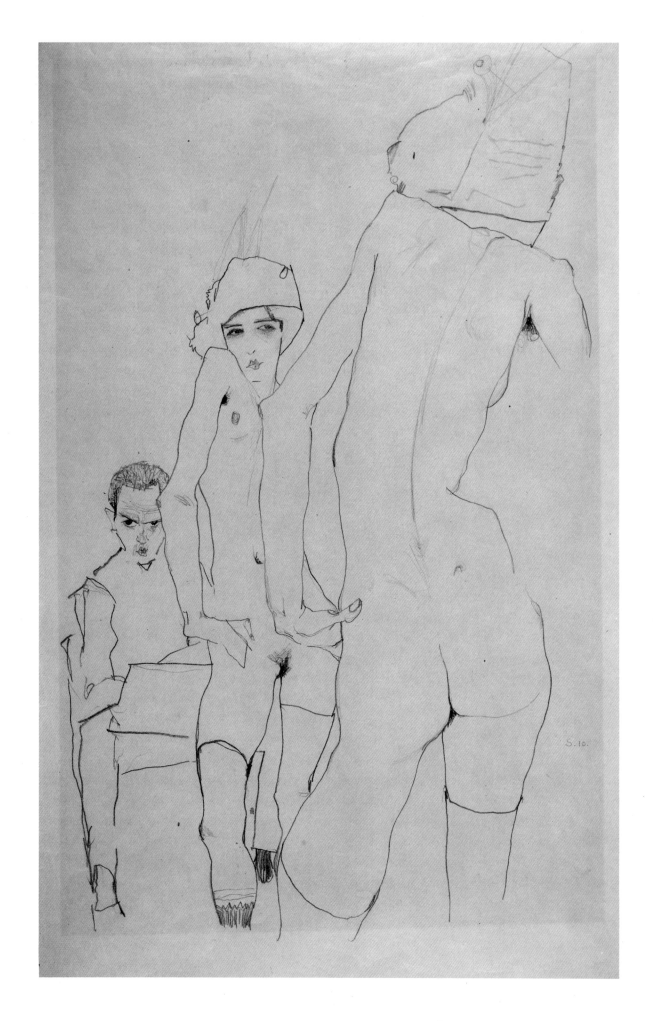

fig. 55. Gustav Klimt. *Danae.* c. 1907–8. Oil on canvas.
30⅜ × 32⅝" (77 × 83 cm). Novotny/Dobai 151. Private
collection

The Danae myth is the sort of sexually charged story that appealed to artists of Vienna's fin de siècle. In this Greek legend, the beautiful Danae is imprisoned in an open-roofed tower by her father, who wants to preserve his daughter's virginity. The wily god Zeus penetrates Danae's lair by transforming himself into a golden shower and raining down upon her. Klimt's interpretation of the myth (fig. 55)—in which a swooning Danae lies coiled within a protective cocoon—was first exhibited at the Vienna "Kunstschau" in 1908. It was one of three Klimts in the exhibition that Schiele chose to imitate over the course of the next year.

Schiele's *Danae* (plate 2) differs noticeably from that of the older master. Strangely enough—considering the artist's later reputation—his work is far less erotic. The golden torrent, which in Klimt's painting caresses Danae's loins, cascades over her head in Schiele's version, so that the nude appears to be bathing, not copulating. Moreover, where Klimt's Danae is a rotund and sensual creature, Schiele's figure is as flat and stylized as her decorative surroundings. Little passion comes through in this work.

The excessively simplified outlines of Schiele's *Danae* are typical of his contemporaneous drawings and watercolors and constitute an important way station in his development. Several years of academy life classes had taught him to draw the human figure quickly and accurately, but, according to academic precepts, such contour drawings were merely armatures on which to build fully modeled flesh-and-blood figures. The extreme stylization of Schiele's work is suggestive of Jugendstil graphic design, though the artist was no more interested in frivolous decoration than he was in rote representationalism. His goal was rather to strip drawing both of artifice and academic pretension, to pare line down to its barest essentials.

plate 2. *Danae*. 1909. Oil and metallic paint on canvas.
Signed and dated, lower right.[1] 31½ × 49⅜" (80 ×
125.4 cm). Kallir P. 148. Private collection

[1]The word "signed" means signed by the artist with his first and
last name; "dated" means with the year (e.g., "1910" or "10").

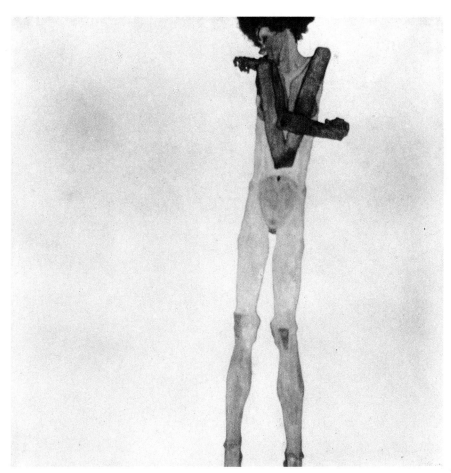

fig. 56. *Standing Female Nude with Crossed Arms (Gertrude Schiele)*. 1910. Oil on canvas. 59×59" (150×150 cm). Kallir P. 169. Present whereabouts unknown

opposite
plate 3. *Nude Girl with Folded Arms (Gertrude Schiele)*. 1910. Watercolor and black crayon on paper. Initialed "S," lower right. Study for *Standing Female Nude with Crossed Arms* (Kallir P. 169). 19¼×11" (48.8×28 cm). Kallir D. 516. Graphische Sammlung Albertina, Vienna; Inv. 30.772

In early 1910, Schiele emerged with an Expressionistic idiom so unique that its origins defy ready analysis. His friend Max Oppenheimer and the artist Oskar Kokoschka had both been executing Expressionistic work (chiefly portraits) for about a year, but their somber, murky colors were distinctly different from Schiele's ebullient palette. While Kokoschka had demonstrated, in his illustrated tale *Die träumenden Knaben* (The Dreaming Youths), that Jugendstil stylization could be turned to more expressive ends, the jerky primitivism of his rendering was totally at odds with Schiele's elegant virtuosity. Schiele's refined lines derive in part from his academic training and in part from the Klimtian/Jugendstil legacy. However, no Austrian precedent can be found for the brilliant reds, luminous yellows, and poison greens that dominate so much of the artist's work in early 1910.

Schiele's first major artistic statement was a series of five large nudes: two females (for which his sister Gerti posed; figs. 56 and 57) and three males (which were self-portraits; see fig. 58). Only one of these paintings survives (Kallir P. 172), and the related studies are thus our most reliable guide to the series as a whole (plates 3, 4, 18, and 19). Whereas in earlier works, such as *Danae* (see plate 2), Schiele had consciously emulated Klimt's decorative backgrounds, here all mitigating context and protective cover have been eliminated: The figure is left alone to confront her or his most intimate fears and desires. In the depictions of Gerti, the model's evident shyness (which is confirmed by her own recollections of these sessions) and the artist's uneasiness with the opposite sex become inextricably entangled. Those body parts that Gerti herself does not conceal with her crossed arms are disguised by Schiele's androgynous interpretation. The nude series is essentially an exploration of emergent sexuality.

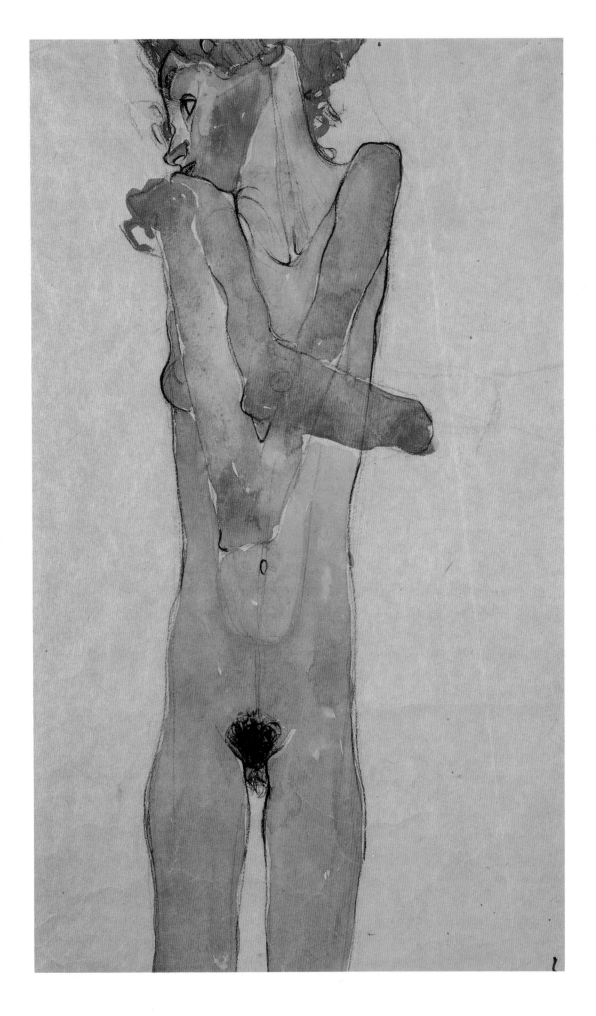

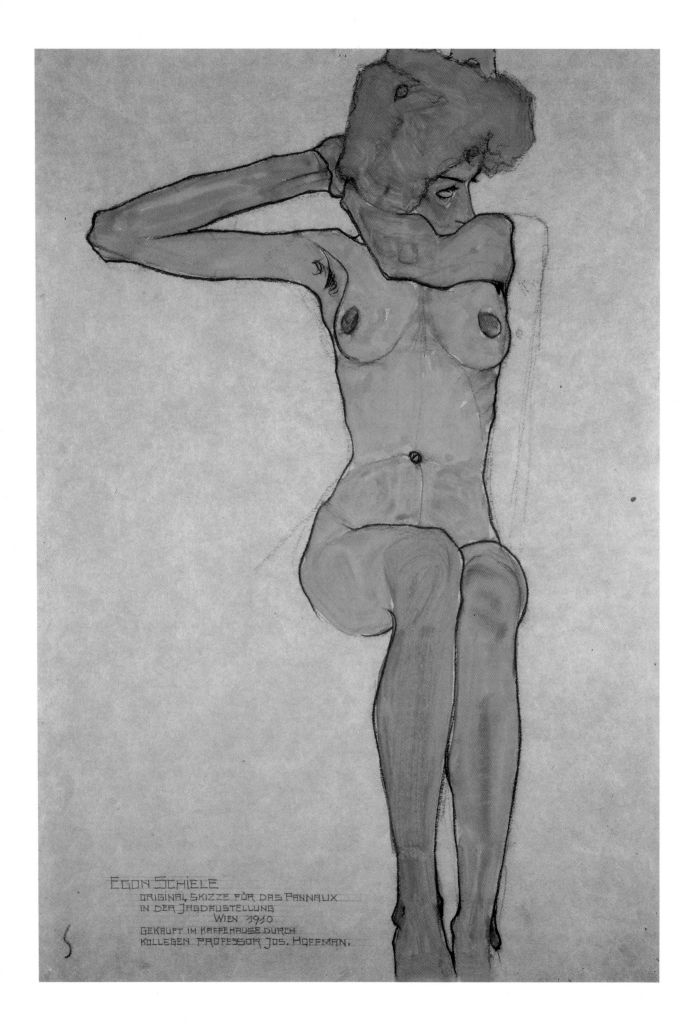

fig. 57. *Seated Female Nude with an Outstretched Arm.*
1910. Oil and/or watercolor on panel or canvas.
59 × 59" (150 × 150 cm). Kallir P. 170. Present
whereabouts unknown

plate 4. *Seated Female Nude with Raised Right Arm.*
1910. Gouache, watercolor, and black crayon on paper.
Initialed "S.," lower left. Inscribed "Egon Schiele/Original
Skizze für das Pannaux/in der Jagdausstellung/Wien
1910/gekauft im Kaffeehause durch/Kollegen Professor
Jos. Hoffman [sic]," by Otto Wagner, lower left. Study
for *Seated Female Nude with an Outstretched Arm* (Kallir
P. 170). 17¾ × 12⅜" (45 × 31.5 cm). Kallir D. 518.
Historisches Museum der Stadt Wien; Inv. 96030/2

The second 1910 painting depicting Gerti Schiele (see also fig. 56) is known only from an installation photograph (fig. 57), in which the general composition, but few precise details, can be made out. The watercolor study (plate 4) that survives is thus of special importance.

As stated in the inscription, the watercolor was originally purchased by the renowned architect Otto Wagner at the recommendation of his colleague Josef Hoffmann. This provenance confirms Schiele's growing stature within the Viennese art world. By 1910, he was well within Hoffmann's orbit. Hoffmann's friends, as well as the Wiener Werkstätte, regularly purchased Schiele's work. And it was Hoffmann who arranged for the female nude painting to be included in the 1910 "Jagdausstellung," where it was photographed. Wagner for a time tried to extend his patronage of Schiele by sitting for a portrait. However, the elderly architect soon grew impatient with the painter's ponderous ways, and Schiele cut up the half-finished canvas (Kallir P. 164) and sold the face to Arthur Roessler (see plate 31) for a pittance.

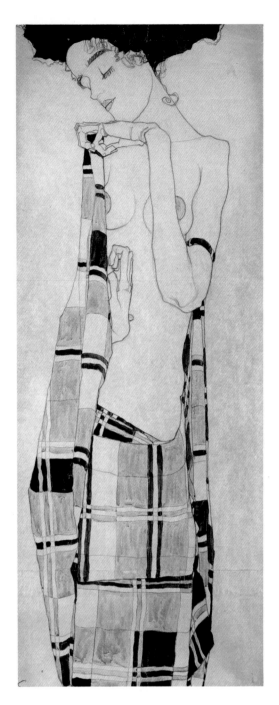

The alliance between art and interior decoration promulgated by the Wiener Werkstätte was an uneasy one, and members of the younger Expressionist generation, with their more disturbing (and sometimes downright ugly) canvases, found themselves inherently at odds with it. Kokoschka, who owed his professional start to Klimt and the Werkstätte, soon turned away from them. And even though Schiele remained forever indebted to Klimt's elegant line, he did not fare much better in his fleeting encounters with the Wiener Werkstätte.

Among the projects that went awry were an abortive attempt at fashion design and a series of postcard studies. (The Werkstätte did publish three Schiele postcards, but all the drawings specifically created for this purpose were rejected.) Less fully documented is a commission Schiele received in June 1910 to contribute to the Wiener Werkstätte's most ambitious project: the design, construction, and decoration of the lavish mansion of Brussels industrialist Adolphe Stoclet. Eduard Kosmack (see plate 32 and fig. 62), who, as the publisher of several design magazines, had an ongoing relationship with the Werkstätte, later recalled that the commission involved a stained-glass window, and he identified the product as the *Portrait of Poldi Lodzinsky* (see plate 6). However, the surviving correspondence indicates that Schiele's assignment was rather to produce a sketch for a hammered metal panel, and it is more than likely that *Standing Girl in Plaid Garment* (plate 5) was the result.

Standing Girl in Plaid Garment is virtually unique among Schiele's works on paper in its scale and its monochromatic palette, both of which validate the hypothesis that it was intended to be reinterpreted in metal. The Wiener Werkstätte connection is further substantiated by the drawing's provenance: the work was brought to the United States by Josef Urban, a designer closely associated with the Werkstätte who opened a New York branch in the 1920s. The confusion with the Lodzinsky portrait may be attributed to the bold "Scottish" blanket that appears in both works and that was a standard studio prop used by Schiele in the summer of 1910.

Considering how far Schiele had traveled from the Klimtian precedent by 1910, *Standing Girl* seems like a throwback to an earlier time, and, indeed, there has been some uncertainty about the dating. However, there are also clear connections to Schiele's 1910 drawings of his sister Gerti, particularly in the coyly deflected head and in the elaborately twisted arm and hands (compare plates 3, 4, and 7). It has been suggested that Gerti modeled for this work as well, although old records make mention of a "Frl. Steiner." Whoever she may be, the *Standing Girl* is far more demurely draped than Schiele's nude studies of his sister. The blanket serves both to conceal the subject's sexuality and to strengthen the piece's decorative framework—as befits an architectural commission of this sort.

It is not clear why the hammered metal panel was (apparently) never executed, much less installed in Brussels. Perhaps Schiele, as was his wont, was lax in following through, or perhaps even the veiled eroticism of this work was deemed too extreme for the industrialist's home. In any case, like the postcard studies and the fashion drawings, this project came to naught.

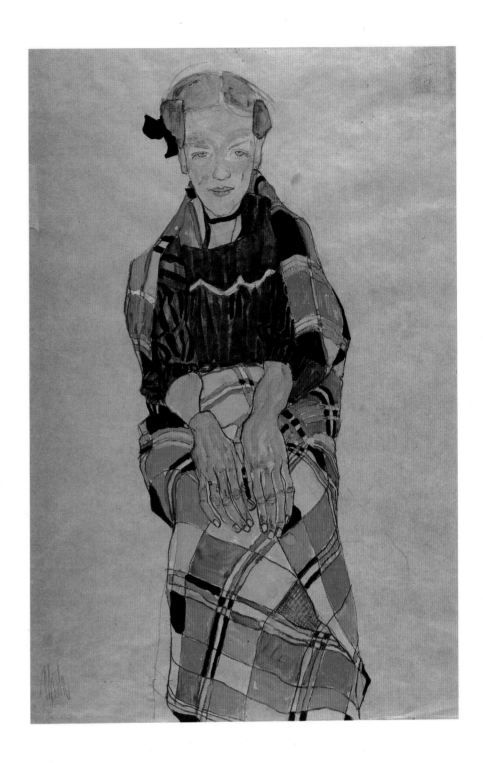

plate 6. *Girl in Black Pinafore, Wrapped in Plaid Blanket (Poldi Lodzinsky).* 1910. Gouache, watercolor, and charcoal on paper. Signed "Schiele," lower left. Study for *Portrait of Poldi Lodzinsky* (Kallir P. 162). 17¾ × 11¾" (45.1 × 29.9 cm). Kallir D. 400. Private collection

The circumstances surrounding the creation of Schiele's *Portrait of Poldi Lodzinsky* (for which plate 6 is a study) remain somewhat obscure. Eduard Kosmack, who probably confused the painting with *Standing Girl in Plaid Garment* (see plate 5), contended that it was a design for a stained-glass window commissioned by the Wiener Werkstätte. However, the portrait—a touchingly forthright appraisal of a gawky adolescent—has none of the decorative structure that Schiele, however halfheartedly, invariably tried to incorporate into his Werkstätte assignments. Poldi Lodzinsky and her sister Trude, daughters of a Krumau *Fiaker* (cabby), were befriended by Schiele in the summer of 1910. Like most of the artist's contemporaneous portraits of friends, this cannot be considered a formal commission. There is no evidence that the subject ever owned the oil or any of the preliminary studies.

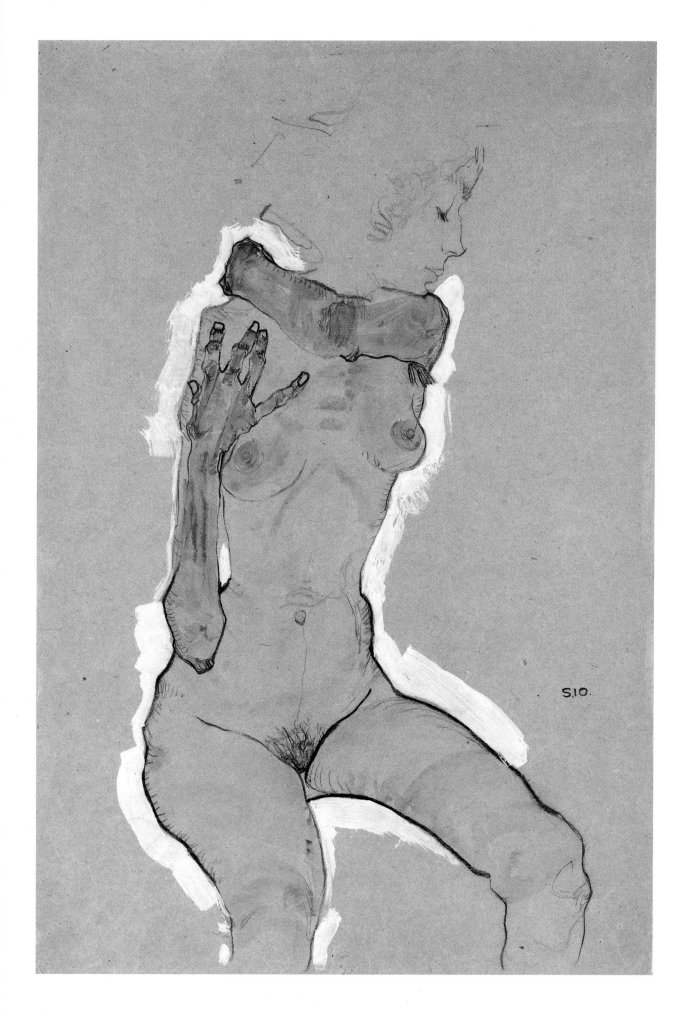

Schiele's sister Gerti remained one of his principal models throughout 1910, in part because she did not have to be paid, but also in part because the artist found her sexuality comparatively unthreatening. The turned-head gesture so common in Schiele's nudes from this time suggests a pervasive reluctance to confront the female personality. In this, there is little difference between Schiele's representations of Gerti and those of unrelated (and often older) women. The models offer up the most intimate parts of their bodies but conceal their inner feelings.

Schiele's stylistic development in 1910 was rapid and composed of distinct phases. The brilliant palette that is the year's hallmark actually faded by the summer, to be displaced by dusky mauves and deep blues. The artist also rejected the loose, limpid watercolors of early 1910 for thicker gouache, which can be more easily controlled. Pushing and pulling varying densities of pigment about with the brush became his chief means of articulating the surfaces of his sheets. The distinctive "body halo" of white gouache that Schiele used intermittently into 1911 serves to set off the interior coloring and embolden the contours of the drawings, especially those done on relatively inexpensive dark packing paper. Whether there is also an underlying mystical intent to these halos is uncertain.

plate 7. *Seated Nude (Gertrude Schiele)*. 1910. Gouache and black crayon on paper. Initialed "S" and dated, lower right. Verso: study of a male nude, 1909 (Kallir D. 334). 20⅞ × 17¾" (53 × 45 cm). Kallir D. 544. Pierre Gianadda Foundation, Martigny, Switzerland

Toward the end of 1910, a noticeable change became manifest in Schiele's relationship to the nude—a change apparent on the sheet that probably reflected changes in his personal life. Representations of Gerti became far less ubiquitous, and she was replaced by a cohort of new models, at least some of whom seem to have been on intimate terms with the artist. These models, like Gerti, were relatively young, and many may have been prostitutes. In Vienna at the time, the line between modeling and prostitution was slender, and often poor adolescents were forced to ply these trades.

Whatever Schiele's personal ties to his models, the resultant drawings show a far more forthright engagement with personality than had previously been the artist's habit. For the first time, he seemed to be aware of his models as people. Did he understand them? Not entirely. They stare at the viewer much as they must have stared at Schiele, and their self-protective reserve or dreamy puzzlement become adjuncts to their sexuality. Once again, Schiele's own responses—his fascination and confusion—have been intertwined with those of his model. However, the model has become a more integral part of the exploratory process rather than just a faceless projection of the artist's fantasies.

opposite left
plate 8. *Seated Nude Girl*. 1910. Gouache, watercolor, and pencil with white heightening on paper. Initialed "S" and dated, center right. Verso: Oskar Reichel collector's stamp. 22 × 14⅝" (55.8 × 37.2 cm). Kallir D. 564. Graphische Sammlung Albertina, Vienna; Inv. 33.356

opposite right
plate 9. *Black-Haired Nude Girl, Standing*. 1910. Watercolor and pencil with white heightening on paper. Initialed "S" and dated, lower right. 21⅜ × 12⅛" (54.3 × 30.7 cm). Kallir D. 575. Graphische Sammlung Albertina, Vienna; Inv. 30.892

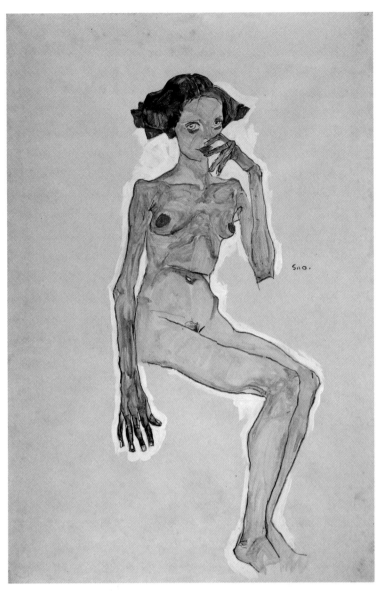

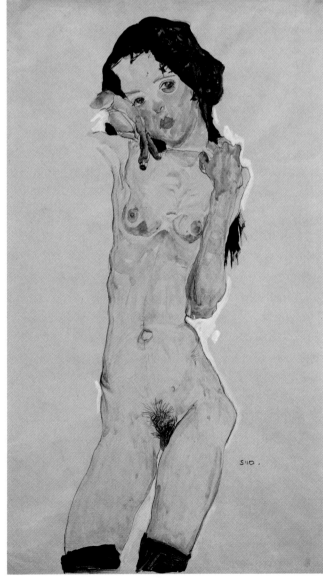

Often the poses of Schiele's models appear awkward or unnatural. Despite its title, *Semi-Nude Girl, Reclining* is signed as a vertical and properly displayed as such. If one flips the image on its side, the pose appears no less strained. This curious—and by no means uncommon—phenomenon stems from Schiele's customary manner of viewing his subjects from above, while perched on a stool or ladder. Since background detail and supporting props are substantially deleted from the final drawing, the low sofa or mattress on which the model lies becomes directly analogous to the artist's sheet. Schiele's nudes do not occupy real space but an artistic space of his own invention.

plate 10. *Semi-Nude Girl, Reclining.* 1911. Gouache, watercolor, and pencil with white heightening on paper. Initialed "S." and dated, upper right. Verso: Oskar Reichel collector's stamp. 18⅛ × 12¼" (45.9 × 31.1 cm). Kallir D. 812. Graphische Sammlung Albertina, Vienna; Inv. 33.357

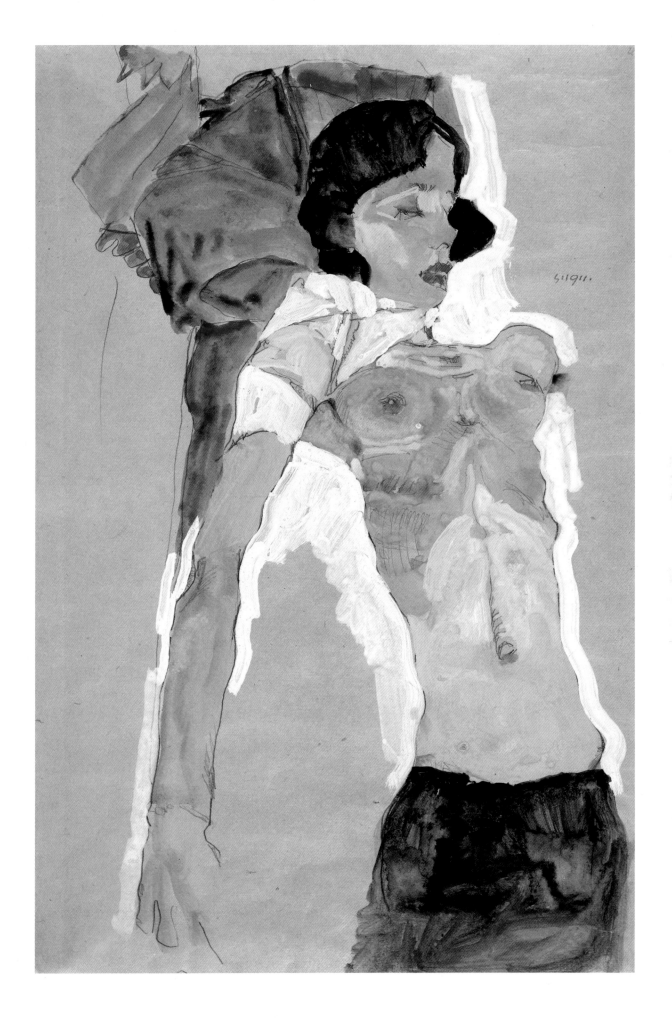

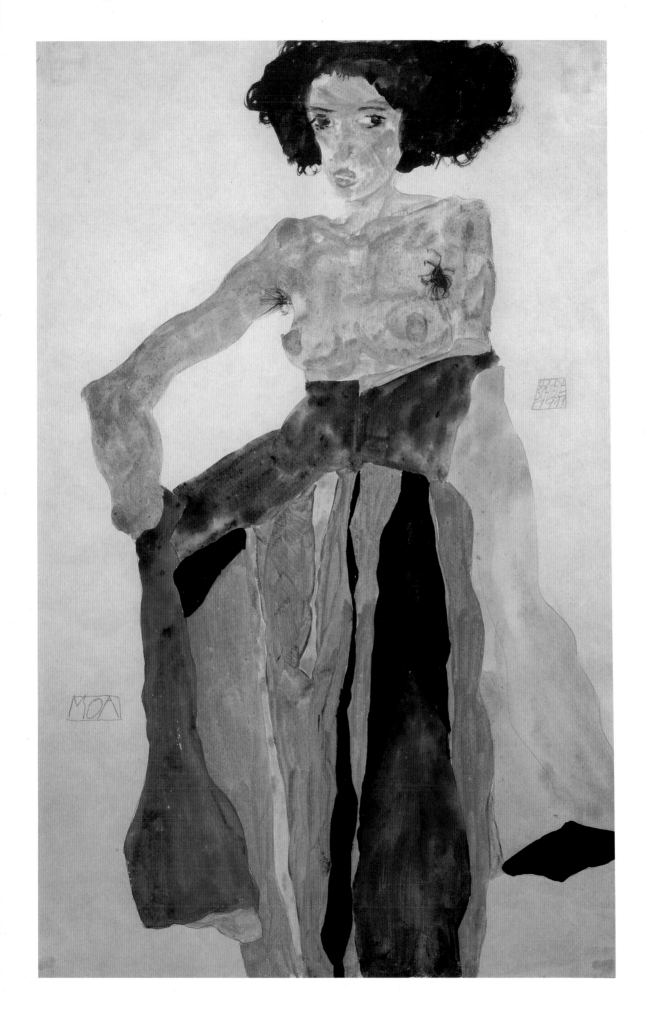

Moa is the only one of Schiele's early nude models, other than his sister Gerti, to be identifiable by name. He made sure of that by inscribing the name ecstatically on almost every drawing he did of her. If prior models had frightened and then puzzled Schiele, Moa bewitched him.

Moa was the companion of Erwin Osen, a member of Schiele's Neukunstgruppe who had accompanied the artist to Krumau in the summer of 1910. Together, Moa and Osen performed in cabarets, she as dancer and he as mime. Whether she invented her unusual name and Polynesian origins, just as Osen made up a personal history to conceal his own bourgeois Viennese background, is hard to say, for even Moa's surname (which may have been Nahuimur or Mandú) is unverifiable.

Moa surely had no qualms about posing nude, but her sexuality was not of primary interest to Schiele. Rather, he was entranced by the dancer's graceful gestures and the luxuriant folds of her costume. Drapery for Schiele was usually subordinate to his subject's primal physicality, but occasionally, as here, it was invested with a spiritual life of its own. The bright colors of Moa's raiment also reflect the pronounced brightening of Schiele's palette in late 1911—a noted departure from the more somber hues dominant since mid-1910. Mostly, however, the flow of the dress served to reinforce the model's expressive body language, creating an intoxicating amalgam: Moa represented unleashed inhibition and an exotic bohemian world in which the artist longed to reside.

plate 11. Moa. 1911. Gouache, watercolor, and pencil on paper. Signed and dated, center right. Inscribed "Moa," lower left. 18⅞ × 12¼" (48 × 31 cm). Kallir D. 908. Private collection

Just as, in his early encounters with the female nude, Schiele gravitated to the familiar—his sister Gertrude or his fledgling girlfriends—so, too, could he readily identify with children. The artist, who described himself as an "eternal child,"[1] was in many ways still a boy himself. Certainly his emotional maturity lagged far behind his artistic precocity, making it possible for him to depict puerile mental states that generally elude older artists. The torment of growing up remained very real to him; not only did he still suffer the pangs of puberty, but he also found young models far less intimidating than adults.

Children had another advantage over mature models in Schiele's early, impecunious days: they could be persuaded to pose for spare change, or even for a bit of candy. The streets of Vienna were teeming with young urchins, and Schiele lured them like the Pied Piper. His friend the artist and writer Paris von Gütersloh gave the following description:

There were always two or three smaller or larger girls in [Schiele's] studio; girls from the neighborhood, from the street, solicited in nearby Schönbrunn Park; some ugly, some attractive, some washed, but also some unwashed. They sat around doing nothing. . . . Well, they slept, recovered from parental beatings, lolled about lazily (which they were not allowed to do at home), combed . . . their closely cropped or tangled hair, pulled their skirts up or down, tied or untied their shoelaces. And all this they did—if one can call that doing something—because they were left to themselves like animals in a comfortable cage, or so they perceived it.[2]

In 1911, when Schiele moved first to Krumau and then to Neulengbach, his child models of necessity became more middle-class. These small towns lacked the wayward street life of Vienna, and it may be assumed that the children were subject to stricter parental supervision. There is little in Schiele's drawings of children that could shock even the most puritanical adult, but the mere fact that he was an artist—by definition, someone who consorts regularly and openly with naked women—was cause for alarm in these provincial communities. Schiele's friends often urged him to obtain advance permission from the parents of his underage models, but he seems to have ignored this advice. His legal troubles of 1912 were to stem from these circumstances (see plates 55 and 56).

[1] Unless otherwise indicated, all quotes accompanying the plates are by Egon Schiele, as transcribed by Christian M. Nebehay in *Egon Schiele, 1890–1918: Leben, Briefe, Gedichte* (Salzburg: Residenz, 1979). Translations from the German are by Jane Kallir.
[2] Paris von Gütersloh, in Graphische Sammlung Albertina, Vienna, *Gustav Klimt—Egon Schiele: Zum Gedächtnis ihres Todes vor 50 Jahren*, exhib. cat. (Vienna: Graphische Sammlung Albertina, 1968), 74.

opposite above
plate 12. *Two Proletarian Children.* 1910. Watercolor and black crayon on paper. 17⅜ × 11¾" (44 × 30 cm). Kallir D. 412. Private collection

opposite below
plate 13. *Two Little Girls.* 1911. Gouache, watercolor, and pencil on paper. Signed and dated, center right. 15¾ × 12" (40 × 30.6 cm). Kallir D. 761. Graphische Sammlung Albertina, Vienna; Inv. 27.945

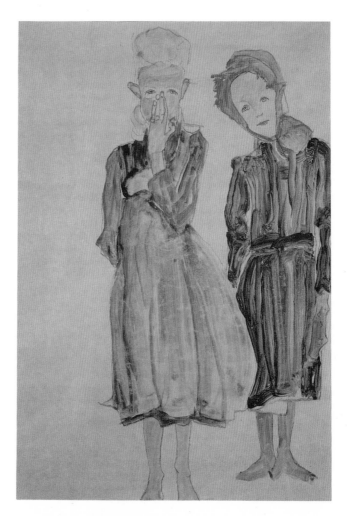

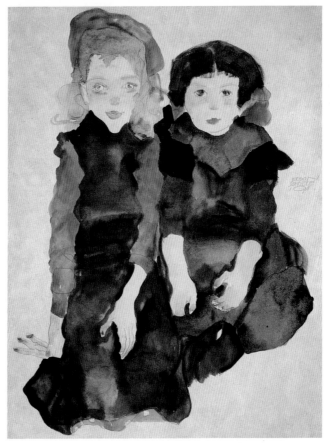

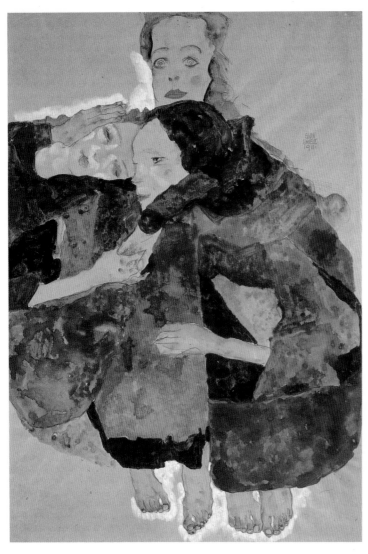

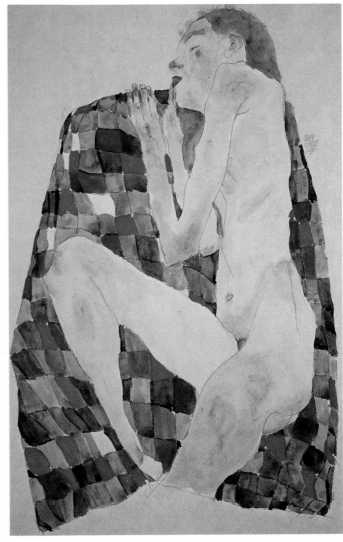

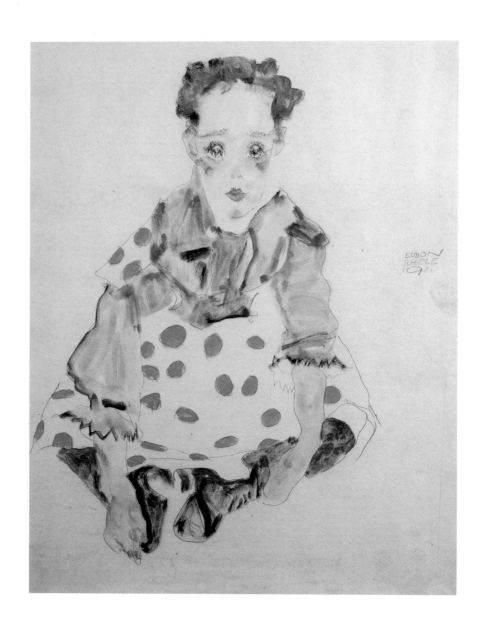

opposite left
plate 14. *Group of Three Girls.* 1911. Gouache, watercolor, and pencil with white heightening on paper. Signed and dated, upper right. 17½ × 12⅛″ (44.4 × 30.8 cm). Kallir D. 764. Graphische Sammlung Albertina, Vienna; Inv. 31.171

opposite right
plate 15. *Female Nude on Checkered Cloth.* 1911. Watercolor and pencil on Strathmore Japan paper. Signed and dated, upper right. 18⅞ × 12⅜″ (48 × 31.5 cm). Kallir D. 775. Neue Galerie am Landesmuseum Joanneum, Graz; Inv. II/1302

above
plate 16. *Girl in Polka-Dot Dress.* 1911. Watercolor and pencil on paper. Signed and dated, center right. 17 × 11⅞″ (43.3 × 30.3 cm). Kallir D. 786. Private collection

If Schiele favored child models because he could readily identify with them, he himself was the most accessible—and affordable—of all possible models. Some of his earliest known paintings are self-portraits, but around 1909 his approach to the genre underwent a noticeable change: Schiele consciously began to explore and enact various roles. Self-portraiture became a logical extension to the process of postadolescent identity formation encountered elsewhere in his work.

plate 17. *Self-Portrait*. 1909. Colored crayon on paper. Initialed "S.," lower left. 15⅞ × 7⅞" (40.2 × 20 cm). Kallir D. 348. Historisches Museum der Stadt Wien; Inv. 75.404

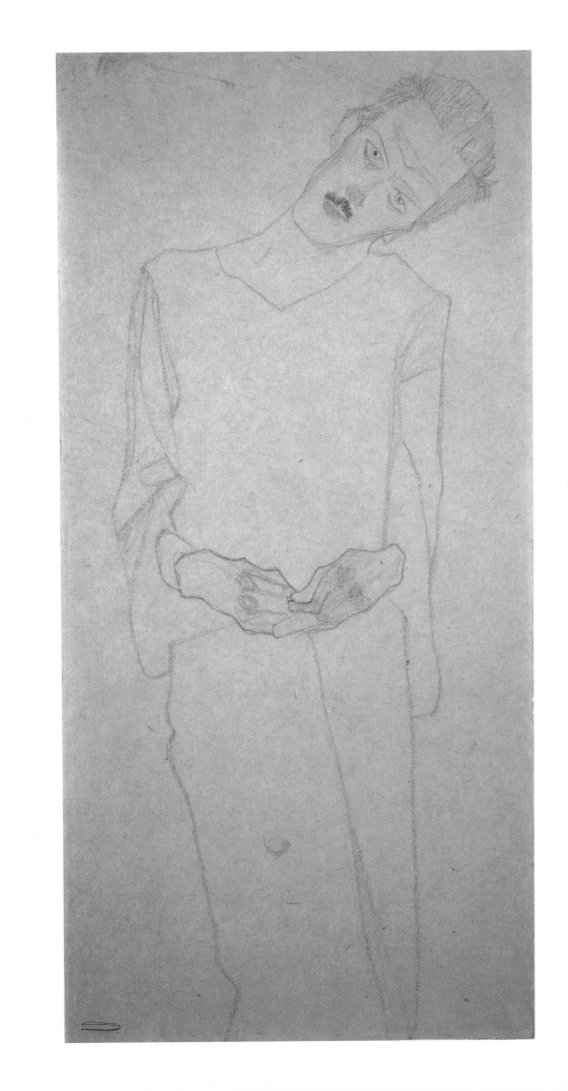

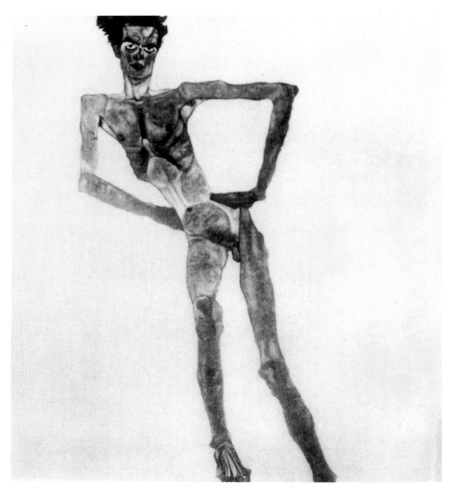

fig. 58. *Standing Male Nude with Hands on Hips (Self-Portrait)*. 1910. Oil on canvas. 59 × 59" (150 × 150 cm). Kallir P. 171. Present whereabouts unknown

opposite above
plate 18. *Seated Male Nude with Legs Spread, Back View*. 1910. Watercolor and charcoal on paper. Initialed "S," lower left. Verso: inscribed and numbered by another hand. 17¾ × 12⅝" (45 × 32 cm). Kallir D. 655. Private collection

opposite below
plate 19. *Seated Male Nude, Back View*. 1910. Gouache, watercolor, and black crayon on paper. Initialed "S," lower right and lower left. 17¼ × 12¼" (43.8 × 31.1 cm). Kallir D. 656. Private collection, courtesy Serge Sabarsky, New York

In tandem with his new emphasis on self-portraiture, Schiele in early 1910 became increasingly fascinated with the male nude. The stylistic characteristics of the resulting watercolor series (of which more than thirty examples are documented; see plates 18 and 19), as well as some of the specific poses, make it evident that all were connected to three large canvases that Schiele executed in the first months of the year (see fig. 58). Like much of Schiele's work from early 1910 (compare plates 3 and 4), the watercolors were boldly colored, and it may be assumed that the finished paintings (of which only one, Kallir P. 172, survives) employed a similar palette.

Since all three paintings were self-portraits, the watercolors should at the very least be considered part of an ancillary process of self-exploration. Schiele may, indeed, have modeled for most or all of the studies, though the great majority remain faceless. The use of body language is similar to that in the self-portraits, and in some ways more exaggerated. Lacking recognizable facial features, the series is largely reliant on the impact of pose and gesture. These effects are heightened by Schiele's elimination of all supporting props, so that the figures appear to levitate in physically impossible positions. Though naked, there is nothing erotic about these bodies: rather, they seem condemned to perpetual tension and discomfort. Where the contemporaneous nude paintings are bold assertions of libido, the watercolors remain ambiguous.

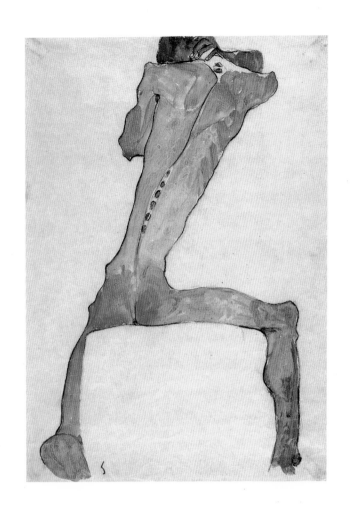

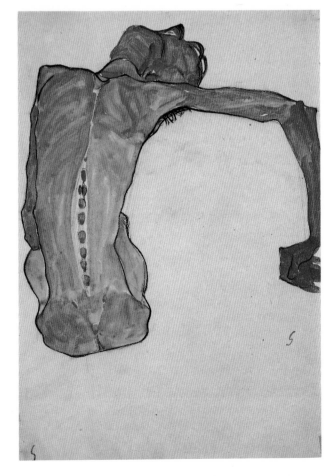

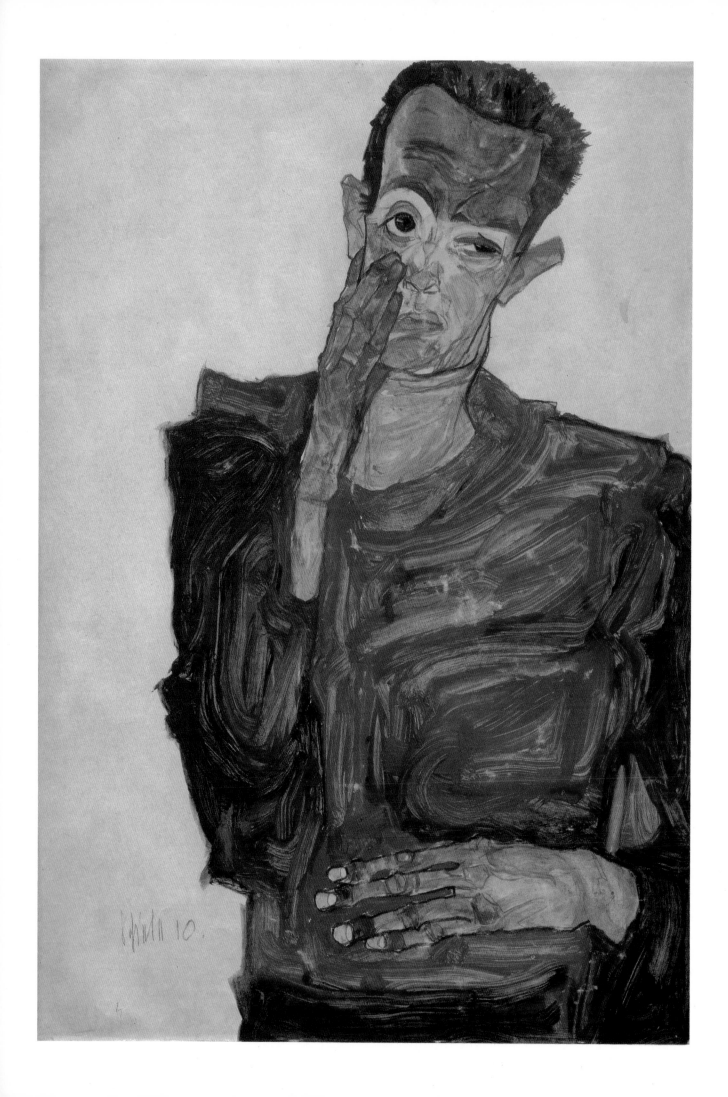

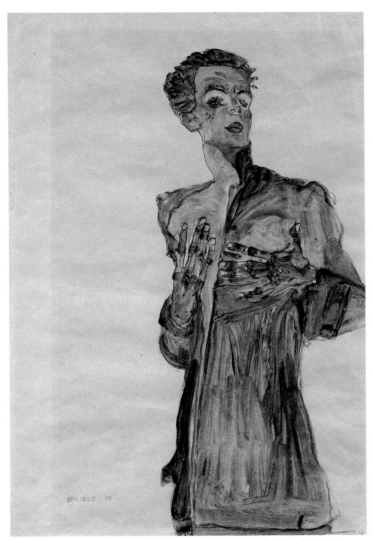

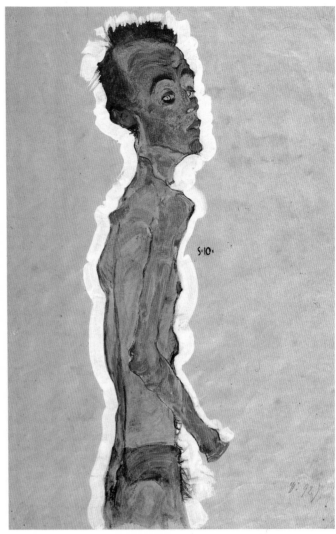

opposite
plate 20. *Self-Portrait with Hand to Cheek.* 1910.
Gouache, watercolor, and charcoal on paper. Signed
"Schiele" and dated, lower left. 17½ × 12" (44.3 × 30.5
cm). Kallir D. 706. Graphische Sammlung Albertina,
Vienna; Inv. 30.395

above left
plate 21. *Self-Portrait in Street Clothes, Gesturing.* 1910.
Watercolor and pencil on paper. Signed "Schiele" and
dated, lower left. 16¾ × 10¾" (42.5 × 27.3 cm). Kallir
D. 695. Private collection

above right
plate 22. *Male Figure (Self-Portrait).* 1910. Gouache,
watercolor, and charcoal on paper. Initialed "S." and
dated, center right. Verso: study of a male nude, 1908
(Kallir D. 231). 17¾ × 11¾" (45 × 30 cm). Kallir D. 711.
Collection Robert Lee

The large male nudes of early 1910 (see fig. 58) laid the groundwork for an extensive series of
self-portraits, which rank among Schiele's profoundest achievements. As both vehicle and
emblem, the artist simultaneously conducted and recorded his own psychological biopsy. With
fearless virtuosity, he combined equal parts agonized introspection and self-conscious
posturing. Strikingly, each element prevented the other from going to excess, so that the self-
portraits successfully skirted the very real dangers of bathos and mannerism.

Perhaps influenced by his friend the mime Erwin Osen, Schiele was developing an
idiosyncratic and highly expressive language of gesture. Here he puffs out his chest, there he
pulls down an eyelid, and then again his hair stands on end as though electrified by a high-
voltage shock. At one moment, he basks in newfound sexual potency; the next, he is horrified by
his physical desires. Now he struts forward, and then again, he pulls back in evident terror.
Haunted by death, yet driven by a passion for life, Schiele in these works reveals both
vulnerability and bravado. It is here, above all, that his dualism—his ability to embody
contradictions—is most eloquently expressed.

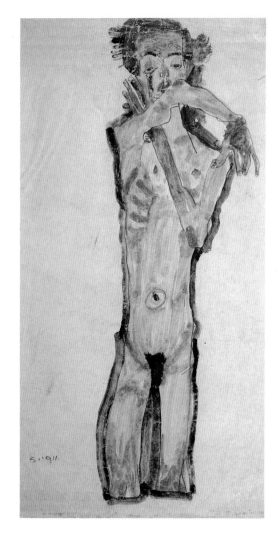

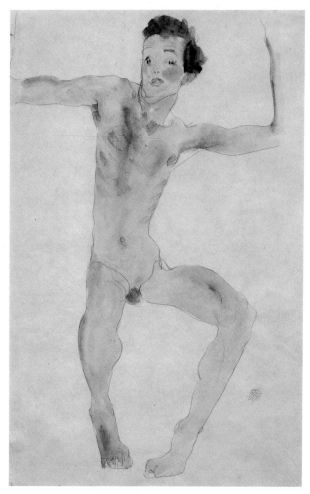

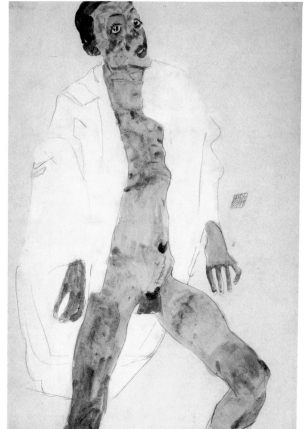

above

plate 23. *Standing Male Nude with Arms Crossed (Self-Portrait).* 1911. Gouache and pencil on paper. Initialed "S." and dated, lower left. Verso: study of a female nude, 1910 (Kallir D. 578). 22 × 13⅞" (55.8 × 35.3 cm). Kallir D. 945. Collection F. Elghanayan, United States

above right

plate 24. *Male Nude with Raised Arms (Self-Portrait).* 1911. Watercolor and pencil on paper. Signed and dated, lower right. 18⅞ × 12¼" (48 × 31 cm). Kallir D. 955. Collection Byron Goldman

plate 25. *Self-Portrait.* 1911. Watercolor and pencil on paper. Signed and dated, center right. 17½ × 12¼" (44.5 × 31.1 cm). Kallir D. 937. Collection of McMaster University, Hamilton, Ontario. Levy Bequest Purchase

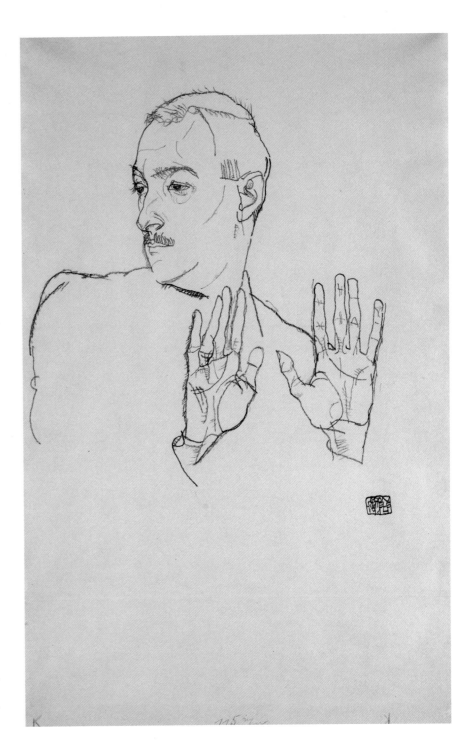

plate 26. *Portrait of the Art Critic Arthur Roessler.* 1914.
Pencil on paper. Signed and dated, lower right.
19⅛ × 12¼" (48.6 × 31 cm). Kallir D. 1630. Historisches
Museum der Stadt Wien; Inv. 115.168

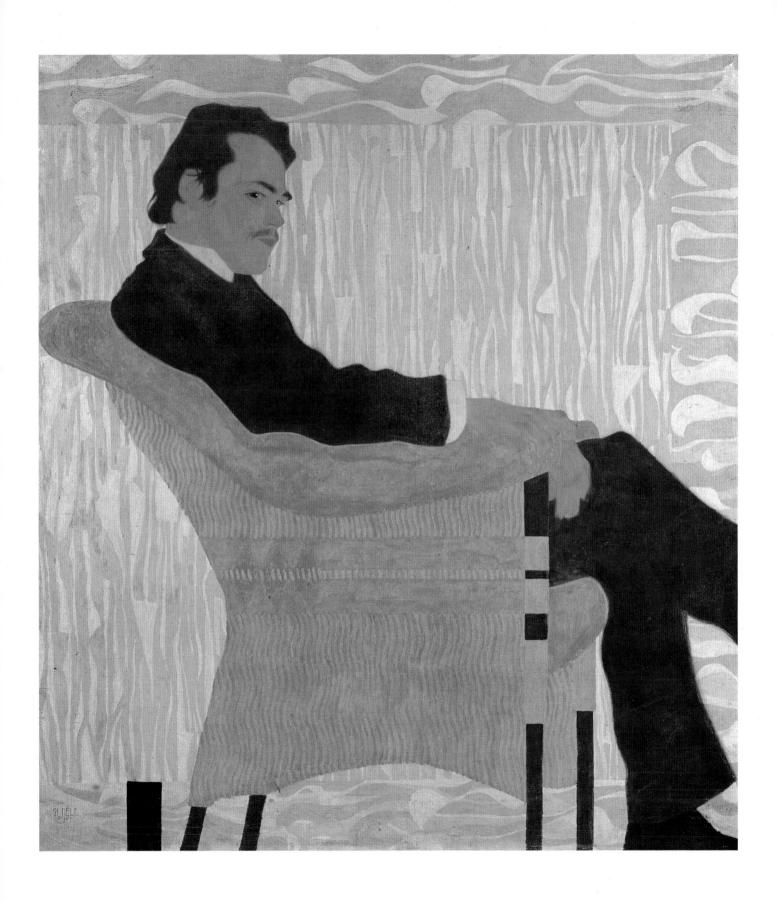

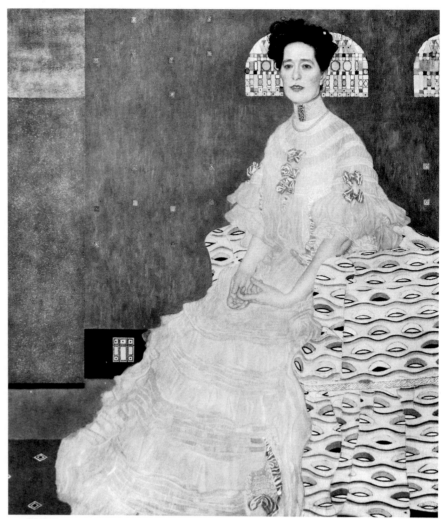

fig. 59. Gustav Klimt. *Portrait of Fritza Riedler.* 1906. Oil on canvas. 60¼ × 52⅜" (153 × 133 cm). Novotny/Dobai 143. Österreichische Galerie, Vienna

plate 27. *Portrait of Hans Massmann.* 1909. Oil and metallic paint on canvas. Signed and dated, lower left. 47¼ × 43¼" (120 × 110 cm). Kallir P. 149. Private collection

Hans Massmann, a classmate of Schiele's at the Vienna Academy of Fine Arts, was among those who joined him in founding the insurgent Neukunstgruppe. His portrait (plate 27) is one of three (the others depict the artist Anton Peschka, Kallir P. 150, and Gertrude Schiele, Kallir P. 151) that Schiele selected for his Vienna debut at the 1909 "Kunstschau." It is understandable that Schiele, in seeking for the first time to establish a public identity, should stress his association with the Neukunstgruppe (of which Peschka was also a member). He executed studies of at least two other members, Anton Faistauer (Kallir D. 319–21) and Arthur Loewenstein (Kallir D. 322), and in 1910 painted a third, Karl Zakovsek (Kallir P. 160). He was trying to foster, within the younger generation, the sort of camaraderie that had united Klimt and his colleagues, first at the Secession and subsequently at the Wiener Werkstätte.

However, *Portrait of Hans Massmann* imitates Klimt far more directly than did Schiele's attempts at collegial organizing. Like the portraits of Fritza Riedler (fig. 59) and Adele Bloch Bauer, both of which were included in Klimt's retrospective at the 1908 "Kunstschau," the Massmann painting employs a triangulated profile pose, which peaks at the sitter's head and then descends at an angle to his feet. The rigid geometry of the pose is reinforced by the flat expanse of the chair, which is articulated no differently from the two-dimensional figure or the decorative background. The whole has an ornamental, posterlike quality that is reinforced by the use of metallic paint and the stylized Jugendstil signature.

Schiele in 1909 billed himself as the "Silver Klimt," and it is evident that he had yet to cut the umbilical cord linking him with his nurturing role model.

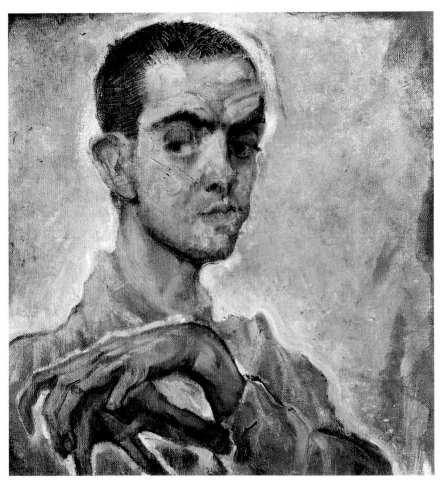

fig. 60. Max Oppenheimer. *Portrait of Egon Schiele.* c. 1910. Oil on canvas. Historisches Museum der Stadt Wien

Max Oppenheimer, known as Mopp, and Oskar Kokoschka can be credited as the earliest exponents of Expressionism in Vienna. Sometime in 1909, both artists emerged with a scraped, pseudoprimitive portrait style so similar and so temporally allied that it is impossible to assign priority to either instigator. Schiele may or may not have been aware of Kokoschka's innovations, which (with the exception of a few preliminary efforts shown at the 1909 "Kunstschau") were not immediately exhibited in Vienna, but he most certainly knew Mopp's work.

In early 1909, Schiele sought contact with Mopp, who was five years his senior, and for a period thereafter they worked side by side. Schiele was still very much in thrall to Gustav Klimt, but Mopp somehow sensed a kindred spirit in the younger artist. In 1910, he painted Schiele's portrait in his typically subdued Expressionistic style (fig. 60), and Schiele created several watercolor studies of his friend (plate 28), possibly with the intention (never carried through) of eventually doing an oil.

Schiele's studies of Mopp crystallize his transition from Jugendstil to Expressionism. Schiele would retain some aspects of the older tradition—its graceful lines and acute awareness of negative space—for the rest of his life. The stark two-dimensionality of Mopp's black garb is, however, a vestigial formal device that Schiele would soon abandon. While Klimt had characteristically insinuated conventionally modeled figures into decorative backgrounds, Schiele here combined expressively modulated flesh tones with a stark, abstract surround. The whole is a subversion of the Klimtian conception, a mere stone's throw from Expressionism proper.

opposite
plate 28. *The Painter Max Oppenheimer.* 1910. Watercolor, ink, and black crayon on paper. Initialed "S," lower left. Inscribed "OPP," upper right. 17¾ × 11¾" (45 × 29.9 cm). Kallir D. 587. Graphische Sammlung Albertina, Vienna; Inv. 32.438

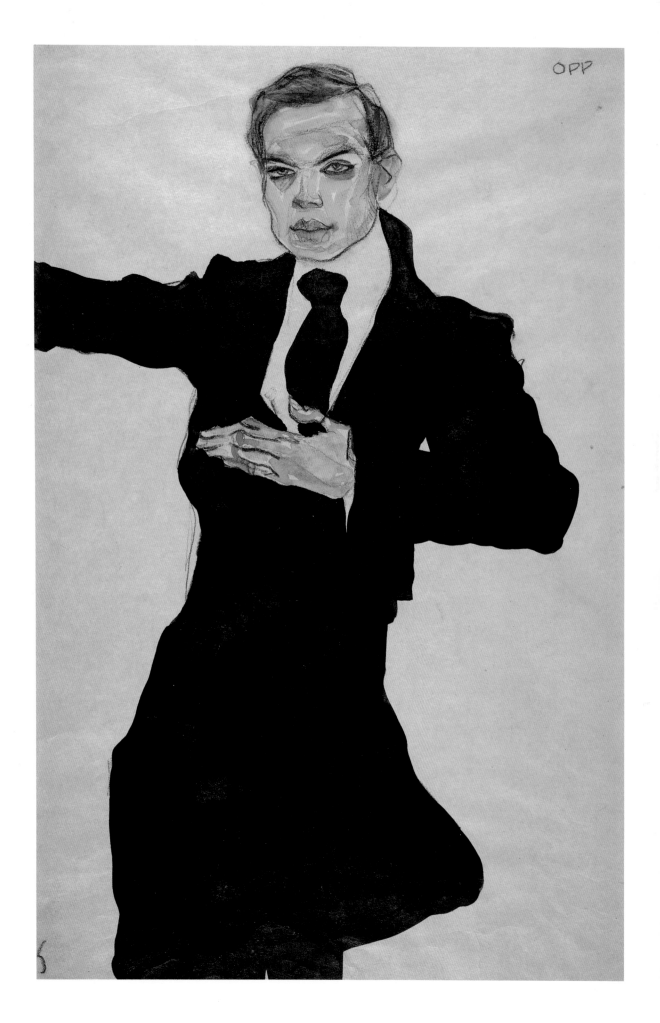

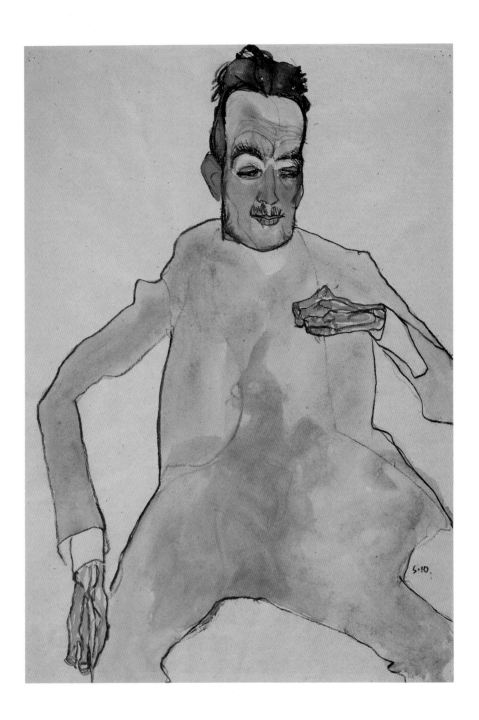

Cellist (plate 29) brings the innovations essayed in *The Painter Max Oppenheimer* (see plate 28) to their next logical stage. The body of this figure is outlined in the same stylized and somewhat abstract manner, but because it is not solidly filled in, it functions as more than just a design element. Schiele had learned to anoint his forms with paint, caressing the surface lightly as he deposited deeper pools of color at strategic junctures, such as the ears, eyelids, fingers, and the stubbly edge of the sitter's cheeks. Pigment and line began to work in consort rather than fighting each other for dramatic effect.

This watercolor has long been known by its present title because of the position of the hands and legs. It could surely be that the model posed with a cello, and that Schiele—as was often his habit—merely left it out. Or the pose may be a more nonspecific exercise in expressive gesture and body language, such as those Schiele was carrying out in his contemporaneous self-portraits and nudes. Since the artist is known to have been interested in mime, it actually makes little difference if the sitter was holding a real cello or an imaginary one.

plate 29. *Cellist.* 1910. Watercolor and black crayon on paper. Initialed "S." and dated, lower right.
17⅝ × 12⅜" (44.8 × 31.3 cm). Kallir D. 604. Graphische Sammlung Albertina, Vienna; Inv. 31.178

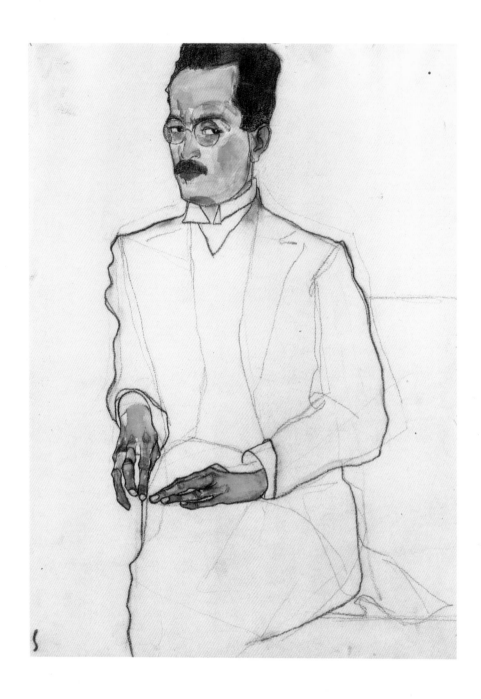

So far it has been impossible to identify conclusively the subject of *Portrait of a Gentleman* (plate 30). A second study of the same man (Kallir D. 605) has traditionally gone by the title *Portrait of Dr. X*. However, there is no indication where this title came from. Arthur Roessler (see plate 31) recalled that Schiele once had a run-in with a "Dr. X.," who supposedly fled the artist's studio in disgust. It is unlikely, however, that Roessler's "Dr. X.," appalled by what he termed the "psychopathic" quality of Schiele's art, would have sat for a portrait.

plate 30. *Portrait of a Gentleman.* 1910. Watercolor and charcoal on paper. Initialed "S," lower left. 15⅝ × 11½" (39.7 × 29.1 cm). Kallir D. 606. Private collection, courtesy Richard Nagy, London

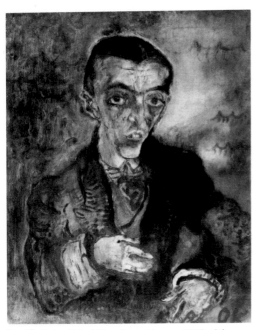

Arthur Roessler was one of Schiele's most ardent champions and patrons, a relationship that endured, with sporadic ups and downs, throughout the artist's career and perhaps reached its apogee after his death, when Roessler became his first biographer and memoirist. Within the small and relatively unsophisticated prewar Viennese art world, Roessler wore a number of hats. He is best remembered as the art critic of the Socialist *Arbeiter-Zeitung*, though he also penned a number of volumes about artists whom he favored. He dabbled as well at dealing, serving for a time as artistic adviser to the Galerie Miethke. For Schiele, he was no ordinary supporter. Not only did he promote the artist in the press and personally buy his work, he also established connections with other collectors and dealers. He was, so to speak, Schiele's de facto agent, though the relationship was never spelled out and sometimes there were misunderstandings about Roessler's proper compensation.

Portrait of Arthur Roessler typifies a stylistic shift that Schiele experienced in the latter months of 1910. For the first time, the influence of Max Oppenheimer and Oskar Kokoschka became readily apparent: the palette was more subdued, the paint surface more consciously rubbed and scraped. Nonetheless, there were distinct differences in the methods whereby Kokoschka, Mopp, and Schiele achieved their superficially similar effects. Kokoschka's approach was reductive: paint was applied in bold swaths that were then partially pared away, sometimes down to the bare canvas, so that the subject appears to float wraithlike to the surface (fig. 61). Mopp's technique was more conventionally additive, his paint surface somewhat denser (see fig. 60). Schiele, for his part, remained a watercolorist at heart. The Roessler painting is structured like a large drawing, in its disposition of the figure on the picture plane, its use of negative space, and the tensile correlation between the surface brushstrokes and the figure's boundaries.

The Roessler portrait is in some respects curiously similar to the depictions of Gerti Schiele done earlier the same year (compare plates 3, 4, and 7). The pose, with its crossed arms and deflected gaze, is nearly identical to that in one of the large nudes (see fig. 56) and several of the watercolor studies. Just as Schiele was cowed by the force of his sister's sexuality, he may here have been in awe of this seemingly powerful older man. The artist surely viewed Roessler as a magical "fixer," capable of solving or arranging just about anything. At least at this early stage in their friendship, it behooved Schiele to maintain a respectful distance.

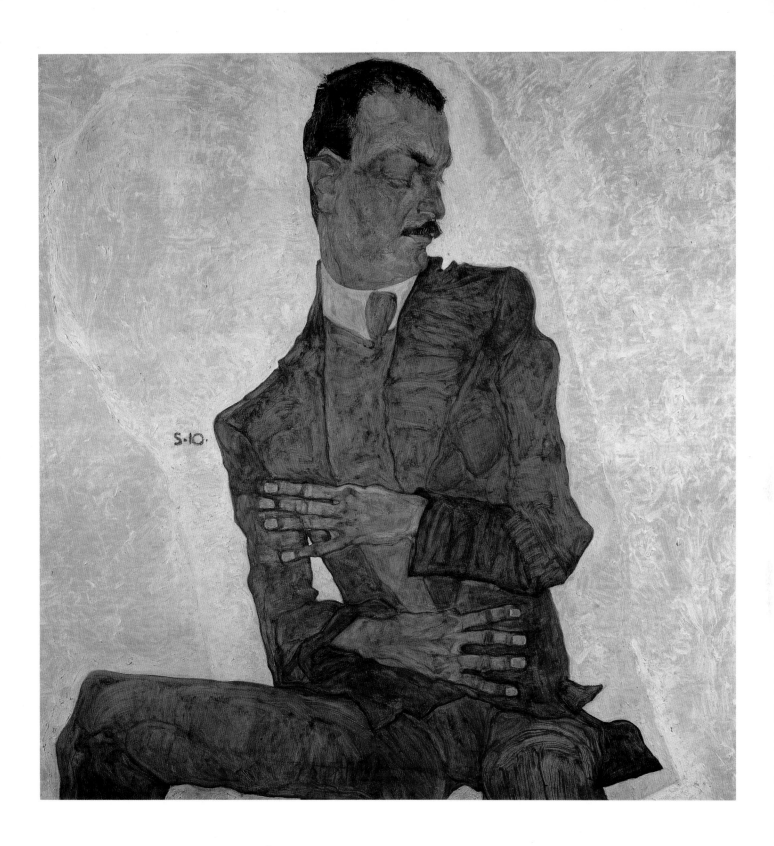

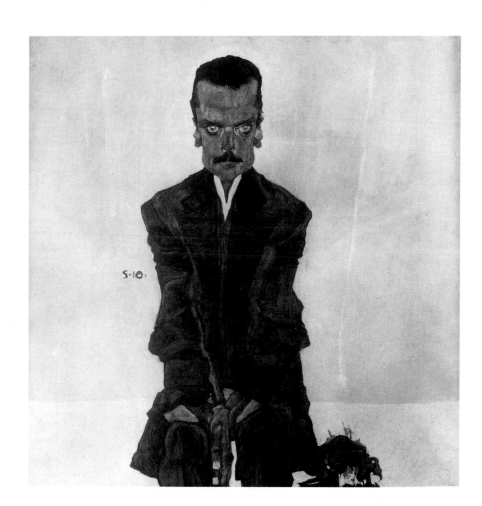

fig. 62. *Portrait of the Publisher Eduard Kosmack*. 1910.
Oil on canvas. Initialed "S." and dated, center left.
Verso: inscribed "Kosmack," probably by the artist.
39⅜ × 39⅜" (100 × 100 cm). Kallir P. 165.
Österreichische Galerie, Vienna; Inv. 4702. On extended
loan to Museum moderner Kunst, Vienna

opposite
plate 32. *Portrait of Eduard Kosmack, with Raised Left
Hand*. 1910. Gouache, watercolor, and charcoal with
white heightening on brown paper. Initialed "S" and
dated, lower right. Inscribed "Kosmak," center right.
Verso: drawing of a recumbent man, 1910 (Kallir D.
592). Study for *Portrait of the Publisher Eduard Kosmack*
(Kallir P. 165). 17⅝ × 12" (44.7 × 30.5 cm). Kallir D.
634. Collection Alice M. Kaplan

Among the many influential men to whom Arthur Roessler introduced Schiele in the first months of
their acquaintance were Carl Reininghaus and Oskar Reichel, both of whom almost immediately
began buying the artist's work in quantity. Less successful was Schiele's encounter with Eduard
Kosmack, an avant-garde publisher whom Roessler persuaded to commission a portrait.
Kosmack, having arranged to pay for the painting in installments, apparently never fulfilled his
obligation. Later, Schiele accused him of absconding with a portfolio of drawings that had been
entrusted to him for reproduction in one of his magazines.

The Kosmack painting (fig. 62) was one of eight portrait oils—at least six of them commis-
sioned—that Schiele executed in 1910. Portraiture, a fading art form in the rest of Europe,
experienced surprising longevity in Vienna, for several reasons. In the nineteenth century, it was
sustained by a rising bourgeoisie that longed to emulate the prerogatives of the aristocracy,
including patronage, and found confirmation of its newfound stature in the commissioned
portrait. After official support of the arts dwindled at the turn of the century, portraiture became
the financial mainstay of successful artists such as Klimt. Vienna lagged behind much of Europe in
the development of a commercial gallery network, and therefore direct contact between artist
and patron remained the rule at least until after World War I. This, as well, created circum-
stances conducive to the production of portraits.

It appears that in Schiele's day portraiture was viewed as a surefire way to establish an artistic
reputation. Kokoschka's early promoter, Adolf Loos, quickly set him to painting a series of
portraits of Viennese notables, and the architect Otto Wagner unsuccessfully tried to launch
Schiele on a similar project. Wagner's and Roessler's efforts in this direction notwithstanding,
however, Schiele was ill-suited to be a society painter. His portraits, seldom flattering, were not
infrequently rejected by the sitters. His output in this vein declined sharply after 1910, at least in
part because the artist had physically removed himself from the orbit of his patrons.

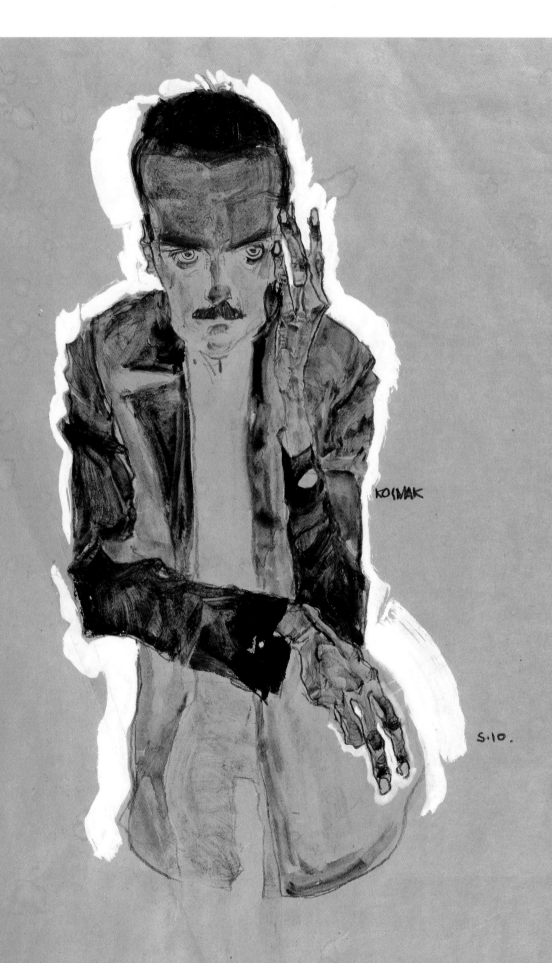

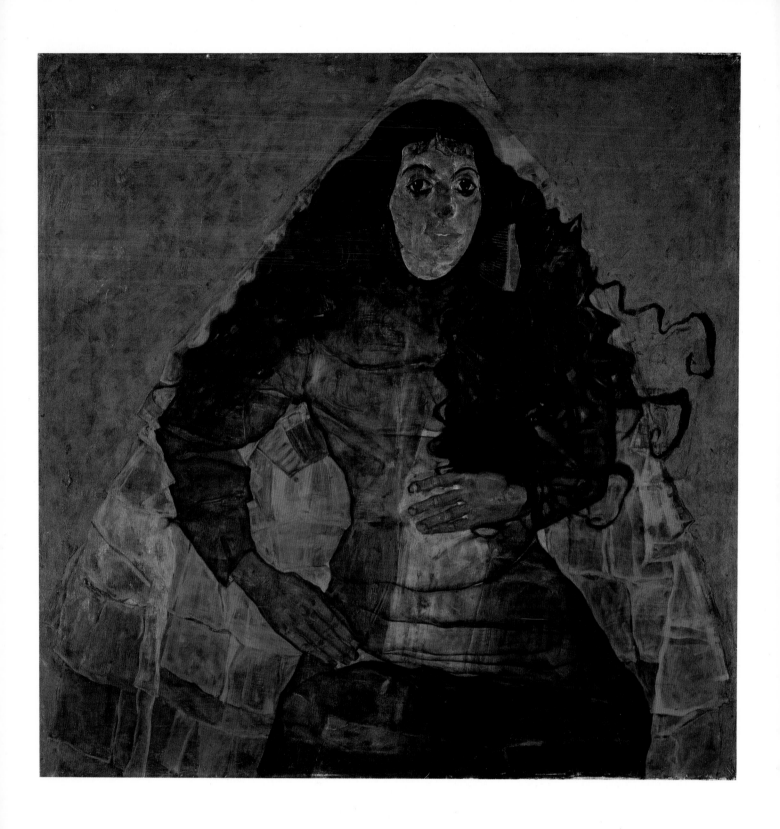

Austrian Expressionism in its formative years was a decidedly masculine genre. Whereas Klimt had been coddled by the idle wives of wealthy businessmen, Kokoschka's and Schiele's early patrons were predominantly male. Women did not want their husbands hanging Schiele's more explicit nudes in their homes, and mothers feared his influence on their sons and daughters. Though Schiele as well as Kokoschka would later create many sensitive portraits of women, females were initially reluctant sitters, for both artists had an unfortunate tendency to age their subjects by several decades. *Portrait of Trude Engel* is one of only three commissioned oil portraits of women ever painted by Schiele, and it has a rather checkered history.

Hermann Engel, the subject's father, was a dentist recommended to Schiele by Arthur Roessler for his willingness to trade services for art. (Schiele suffered from a weakness for sweets and notoriously bad teeth.) The portrait of Trude, however, failed in the dentist's estimation to satisfy his bill, for at some time in the course of its execution Schiele had to be forcibly banished from the Engel household. Subsequent correspondence between Engel and Schiele alludes to the artist's "mistreatment" of the sitter, and Engel further complained that portions of the canvas (obviously since painted over) were too intimate. Whether Schiele made untoward advances to his subject or whether (as the artist's family would have it) he was the victim of her unrequited passion is uncertain. In any event, the Trude of this painting as it survives is one of Schiele's most asexual female models, cloaked to her wrists and chin in bulky, unflattering garments. It was perhaps this, more than any ill-conceived flirtation, that the obviously attractive young girl found so upsetting.

plate 33. *Portrait of Trude Engel.* 1911. Oil on canvas. Verso: inscribed "Frika" by another hand and stamped "Alois Ebeseder/Wien I Opernring 3" twice. 39⅜ × 39⅜" (100 × 100 cm). Kallir P. 201. Neue Galerie der Stadt Linz; Inv. 11

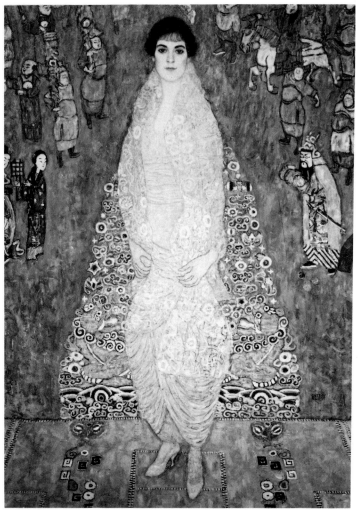

fig. 63. Gustav Klimt. *Portrait of the Baroness Bachofen-Echt.* c. 1914–16. Oil on canvas. 70⅞ × 50⅜" (180 × 128 cm). Novotny/Dobai 188. Private collection

Elisabeth Lederer, nineteen years old in 1913, was the daughter of the wealthy industrialist August Lederer and his wife Serena. The Lederers were Klimt's most important patrons, and Schiele's mentor had, toward the end of 1912, facilitated his introduction to them. Though he was initially commissioned to execute the portrait of Elisabeth's younger brother, Erich (see fig. 30), there was talk that Schiele might eventually paint the entire family. Nothing ever came of the idea, though he did produce several studies of Elisabeth and, some years later, her parents.

The stylized background of *Portrait of Elisabeth Lederer* (plate 34) suggests that Schiele was thinking about blocking out a larger composition. The watercolor contrasts sharply with the more formal oil (fig. 63) that Klimt painted shortly thereafter, following Elisabeth's marriage to the Baron Bachofen-Echt. Like many of Klimt's society portraits, this one encases the subject in a decorative crust. Her face is lovely but impassive, like that of an ice goddess. Schiele's Elisabeth is, by comparison, vibrantly alive, her visage not merely beautiful but imbued with forthright intelligence. The presentation was a great step forward from the somewhat awkward *Portrait of Trude Engel* (see plate 33) and presaged the increasingly sensitive female portraits of 1915–18 (see plates 89–91, 95, and 96).

opposite
plate 34. *Portrait of Elisabeth Lederer.* 1913. Gouache, watercolor, and pencil on paper. Signed and dated, lower right. 18⅞ × 11⅜" (48 × 29 cm). Kallir D. 1263. Private collection

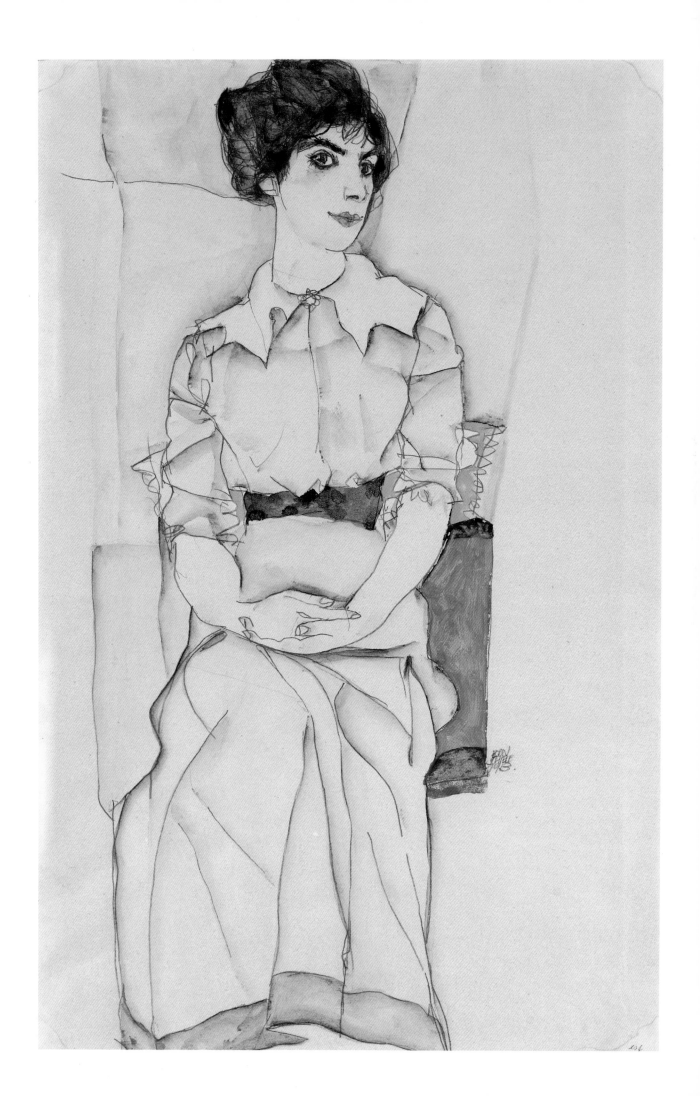

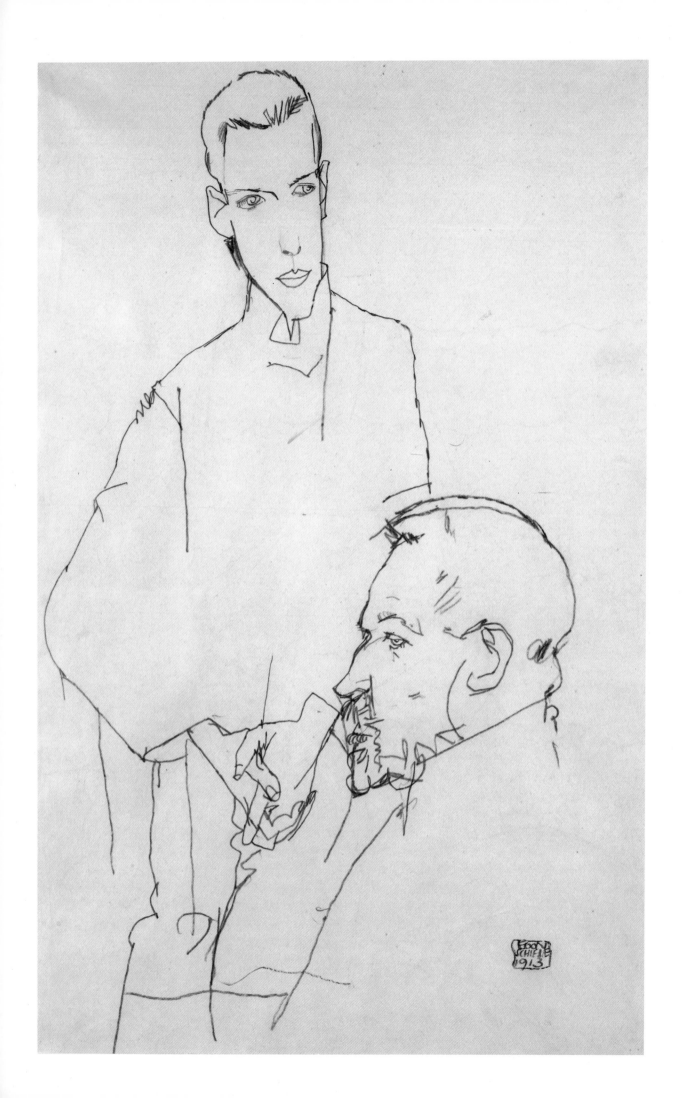

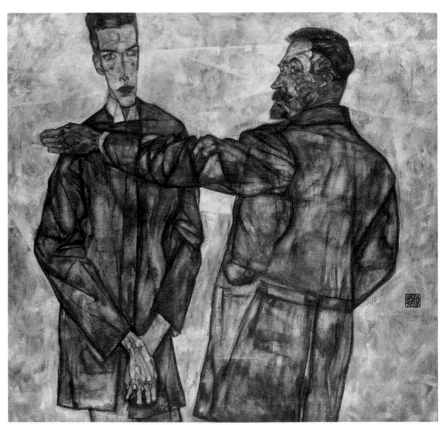

fig. 64. *Double Portrait (Chief Inspector Heinrich Benesch and His Son Otto)*. 1913. Oil on canvas. Signed and dated, lower right. Verso: inscribed "Reininghaus" and "C. R." by another hand and stamped "Arnold Landsberger/Wien/I Operngasse 4." 47⅝ × 51⅝" (121 × 131 cm). Kallir P. 250. Neue Galerie der Stadt Linz; Inv. 12

plate 35. *Chief Inspector Benesch and His Son Otto*. 1913. Pencil on off-white paper. Signed and dated, lower right. Verso: Study of a female nude, 1913 (Kallir D. 1305). Study for *Double Portrait (Chief Inspector Heinrich Benesch and His Son Otto)* (Kallir P. 250). 18½ × 12⅛" (47 × 30.8 cm). Kallir D. 1403. Fogg Art Museum, Harvard University Art Museums, Cambridge, Mass. Shelter Rock Foundation and Anonymous Donor Funds; Inv. 1964.170

Heinrich Benesch was among Schiele's most endearing—because most humble—patrons. A railroad inspector of limited financial means, he could not compete with wealthier collectors for Schiele's oils, and for the most part he had to content himself with works on paper. At one point he even begged the artist not to burn his discards but, rather, to reserve them for him.

By 1913, however, Benesch had begun to feel ill-used by Schiele. He feared the artist slighted him in favor of better heeled patrons and even gave the latter—who were able to buy in quantity—greater bargains. Above all, he resented the fact that he alone, among all Schiele's major supporters, had not yet been the subject of a portrait. "It is bitter to be treated as an expendable commodity by a friend," Benesch wrote him.

Undoubtedly, all Benesch had in mind was a portrait drawing, for he could not afford an oil. In the spring of 1913, Schiele at last began a series of studies, initially of Heinrich alone. However, the project quickly expanded to include the inspector's seventeen-year-old son, Otto (who shared his father's interest in art and later became the director of the Albertina museum). Ultimately, the drawings evolved into a major canvas (fig. 64) , though it was evident from the start that the Benesches would never own it. The painting was sold, shortly after completion, to the industrialist Carl Reininghaus.

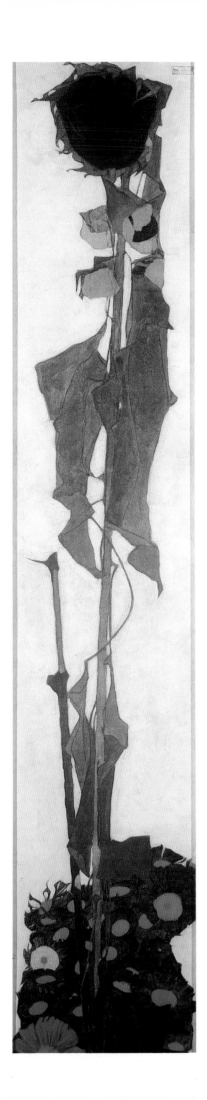

III. Landscape and Still Life, 1909–18

From an early age, Schiele sought solace in nature. Long walks were his way of escaping from what he called his "lifeless schooling," from the unsympathetic strangers with whom he, as a student, had to board, and, slightly later, from a home life grown increasingly disturbed and tenuous. It is therefore understandable that the artist's first significant body of paintings—done from 1907 to 1908—consists primarily of landscapes. These are relatively small works, often executed *en plein air* on ungrounded scraps of cardboard. When in 1909 Schiele began (largely under the influence of Gustav Klimt) to turn his hand to bigger, more ambitious canvases, he temporarily abandoned landscape painting. Depictions of the human figure in various guises dominate his work through mid-1910. It seems that even during his stay that summer in Krumau (which held great visual allure), he executed few townscapes or landscapes.

Schiele's activities as a landscapist increased sharply in the autumn of 1910, when he returned to Krumau for a brief visit. Though many of the landscapes from this period are traditionally counted among the artist's oils, most are executed in gouache on paper (see plate 37). They are, in fact, quite different from the artist's other works on paper in that all are painted out fully to the edges. The intrinsic separation of object from ground that characterizes the figural works is wholly absent in the landscapes, where the subject organically expands to encompass the entire picture plane. For this reason, the compositions of the landscapes are more satisfyingly complex than those of the figural oils.

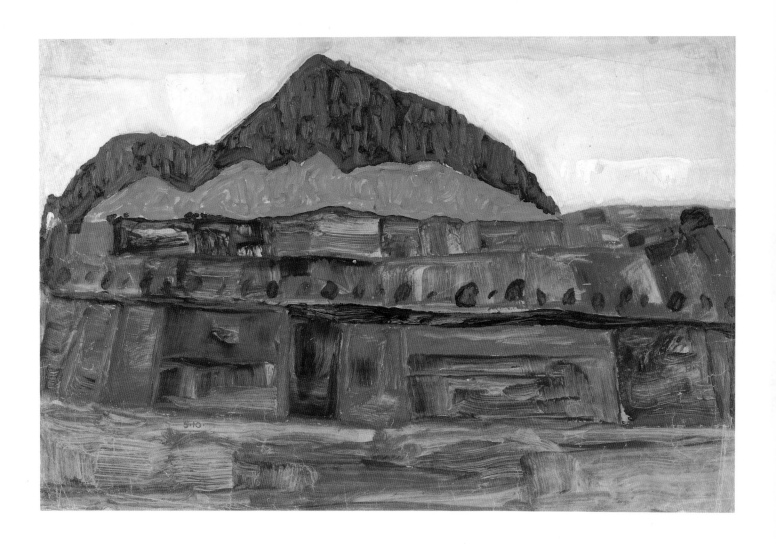

opposite
plate 36. *Sunflower II.* 1909. Oil on canvas. Initialed,
upper right. 59 × 11¾" (150 × 29.8 cm). Kallir P. 159.
Historisches Museum der Stadt Wien; Inv. 117523

above
plate 37. *Mountain Landscape.* 1910. Gouache on
cardboard. Initialed "S." and dated, lower left. 15 × 22"
(38 × 56 cm). Kallir P. 186. Collection Mrs. Fernande
Elkon, courtesy The Elkon Gallery, Inc., New York

fig. 65. Mill on the Breite Gasse, Krumau.
Photograph by Gary Cosimini

opposite
plate 38. *City on the Blue River I (Dead City I)*. 1910.
Gouache with glue and black crayon on paper. Signed
"Schiele" and dated, lower right. 16¼ × 12⅛"
(41.2 × 30.8 cm). Kallir P. 183. Private collection,
courtesy Galerie St. Etienne, New York

Schiele's favorite landscape subject, by a wide margin, was the town of Krumau (today Český Krumlov), to which he referred most frequently as the "dead city" (but also as the "old city" and the "city on the blue river"). Krumau, his mother's birthplace, was indisputably an old city, a medieval time capsule whose winding streets and crumbling buildings embodied for Schiele an eternity of human decay and persistence. Situated around and within a tortuous bend in the Moldau River (now called the Vlatava), Krumau has a compact, islandlike configuration that Schiele found compositionally intriguing. He liked especially to perch on the high left bank of the river and draw the old town from above. He told one friend that this bird's-eye perspective influenced all his work, and, indeed, even his nudes were often viewed from the vantage point of a tall stool or ladder (see plate 10).

Krumau was both spiritually and aesthetically satisfying for Schiele. This was a haunted town — haunted by the many generations (including Schiele's ancestors) who had lived and died within its ancient walls, and haunted specifically by the artist's father, who had once unsuccessfully attempted suicide there and whose ghost allegedly visited the artist's Krumau studio in 1910. As depicted by Schiele, it was a barren, unpopulated town: a beautiful reminder of a derelict past, a shell whose creators and inhabitants had long ago perished.

All his life, Schiele was inspired by what he termed the "Cubistic" quality of certain towns — that is, by their rectilinear geometry — and Krumau was highly qualified in this regard. His was at heart an ersatz Cubism, one in which structures were arranged like building blocks along a child's railroad set or snapped together like the abstract pieces in a jigsaw puzzle. Schiele's vision was fundamentally two-dimensional: distances were foreshortened or flattened, and forms were described by brushwork rather than volumetric modeling. In the Krumau townscapes, walls, streets, river, and sky link together to create an unbroken continuum of shapes. It is a tight, airless network that is in some ways the exact opposite of the wide-open voids of Schiele's figure pieces. At the same time, the claustrophobia of the Krumau compositions ideally evokes the artist's vision of this doomed yet enchanting little city.

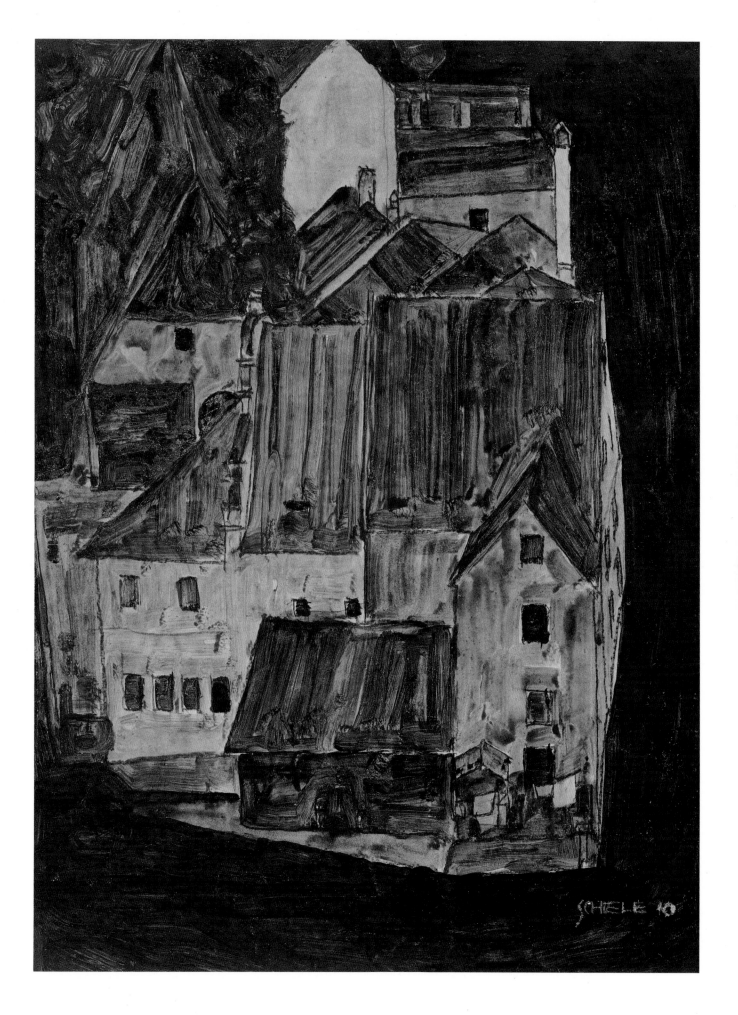

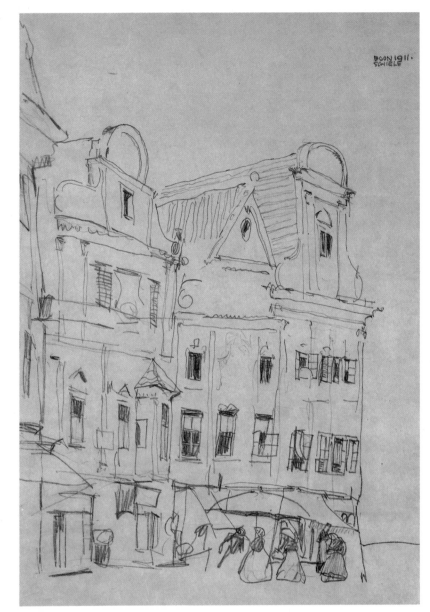

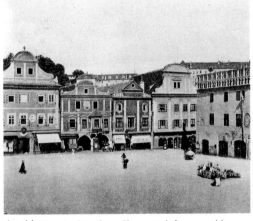

On 24 December 1910, Schiele painted a small picture on wood panel and gave it, still wet, as a Christmas present to his patron Arthur Roessler. Roessler encouraged him to do more works like this—conceptually akin to the edge-to-edge gouaches he had recently been creating (compare plates 37 and 38), but more substantial and therefore theoretically more lucrative. He even offered to fund the project and in May 1911 provided the artist with a small supply of panels.

Of the roughly thirty *Bretteln*, or "little boards" (see plates 40, 41, and 54), that Schiele executed between 1911 and 1913 (when this genre virtually disappeared from the oeuvre), the vast majority are landscapes. Like the landscape oils of 1907–8 and the subsequent gouaches, these panels are small in scale and highly spontaneous. Structurally, they retain certain aspects of the gouaches: in most, one still sees an underlying pencil drawing, and the paint surface is clearly demarcated by the flow of the brush. On some *Bretteln*, Schiele even tried to use gouache, with technically problematical results.

Schiele's tendency to imitate watercolor effects with oils can be observed in many of his canvases. However, the process was probably most successful on the small boards, in part because of their intimate scale and in part because of the manner in which the hard, smooth surface facilitated expressive manipulation of the pigment. As Schiele's overall palette brightened in the latter part of 1911, the panels became increasingly luminous. To heighten this effect, he often varnished them, giving them the quality of jewellike icons.

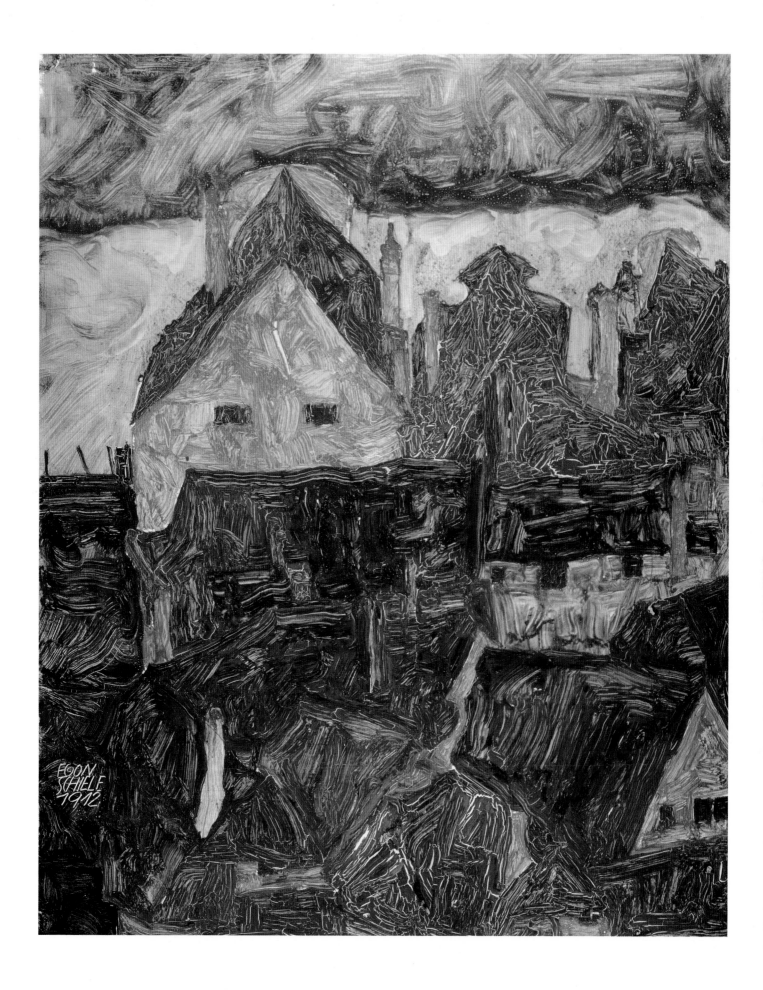

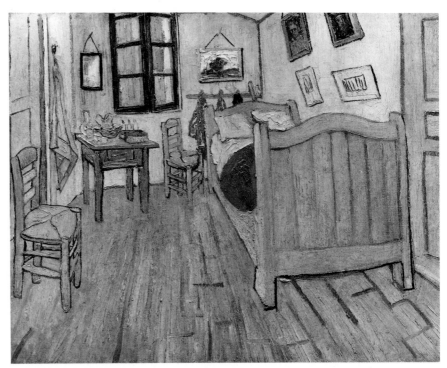

fig. 67. Vincent van Gogh. *Van Gogh's Bedroom.* 1888.
Oil on canvas. 28⅜ × 35⅜" (72 × 90 cm). Vincent van
Gogh Foundation/Van Gogh Museum, Amsterdam

Schiele's admiration of Vincent van Gogh is discernible in many of his works (see, for example,
his depictions of sunflowers, plates 36, 42–45), but nowhere is it clearer than in *The Artist's
Room in Neulengbach. Van Gogh's Bedroom* (a version of which was owned by Schiele's patron
Carl Reininghaus) served as the prototype for this little painting, in which the artist inventoried his
meager possessions with a mixture of pride and humility.

When Schiele arrived in Neulengbach in mid-1911, after having been hounded out of
Krumau, he planned "to stay forever." For the first time, he outfitted his rented rooms with his own
furniture: a suite of heavy wooden pieces (including many from the family home in Tulln) that his
friend Anton Peschka, following explicit instructions, stained black. This furniture was to
accompany Schiele on all his subsequent peregrinations. If the Neulengbach quarters seem a bit
cramped, they are nonetheless limned affectionately. Schiele hoped that he had at last found a
home.

opposite
plate 41. *The Artist's Room in Neulengbach (My Living
Room).* 1911. Oil on wood. Signed and dated three
times, lower center. 15¾ × 12½" (40 × 31.7 cm). Kallir P.
220. Historisches Museum der Stadt Wien; Inv. 117.203

fig. 68. Gustav Klimt. *Farm Garden with Sunflowers.*
c. 1905–6. Oil on canvas. 43¼ × 43¼″ (110 × 110 cm).
Novotny/Dobai 145. Österreichische Galerie, Vienna

above right
plate 42. *Sunflowers.* 1911. Oil on canvas. Signed and
dated, lower left. 35⅝ × 31¾″ (90.4 × 80.5 cm). Kallir
P. 221. Österreichische Galerie, Vienna; Inv. 2494

opposite
plate 43. *Sunflowers.* 1911. Watercolor and pencil on
paper. Signed and dated, center right. Related to
Sunflowers (Kallir P. 221). 17⅛ × 11½″ (43.5 × 29.3 cm).
Kallir D. 985. Graphische Sammlung Albertina, Vienna;
Inv. 27.947

For Schiele, winter represented death, while the sun, its opposite, was viewed as an eternal life force. This was not a unique perception, and Vincent van Gogh's robust, life-affirming sunflowers had been popular in Vienna ever since the artist's work was first exhibited there in the early years of the twentieth century. Klimt created two sunflower paintings shortly after a 1906 Van Gogh exhibition at the Galerie Miethke (fig. 68). Both are typical Klimt compositions, rife with densely suffocating botanical life. For all that, however, his sunflowers look forlorn and a bit nervous amid the surrounding greenery.

Again and again, Schiele would show that Klimt's ornament-packed backgrounds offered scant protection against the existential void they purported to obliterate. Like earlier homages to the master (compare plates 2 and 27), his 1911 canvas *Sunflowers* (plate 42) retains a central decorative nugget, here composed of neatly overlapping leaves and petals. However, instead of filling the picture plane, as Klimt's ornamental structures do, Schiele's tower of foliage pulls away from the edges to reveal the emptiness behind.

Schiele had conceived his first sunflower paintings in 1908 and 1909 (Kallir P. 144 and plate 36), and he would return to the subject sporadically throughout his life (see plates 43–45). His sunflowers typically stand against a vacant sky. Some are frail and slender, others lush with foliage. The blooms may be single or numerous, in full flower or decay. Regardless, the sunflower is stamped with the indelible mark of imminent doom. Flowering in the last warm days between summer and autumn, it blooms to die and bequeath the world its seeds. The sunflower was thus the ideal motif for an artist who had coined the maxim "Everything is living dead."

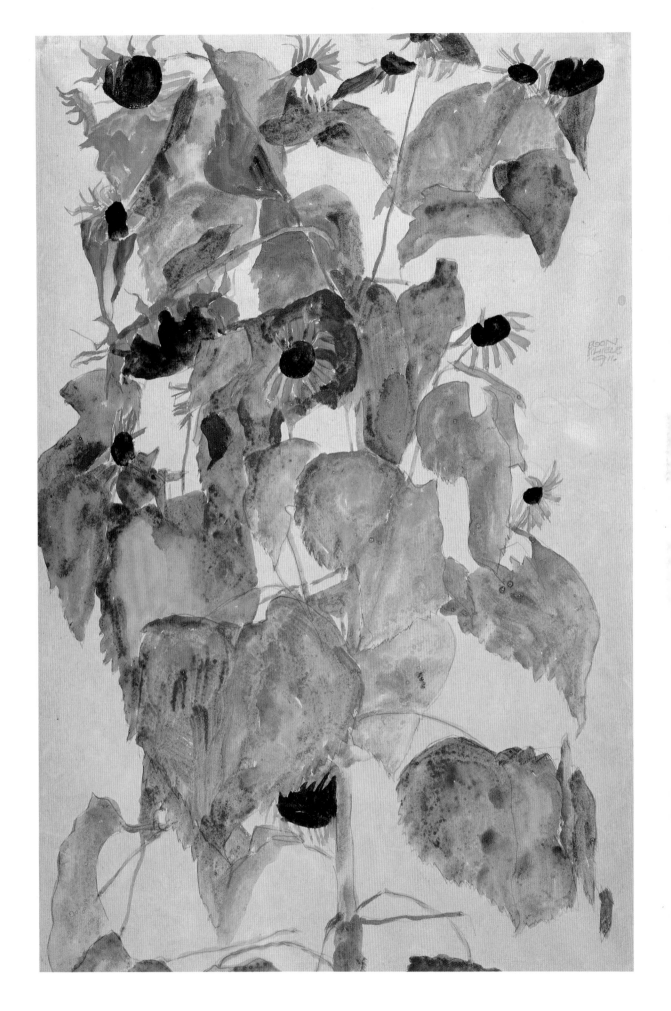

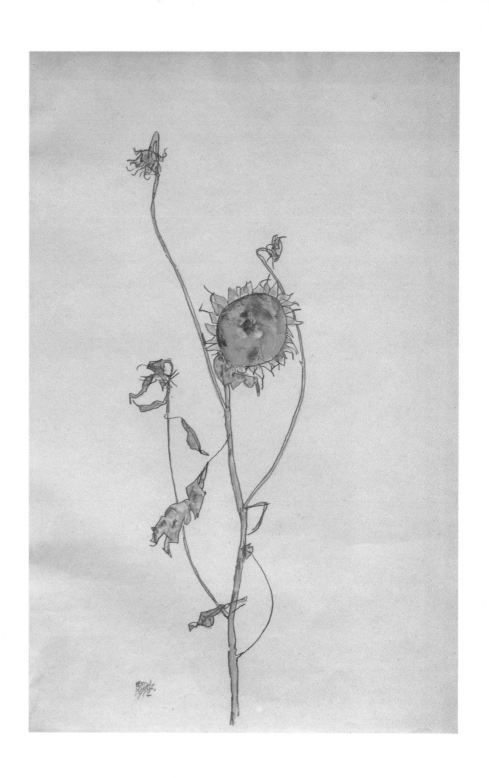

plate 44. *Wilted Sunflower*. 1912. Gouache and pencil on paper. Signed and dated, lower left. 17¾ × 11¾" (45 × 30 cm). Kallir D. 1212. Private collection, courtesy Galerie St. Etienne, New York

opposite
plate 45. *Sunflowers*. 1917. Gouache, watercolor, and pencil on paper. Signed and dated, lower right. 18⅛ × 11¾" (46 × 29.8 cm). Kallir D. 2151. Graphische Sammlung Albertina, Vienna; Inv. 31.123

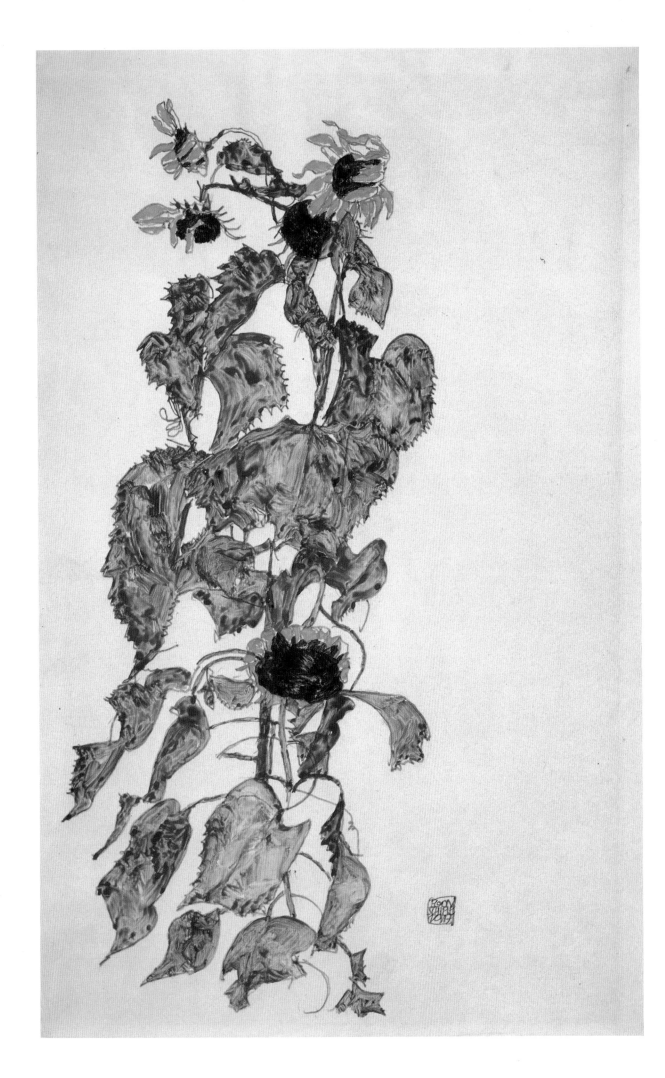

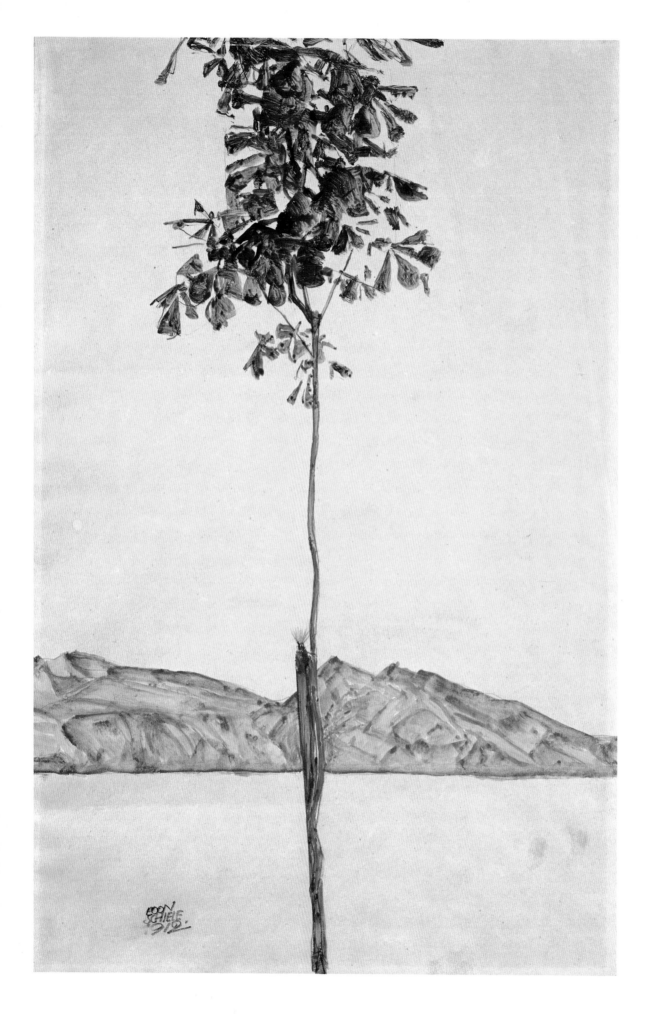

Following his release from prison in May 1912 (see plates 55 and 56), Schiele felt a characteristic need to seek comfort in nature. He traveled almost immediately to Carinthia and Trieste, and then in August visited Bregenz on Lake Constance. *Little Tree* dates from the latter trip.

Though Schiele was very much a product of Austrian soil (and almost never traveled abroad), his prison ordeal had embittered him toward his native land. For the first time, he began to think seriously about leaving. From the Austrian side of Lake Constance, he could imagine the shores of Switzerland beckoning. "I saw nothing but the . . . stormy lake," he later wrote, "and, far away, the white sunny mountains in Switzerland. I wanted to begin a new life. . . . I long for free people. As dear as Austria is, I lament her." The little tree that stands by the water's edge is Schiele himself: fragile but still blooming, and very much alone in the world.

plate 46. *Little Tree (Chestnut Tree at Lake Constance)*. 1912. Watercolor and pencil on paper. Signed and dated, lower left. 18 × 11⅝" (45.8 × 29.5 cm). Kallir D. 1215. Private collection, courtesy Galerie St. Etienne, New York

fig. 69. Ferdinand Hodler. *Autumn Evening.* 1892.
Oil on canvas. 39⅜ × 51¼". Musée d'art et d'histoire,
Neuchâtel, Switzerland

Schiele identified closely with nature, in which he saw correlatives for human emotional states. "Above all I observe the physical movements of mountains, water, trees, and flowers," he wrote. "Everywhere one is reminded of similar movements in human bodies, of similar manifestations of joy and suffering in plants."

In this spirit, Schiele over the course of his career created a series of anthropomorphic "tree portraits." There is a close kinship between these febrile trees and the figures in his contemporaneous allegories. Both represent humankind's isolation in a hostile environment. The trees are typically rooted in cold, relatively barren earth and silhouetted against a blank, usually sunless (and, presumably, godless) sky. Weak and frail, they almost invariably require supporting stakes and seldom carry more than a few leaves. "One experiences an autumnal tree in summer most profoundly," Schiele explained. "This melancholy I want to paint." Winter and autumn were for him the death forces against which the little trees vainly but nobly struggled.

Compositionally, the tree portraits have an elemental structure that places them somewhere between the more complex townscapes and the pared-down figure drawings. Horizontal bands—sky, earth, and, occasionally, water—are worked in various patterns against the vertical trunks. The simple, organic rhythm of these compositions recalls the so-called Parallelism of the Swiss Symbolist Ferdinand Hodler, who was a great favorite of Schiele's. For Hodler, however, the parallel appearance of natural forms, such as trees in a forest, was indicative of a divine order and harmony, whereas Schiele saw in these same forms an essential lonesomeness that evidenced God's desertion.

opposite
plate 47. *River Landscape with Two Trees.* 1913.
Oil on canvas. Signed and dated, lower left. 35 × 35⅜"
(88.9 × 89.7 cm). Kallir P. 264. Private collection,
courtesy Serge Sabarsky, New York

fig. 70. Bridge in Györ, Hungary. c. 1920

plate 48. *The Bridge.* 1913. Gouache, watercolor, and pencil on paper. Signed and dated, lower right. Verso: Austrian export stamp. 12½ × 19" (31.7 × 48.2 cm). Study for *The Bridge* (Kallir P. 262). Kallir D. 1463. Private collection

opposite
plate 49. *The Bridge.* 1913. Oil on canvas. Signed and dated, lower left. 35⅜ × 35⅜" (89.7 × 90 cm). Kallir P. 262. Private collection, courtesy Galerie St. Etienne, New York

Schiele discovered the subject of *The Bridge* (plates 48 and 49) in Györ, Hungary, where he had gone at the end of 1912 to paint the portrait of Erich Lederer (see fig. 30 and plate 34). He was delighted with the unusual architecture of the bridge, which he called "quite Asiatic, Chinese-like." The painting was begun in the early weeks of 1913 and finished by winter's end. Schiele was especially low on funds, and *The Bridge*, like other paintings done at this time, was executed on two pieced-together lengths of canvas.

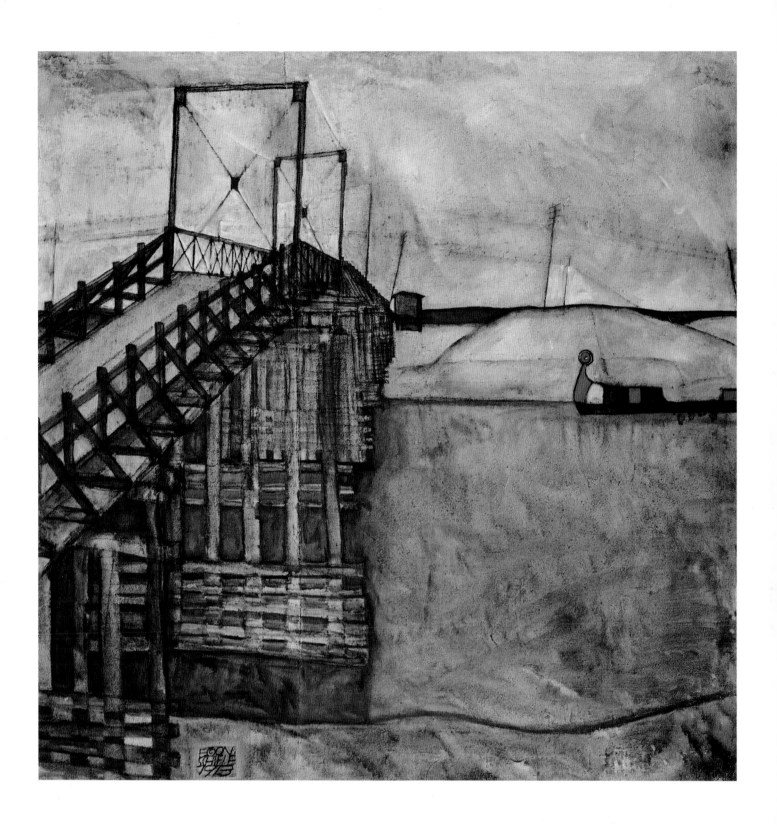

Schiele seems to have found the subject of *Sawmill* on a trip to Carinthia in the summer of 1913, when he wrote one of his patrons, "I discovered charming log houses and mills that I wanted to paint." Like the slightly earlier *The Bridge* (see plate 48), *Sawmill* depicts a singular structure that captured the artist's imagination. Such focused renderings of individual buildings, which recur sporadically until the end of Schiele's life, are a marked departure from the more all-encompassing townscapes that typify his earlier approach to architecture (compare plates 38 and 40). Unlike Schiele's anthropomorphic trees (see plates 46 and 47)—which appear at best loosely rooted—*Sawmill* is firmly embedded in the surrounding hillside. The interweaving of landscape subject and ground into a two-dimensional, tapestry-like whole is one of the leitmotifs of Schiele's late work.

plate 50. *Sawmill*. 1913. Oil on canvas. Signed and dated, lower right. Verso: labeled "Mühle Hauer" and stamped "Arnold Landsberger/Wien/I, Operngasse 4." 31½ × 35⅜" (80.1 × 89.8 cm). Kallir P. 271. Private collection

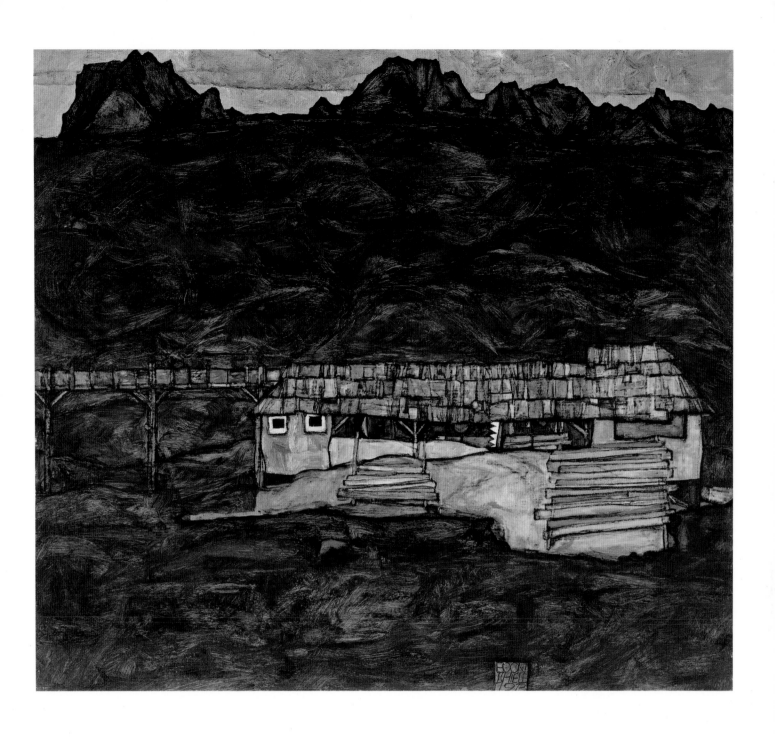

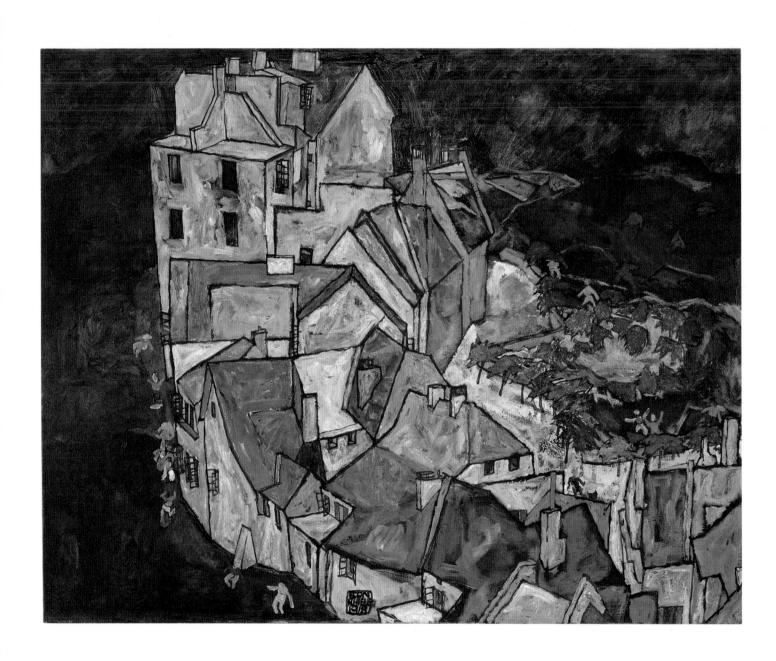

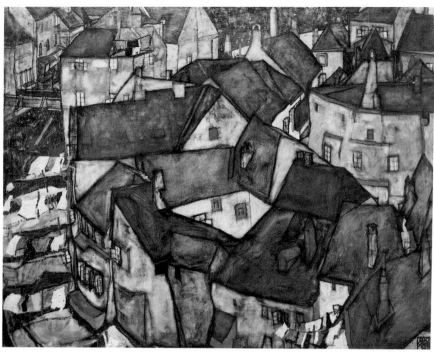

fig. 71. *Small Town (Krumau Town Crescent).* 1915. Oil on canvas. Signed and dated, lower right. 43¼ × 55⅛" (109.7 × 140 cm). Kallir P. 291. Israel Museum, Jerusalem. Gift of the Jewish Restitution Successor Organization

Few return visits to Krumau are documented after Schiele's forced departure in 1911. Yet he seems to have gone back with some regularity, for the subject recurs throughout his subsequent oeuvre. Some of his more fanciful compositions were probably concocted from memory, but surviving drawings suggest on-site study as well.

In 1915, Schiele began a new series depicting what he called the Krumau "town crescent." The crescent, as shown in the earliest and most representationally accurate of the three canvases (fig. 71), was in actuality a curved row of houses on the Lange Gasse. The crescent formation that becomes dominant in the subsequent versions was created by dropping away all surrounding buildings, so that the remaining spit of land assumes the guise of an island or peninsula.

Edge of Town, the last in this series, is also Schiele's final painting of Krumau. Dated 1918, it was probably begun in 1917, or possibly even 1916. Like most of the artist's paintings, it has the filled-in quality of a drawing, with forms demarcated by dark surrounding outlines. But in keeping with Schiele's late style, this canvas is more densely impastoed, more painterly. Perhaps most unusual is the addition of sticklike human figures on the streets and among the trees. The barren, lifeless Krumau has suddenly become populated. A drastic change from Schiele's former conception of the "dead city," it indicates a new sense of harmony and peace with the world.

plate 51. *Edge of Town (Krumau Town Crescent III).* 1918. Oil on canvas. Signed and dated, lower center. 43⅛ × 54⅞" (109.5 × 139.5 cm). Kallir P. 331. Neue Galerie am Landesmuseum Joanneum, Graz; Inv. I/466

IV. Self and the Search for Meaning, 1911–15

plate 52. *Self-Portrait with Outstretched Arms*. 1911. Gouache, watercolor, and pencil on paper. Signed and dated, lower right. 19 × 12½″ (48.2 × 31.7 cm). Kallir D. 959. Graphische Sammlung Albertina, Vienna; Inv. 31.156

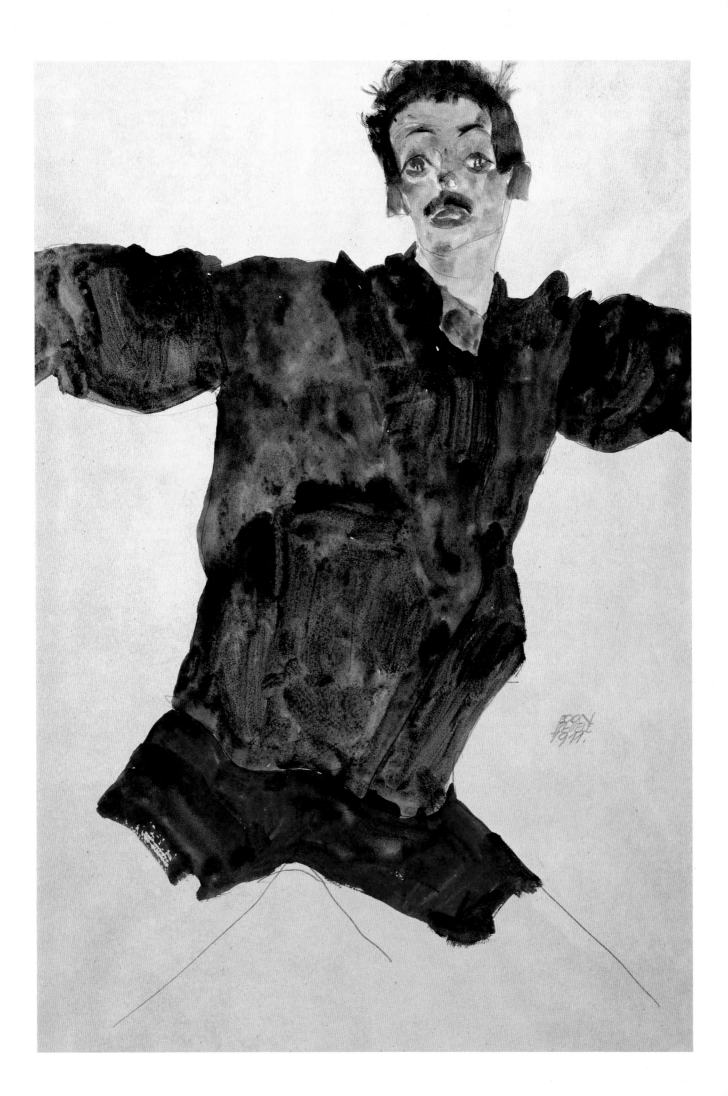

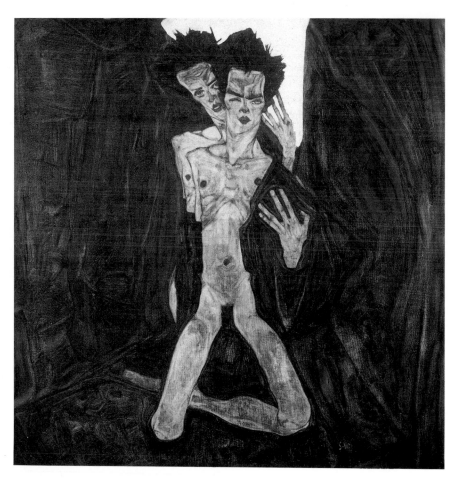

fig. 72. *The Self-Seers I*. 1910. Oil on canvas. Initialed "S." and dated, lower right. 31½ × 31⅜" (80 × 79.7 cm). Kallir P. 174. Present whereabouts unknown

Toward the end of 1910, Schiele began to move beyond the uninhibited role-playing that had thus far dominated his approach to self-portraiture. The shift was announced in a group of allegorical canvases, which may be referred to collectively as the Self-Seers series (although only two of the seven actually bear that name). As is implied by the title, Schiele was now intent on defining his function as an artist: a professional "seer," as it were. Though there was a visionary aspect to Schiele's approach, his glance was characteristically inward. For some years hence, his spiritual revelations would continue to come from the exploration of self.

All the paintings in the Self-Seers series are self-portraits, and most contain at least two images of Schiele: a primary, "living" body and a ghostly duplicate. The role of the double is intentionally ambiguous. In *The Self-Seers I* (fig. 72), it is a muselike figure who manipulates the artist from behind, and in *Prophets* (plate 53), it is likewise an inspirational emissary from the beyond. The latter title also alludes to Schiele's quasi-religious interpretation of the creative mission, a theme that recurs throughout his oeuvre (see plates 58, 59, 62, and 63). Yet the second self in *Prophets* has a malevolent aspect, and it is telling that *The Self-Seers II* (Kallir P. 193) is subtitled *Death and Man*. By his own account, Schiele had been haunted by death ever since his father's passing. The great beyond held wisdom and truth, but also the souls of the dead. Through immortal art Schiele hoped he could both vanquish death and attain enlightenment.

opposite

plate 53. *Prophets (Double Self-Portrait)*. 1911. Oil on canvas. Initialed "S." and dated, upper left. 43⅜ × 19¾" (110.3 × 50.3 cm). Kallir P. 191. Staatsgalerie, Stuttgart; Inv. GVL132

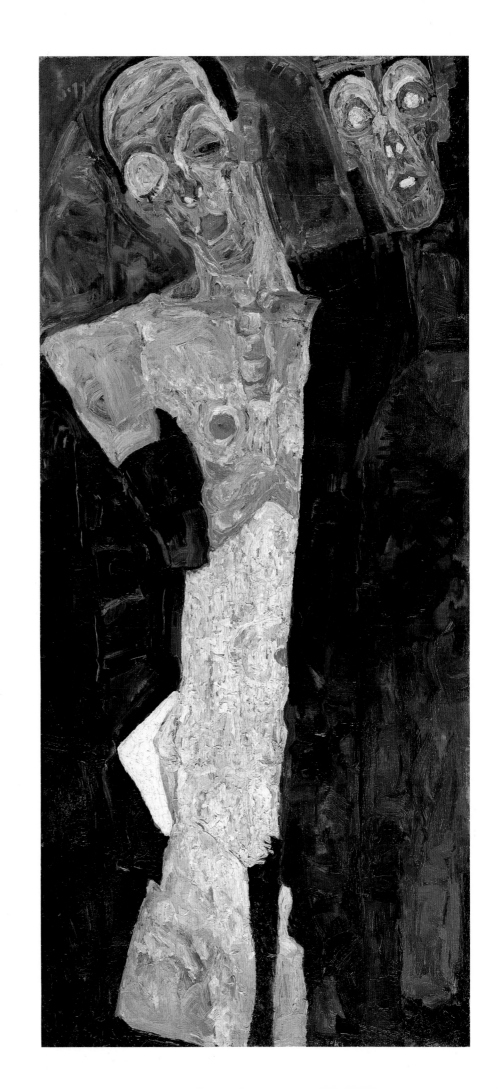

Self-Portrait with Black Clay Vase and Spread Fingers, painted toward the very end of 1911, signals an emergence from the dark and somewhat ponderous Self-Seers phase (see plate 53 and fig. 72). The colors are noticeably brighter, a quality that is accentuated by the artist's luminous oil-on-panel technique. The mysterious second self who haunts the earlier series has here been replaced by a far more subtle (though equally ominous) black profile that juts out behind the right side of Schiele's face, giving him a Janus-like aspect. An inventory of Schiele's possessions reveals that the profile comes from a black vase (see fig. 23), which here holds a desiccated branch. The shriveled foliage, like the black alter ego, is Schiele's acknowledgment of the enduring presence of death in life. These icons, according to his pictorial code, are the equivalent of the human skull found in traditional memento mori compositions. As in the Self-Seers paintings, Schiele was concerned with capturing an elemental dualism, with balancing positive and negative forces, creativity and mortality.

plate 54. *Self-Portrait with Black Clay Vase and Spread Fingers*. 1911. Oil on wood. Signed and dated, lower right. 10⅞ × 13⅜" (27.5 × 34 cm). Kallir P. 204. Historisches Museum der Stadt Wien; Inv. 104.207

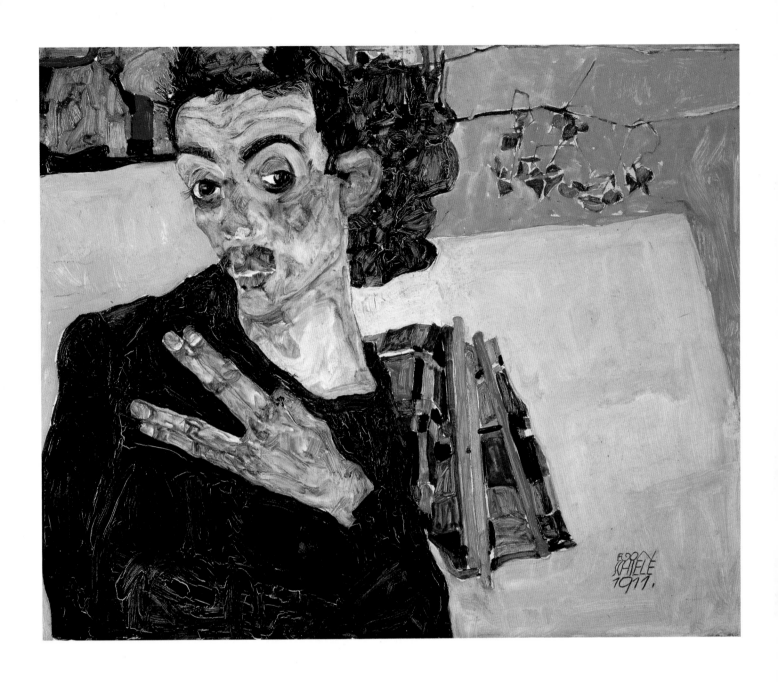

Schiele's inner-directed search for self, coupled with virtual obliviousness to the impact of his outward behavior, put him on a collision course with societal mores. Encouraged by the example of Klimt and the Wiener Werkstätte to believe that his position as an artist placed him beyond the pale of bourgeois custom while simultaneously entitling him to unquestioning support, he blithely pursued a bohemian life-style that was bound to raise eyebrows in the small towns, Krumau and Neulengbach, to which he gravitated in 1911 and 1912. It was not just that he dressed strangely (in modern suits of his own design or cloaklike caftans), or that he declined to go to church, or that his model/girlfriend, Wally Neuzil, stayed overnight. Above all, Schiele's mistake lay in asking young children to pose, for even if (as was usually the case) they remained fully dressed, they were likely, in his studio, to come in contact with his more explicit work. Thus it happened that in April and May 1912, Schiele spent twenty-four days in prison for "offenses against public morality."

It is said that Schiele first received art supplies on April 16, the third day of his imprisonment, but the earliest known drawing is dated the nineteenth. Over the course of the next three days, the artist created a series of watercolors meticulously recording his strange new surroundings: his cell (see fig. 12), the passageway outside (see fig. 10), and the chairs within (virtually the only objects of interest, out of which he fashioned ad hoc still lifes; Kallir D. 1182–85).

On April 23, Schiele started to draw self-portraits. He also at this time began to record on his drawings the day of the week (denoted by an initial) in addition to the date, suggesting an increasingly urgent need to keep track of the passage of time. Prior prison drawings had all been inscribed with descriptive phrases, but in the self-portraits the artist resorted to far more poetic formulations. "Hindering the artist is a crime . . ." is an eloquent summary of Schiele's attitude toward his predicament: jailing an artist is an offense against life itself. Not he, but his jailers were the criminals, for failing to recognize the sanctity of his mission and give him free license to pursue it.

Schiele owned a large, black-framed mirror that he dragged from studio to studio throughout his life and referred to when drawing himself (see fig. 6). This mirror gave his self-portraits a direct, no-nonsense quality. The artist usually squatted or stood; one can imagine that his feet (not always visible) were firmly planted on the ground; his head was up, straight on or cocked sideways. The viewer looks at Schiele much as he must have looked at himself, and the sheet replicates more or less exactly the space in which he posed.

The prison self-portraits, of necessity done without aid of the mirror, are very different. Though the poses are all horizontal (the artist, huddled for warmth and protection beneath a coat or blanket, lies prone on his cot), the signatures and inscriptions invariably give the drawings a vertical reading. Schiele no longer occupies real space but rather a pictorial space of his own invention. This is an orientation frequently encountered in his nudes (which, viewed from above by the artist, routinely defy the physical logic of their poses; see plate 10) but never in the ordinary self-portraits. Schiele, now nearly two weeks into his imprisonment, seems literally to be coming apart. As though disembodied, his artistic persona floats above and observes his suffering self. The structure of these unique self-portraits poignantly reflects the artist's growing psychic alienation, just as the inscriptions chronicle his mounting panic and anguish.

opposite left

plate 55. *Hindering the Artist Is a Crime, It Is Murdering Life in the Bud!* 1912. Watercolor and pencil on paper. Signed, dated "23.IV.12. D.," and inscribed "Den Künstler hemmen ist ein Verbrechen, es heisst keimendes Leben morden!" lower right. 19⅛ × 12½" (48.6 × 31.8 cm). Kallir D. 1186. Graphische Sammlung Albertina, Vienna; Inv. 31.162

opposite right

plate 56. *For My Art and for My Loved Ones I Will Gladly Endure to the End!* 1912. Watercolor and pencil on paper. Signed, dated "25.IV.12. D.," and inscribed "Ich werde für die Kunst und für meine Geliebten gerne ausharren!" upper right. Verso: Arthur Roessler collector's stamp. 19 × 12½" (48.2 × 31.8 cm). Kallir D. 1189. Graphische Sammlung Albertina, Vienna; Inv. 31.027

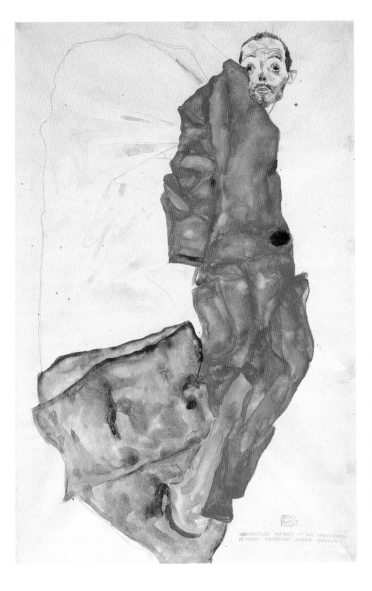

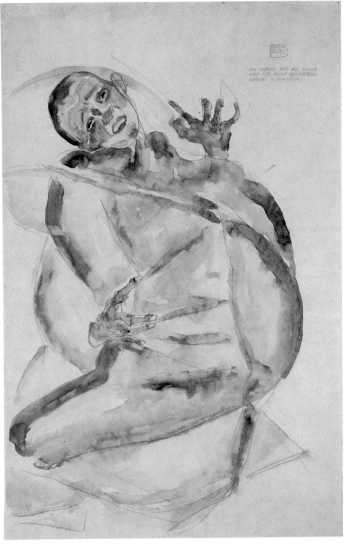

The pain of Schiele's imprisonment lingered on and was evident in his self-portraits for some years thereafter, just as it very directly affected his view of his artistic mission. *Self-Portrait, Bust* was probably done toward the end of 1912. It portrays anger and defiance along with pain and confusion. At the same time, the artist's line is noticeably bolder than earlier in the year. He had switched to a softer, darker pencil and now used drier, somewhat denser paint. These changes persist in 1913.

plate 57. *Self-Portrait, Bust.* 1912. Watercolor and pencil on paper. Signed and dated, lower right. 13¾ × 10″ (35 × 25.3 cm). Kallir D. 1174. Private collection, courtesy Galerie St. Etienne, New York

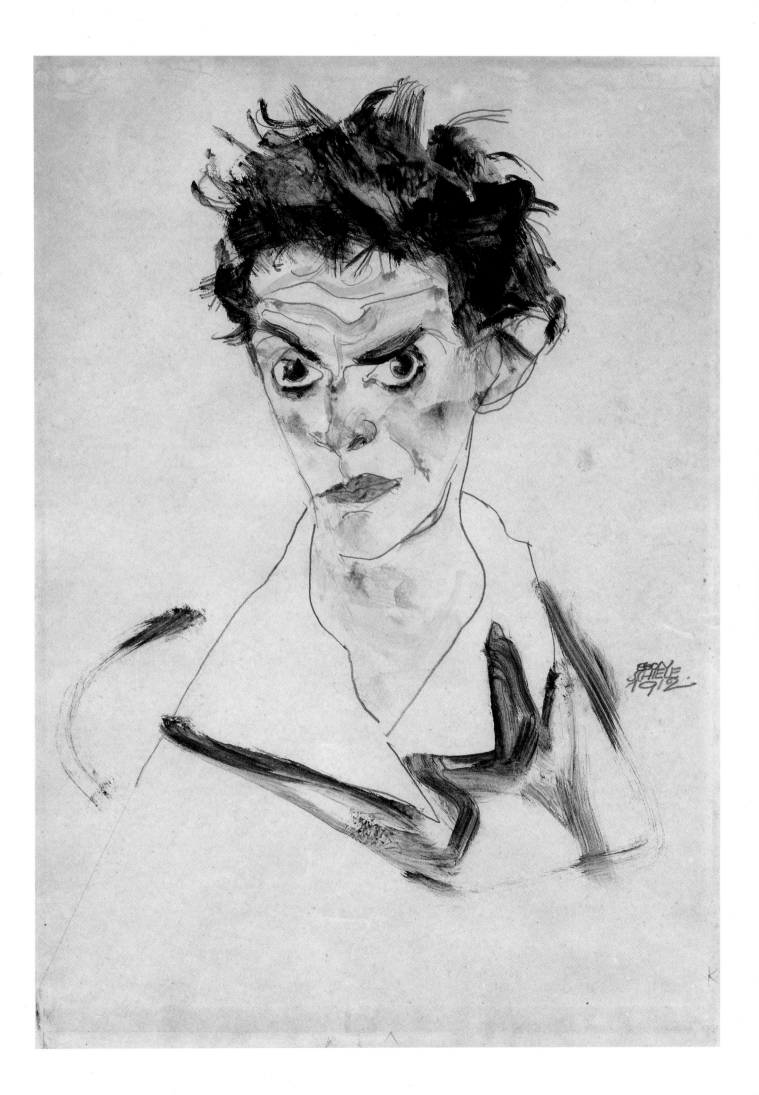

fig. 73. Gustav Klimt in the garden of his Vienna studio. c. 1912–14

Early in his career, Schiele adopted as his customary painting costume a flowing white caftan. He was in part emulating the blue robe worn by his mentor, Gustav Klimt, and in part affirming his membership in the monklike brotherhood of artists. The idea that artists, like religious figures, constitute a special spiritual order can be traced back at least to the nineteenth-century Romantic movement, but Schiele's interpretation was typically idiosyncratic. On the one hand, this was the attitude that had encouraged him to view himself as above the law and thereby led to his imprisonment. On the other, the very notion of a shared creative community to some extent softened the artist's stance as a loner and encouraged a broader identification with the human family.

The outstretched arm and hand seen in the 1913 *Self-Portrait* drawing recur in several contemporaneous works, and this gesture obviously had special significance for Schiele. An artist, of course, holds great power in his fingertips, but the gesture is not one of command. Rather, Schiele shows himself at the mercy of his own creative powers, reaching out as in a trance to find an external truth. In the wake of the prison incident, his orientation had become more outward-looking and more questioning of self. He was no longer the exalted seer but merely a seeker who, in his search, may lead others as well to enlightenment.

opposite
plate 58. *Self-Portrait.* 1913. Pencil on paper. Signed and dated, center right. 18⅞ × 12⅜" (48 × 31.5 cm). Kallir D. 1432. Collection Klaus Hegewisch, Hamburg

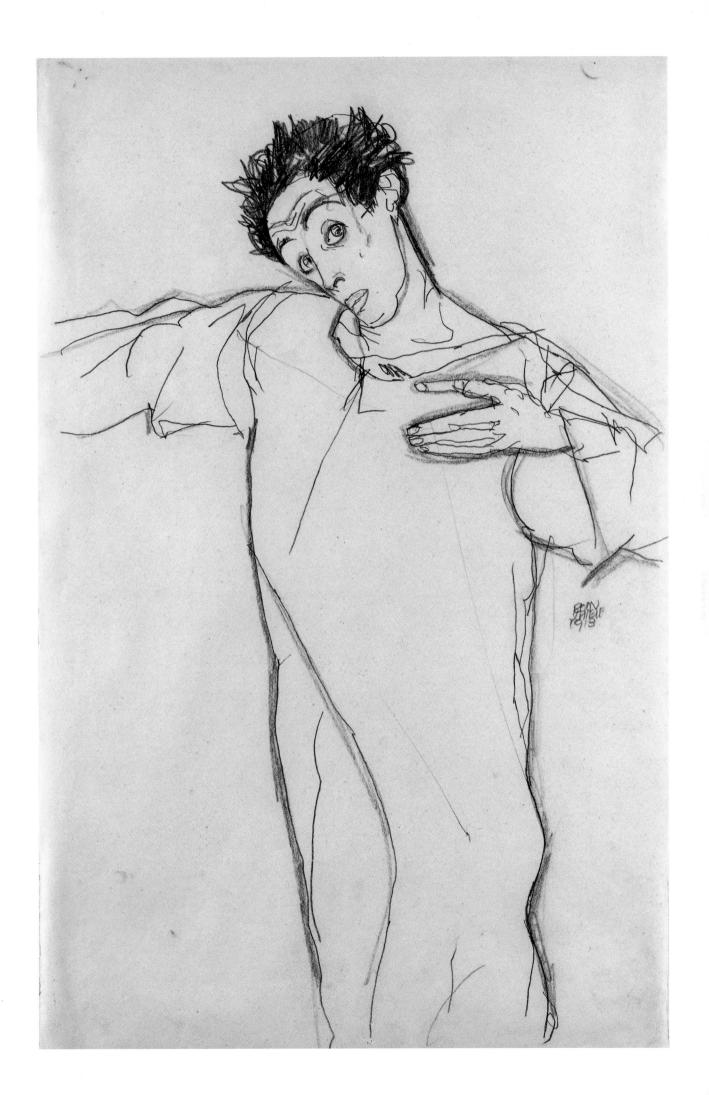

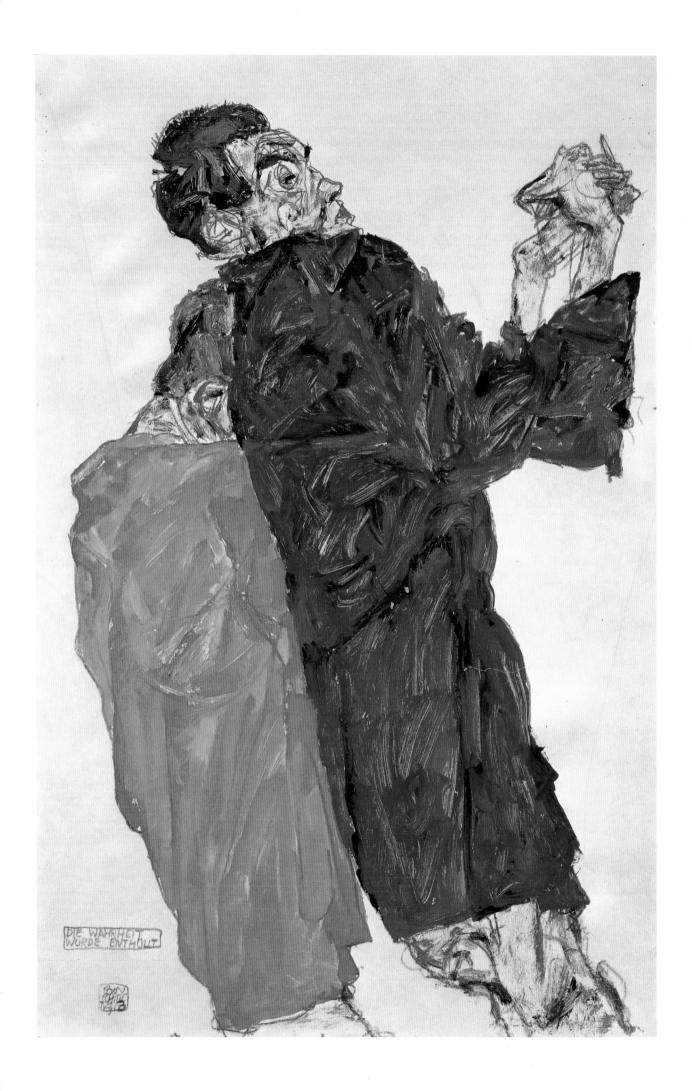

Many of Schiele's 1913 and 1914 self-portraits and figure studies—usually dressed in short tunics—relate to two large allegorical canvases, *Conversion* (Kallir P. XLII) and *Encounter (Self-Portrait with Saint)* (see fig. 74). Since neither painting was ever completed, one can only speculate as to the intended appearance of each. However, surviving fragments suggest that both compositions involved friezelike chains of human figures: a seer with his disciples. The tunics were intended to provide pictorial unity and, much like Schiele's earlier caftans, to signify membership in a hieratic brotherhood.

The Truth Unveiled is one of a series of watercolors from late 1913 that bear inscribed legends. Schiele's friend the collector Erich Lederer recalled that these uncharacteristic inscriptions were added as afterthoughts and had relatively little significance. Though the texts relate loosely to Schiele's ongoing philosophical concerns, they cannot properly be considered titles. Many of these drawings were exhibited at the Munich Secession in late 1913 and early 1914, suggesting that Schiele used the inscriptions either to group all his contributions cohesively or, more practically, to help identify and retrieve them after the showing (a perennial problem).

Over the course of 1913, Schiele had become increasingly concerned with volume, and *The Truth Unveiled* is typical of the manner in which his brush now systematically began to mold human flesh. The drapery was still largely defined by the two-dimensional contours of the surrounding drawing and the gyrations of the paint, but the artist now searched out crevices and curves on the skin with new vigor and anointed them with particolored dabs. The bright, unnatural reds, blues, and greens suggest the influence of Fauvism or German Expressionism—an influence, however, that is undetectable in the generally subdued palette of Schiele's oils. The use of denser gouache in place of watercolor heralded an incipient interest in painterly effect, which was to grow stronger throughout the remainder of Schiele's career.

plate 59. *The Truth Unveiled*. 1913. Gouache, watercolor, and pencil on off-white wove paper. Signed, dated, and inscribed "Die Wahrheit wurde enthüllt," lower left. Verso: study of a female nude, 1913 (Kallir D. 1320). 19 × 12⅝" (48.3 × 32.1 cm). Kallir D. 1443. Private collection, courtesy Wolfgang Werner KG, Bremen

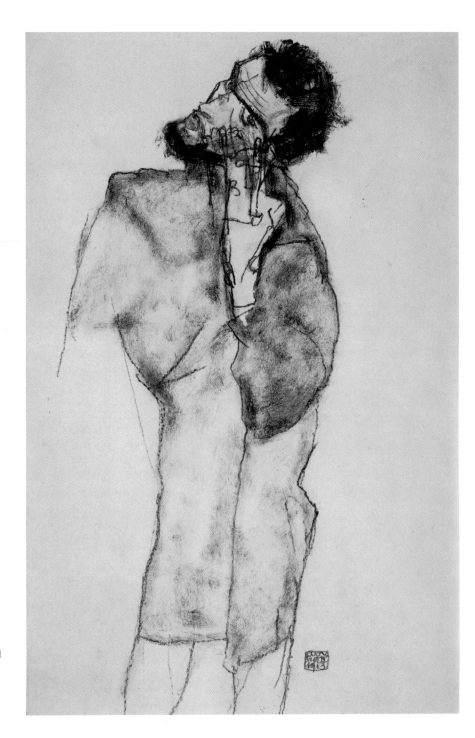

plate 60. *Bearded Man, Standing*. 1913. Gouache and
pencil on paper. Signed and dated, lower right.
18¼ × 12⅝″ (46.5 × 32 cm). Kallir D. 1413. Private
collection

opposite
plate 61. *Fighter*. 1913. Gouache and pencil on paper.
Signed and dated, lower left. Inscribed "Kämpfer," lower
right. Verso: study of Wally Neuzil, 1913 (Kallir D.
1332). 19¼ × 12⅝″ (48.8 × 32.2 cm). Kallir D. 1438.
Private collection

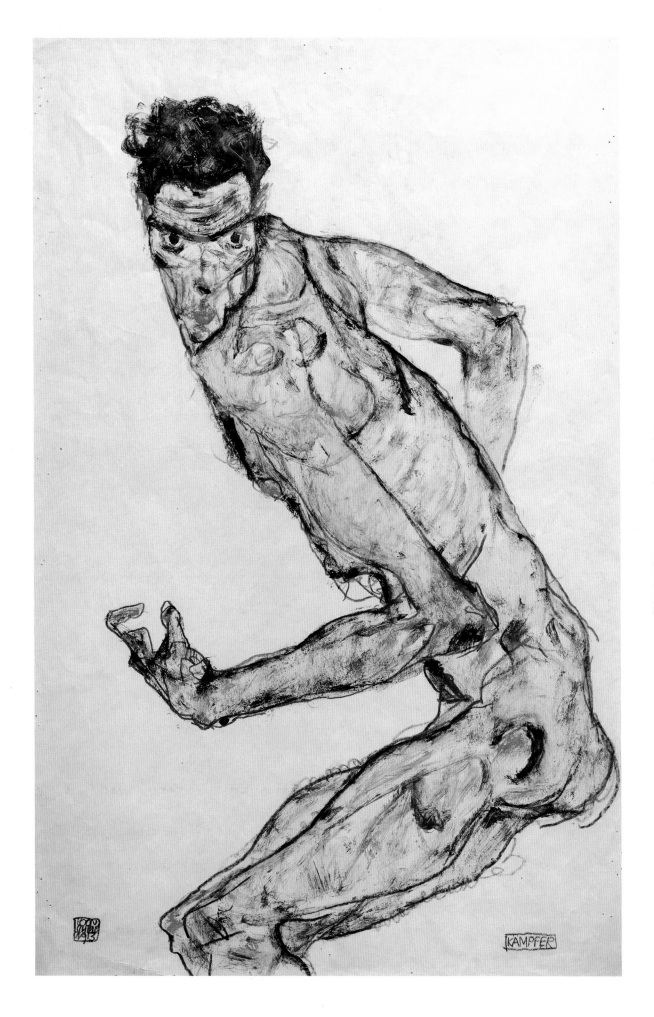

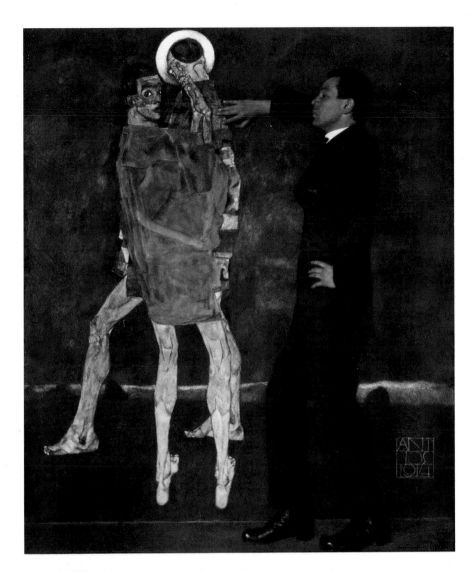

fig. 74. The artist in front of his painting *Encounter (Self-Portrait with Saint)*. 1913. Oil on canvas. 78⅜ × 78⅜″ (199 × 199 cm). Kallir P. 259. Present whereabouts unknown

opposite
plate 62. *Standing Figure with Halo.* 1913. Gouache, watercolor, and pencil on paper. 19 × 12½″ (48.3 × 31.7 cm). Kallir D. 1421. Collection F. Elghanayan, United States

In April 1913, Schiele's patron Carl Reininghaus announced that he was sponsoring a competition for painters from all over Europe. Schiele had nearly a year to fulfill this assignment (the paintings were to be displayed in early 1914), but he seems to have dawdled. His entry, *Encounter (Self-Portrait with Saint)* (fig. 74), was apparently executed in a rush toward the end of 1913. The exhibition catalogue subtitles the painting *Trial for a Mural* and indicates that it was unfinished. Schiele's arrogance in submitting an incomplete work, plus a rumor that the contest had been rigged in his favor, prompted the judges to award the prizes to others.

According to the catalogue of the show, held at the Kunstsalon Pisko, Schiele's canvas, depicting the artist and a saint, was eventually to be complemented by a second panel showing a row of "blind figures." This pendant was never executed, and since *Encounter* itself vanished many years ago, *Standing Figure with Halo* remains our best indication of Schiele's ultimate intentions. The saint figure here replaces the spiritual doppelgänger of the earlier Self-Seers series (see plate 53 and fig. 72). This new character is not, as formerly, an extension of the artist's own persona but very obviously a separate entity, from whom he seeks inspiration and enlightenment. The guise of supplicant is a newly humble one for Schiele.

Like most of Schiele's allegorical characters at this time, the subject of *Standing Figure with Halo* wears a robe or tunic. This, as well as the halo itself, denotes his exalted spiritual stature. The saint of this study (though not of the oil) is an old man who presumably carries within him the wisdom of the ages. Schiele, who still grieved for his father, admired older men and sought them out as patrons and mentors. Gustav Klimt was perhaps the ideal father substitute, and some viewers have purported to discern his features in several of the younger artist's allegorical works. Whether the saint was modeled on Klimt is debatable: Klimt wore a shorter beard, and there is otherwise little similarity between the two faces.

plate 63. *Self-Portrait as Saint Sebastian.* 1914. Pencil on paper. Signed and dated, lower right. 12¾ × 19" (32.4 × 48.2 cm). Kallir D. 1658. Private collection, New York

opposite
plate 64. *Self-Portrait in Lavender Shirt and Dark Suit, Standing.* 1914. Gouache, watercolor, and pencil on paper. Signed and dated, lower left. 19 × 12⅝" (48.4 × 32.2 cm). Kallir D. 1654. Graphische Sammlung Albertina, Vienna; Inv. 31.105

Self-Portrait as Saint Sebastian (plate 63) is the quintessential evocation of Schiele's allegorical martyr complex, and many have traced its origins directly back to his imprisonment two years earlier. Here stands the artist, mortally wounded by the arrows of a philistine society. (The pose, suggestive of a crucifixion, even implies an identification with Christ, for Saint Sebastian in traditional representations is usually bound to a stake or a tree.) Some have taken this analysis one step further, suggesting that Schiele was intentionally exploiting the prison incident when he used the Saint Sebastian drawing as a prototype for the poster advertising his second Viennese one-man show, at the Galerie Arnot in January 1915.

This deductive chain is, however, flawed, for while *Self-Portrait as Saint Sebastian* was conditioned by Schiele's responses to his prison experiences, it is not really "about" his imprisonment. Nor was the Saint Sebastian drawing merely an exercise in self-pity. As a Catholic, Schiele had been taught to see suffering and self-immolation as positive forces, necessary to expiate guilt and attain enlightenment. Though his religious habits were at best erratic, it is evident that he had undergone a self-styled spiritual awakening in the aftermath of his imprisonment. "The important personage and the great artist count less for me than the pure, exalted noble human being (Christ)," he wrote. Schiele did not now presume to have achieved sainthood, much less godliness. He remained, even as Saint Sebastian, a supplicant and seeker rather than a bestower of divine truth.

Schiele's newfound humility expressed itself in a strange transformation of his symbolic persona: in many self-portraits of 1914 and 1915, the artist appears to have become sightless (plate 64). His eyes are swollen shut or, if open, resemble blind, saucerlike disks. Though perfectly in keeping with the self-flagellation enacted in *Self-Portrait as Saint Sebastian,* blindness is a bizarre affliction for one who had previously cast himself as a seer.

Schiele gradually abandoned the cloaks and caftans found in his work of 1911–13 (see plate 58), but shorter tunics or jerkins remained an important adjunct to his allegorical iconography. (For *Self-Portrait in Jerkin with Right Elbow Raised,* he actually wore a sleeveless vest, which was filled in only when the drawing was colored.) As the artist's costumes became briefer and less constraining, his movements became freer. Though the self-portraits of 1914–15 may not be quite as contorted as those of 1910–11, Schiele's fascination with expressive body language had scarcely diminished. If anything, his gestures had become more carefully calibrated and thereby more potent.

Given Schiele's penchant for minimalist compositions, gesture is key to his allegorical oil paintings, defining the way figures relate to one another and to the picture plane. *Self-Portrait in Jerkin with Right Elbow Raised* is not a study for any known oil, though it may be considered a sort of dress rehearsal. Schiele was practicing his repertoire of poses, seeking out those moves that would work best in a larger context.

plate 65. *Self-Portrait in Jerkin with Right Elbow Raised.* 1914. Gouache, watercolor, and black crayon on paper. Signed and dated, lower right. 18¾ × 12¼" (47.6 × 31.1 cm). Kallir D. 1668. Collection Alice M. Kaplan

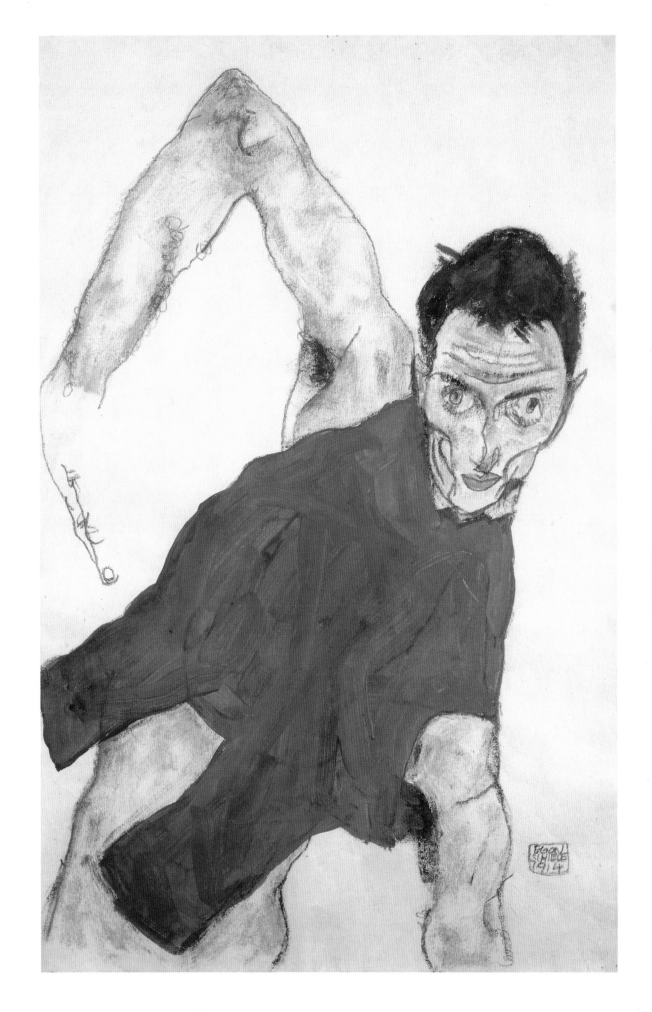

V. Relationships with Women, 1910—18

plate 66. *Nude Girls Reclining*. 1911. Watercolor and pencil on paper. Signed and dated, lower right. 22¼ × 14½″ (56.5 × 36.8 cm). Kallir D. 884. The Metropolitan Museum of Art, New York. Bequest of Scofield Thayer, 1982; Inv. 1984.433.309

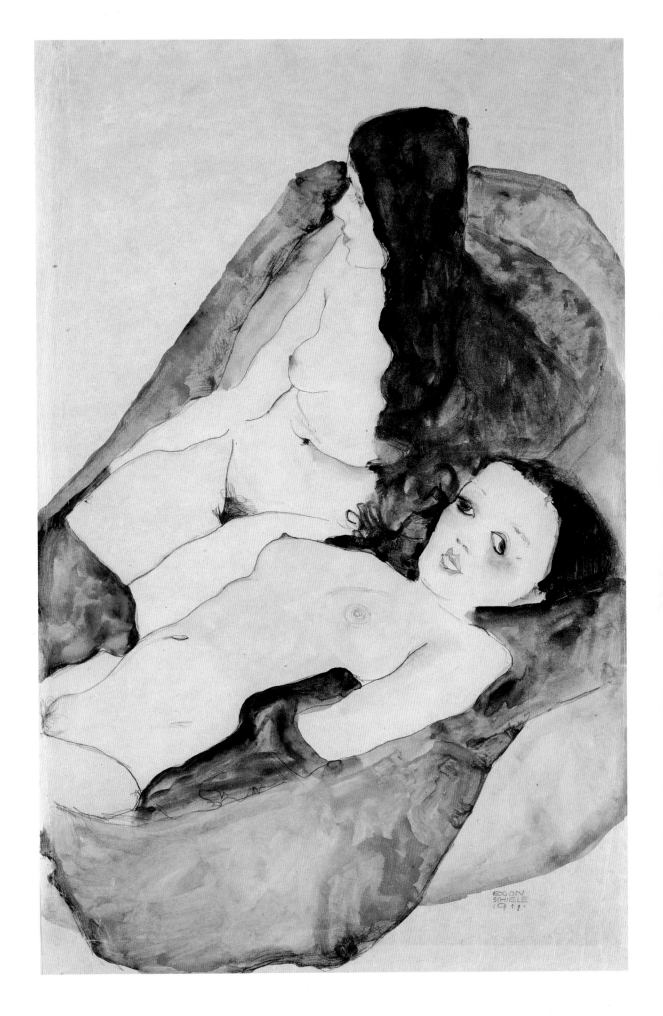

fig. 75. *The Birth of Genius (Dead Mother II)* 1911. Oil on wood. 12⅝ × 10″ (32.1 × 25.4 cm). Kallir P. 195. Presumed destroyed

Many of Schiele's 1910 studies of infants and of female nudes were done at the clinic of the gynecologist Erwin von Graff. However, only toward the end of the year do women appear together with the babies, and there is an intimacy to this later series that suggests a bond deeper than is likely to have developed in a chance encounter at the clinic. The woman in *Mother and Child* (probably not the child's mother; compare plate 68) was one of Schiele's regular models in late 1910 and early 1911.

Schiele's feelings about motherhood were exceedingly complex. He had a poor relationship with his own mother, who tended to whine about his failure to fulfill his filial obligations rather than support him in his artistic pursuits. From Schiele's point of view, his mother—for that matter, any mother—was little more than a useful expedient, a means to an end. It was the child who represented life and the creative spirit, as the artist confirmed in his 1911 painting *The Birth of Genius (Dead Mother II)* (fig. 75). Typically, Schiele in this painting took a traditional subject from German art (one thinks of Max Klinger's well-known etching *The Dead Mother*) and endowed it with intensely personal significance.

Mothers, dead and alive, figure prominently in Schiele's work in late 1910 and 1911, and there may have been reasons for this above and beyond maternal rejection. Shortly after the artist left for Krumau in May 1910, one of his girlfriends, evidently pregnant, was admitted to Graff's clinic. Did *Mother and Child* depict Schiele's own offspring? Or was he, in this and related works, attempting to come to terms with an abortion? For an artist who made a direct connection between creativity and birth, who believed that "Life means sowing seed," either situation would have had profound emotional ramifications.

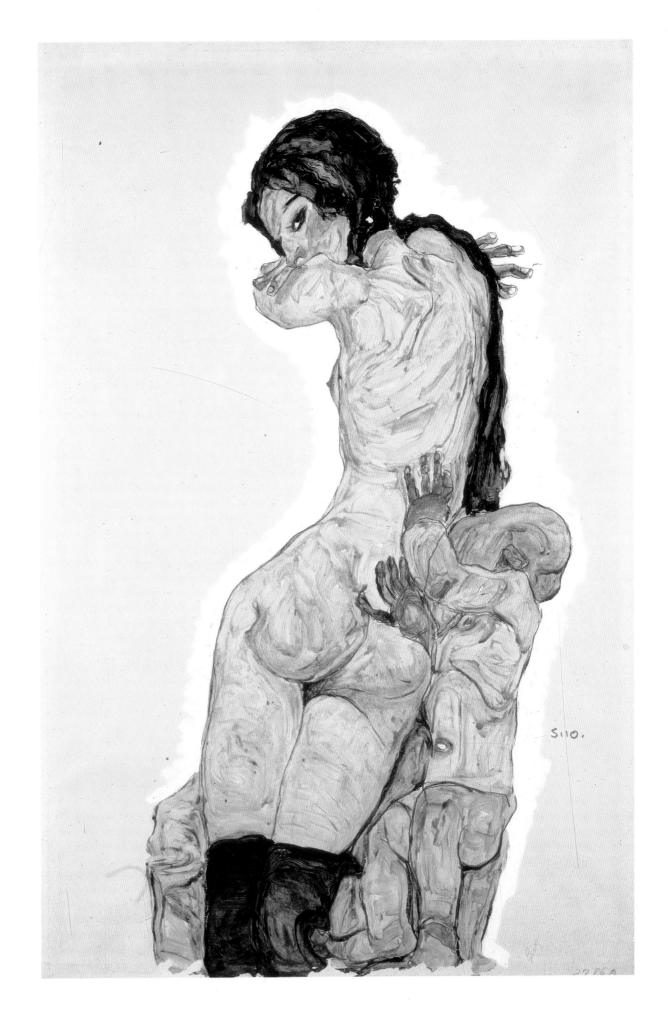

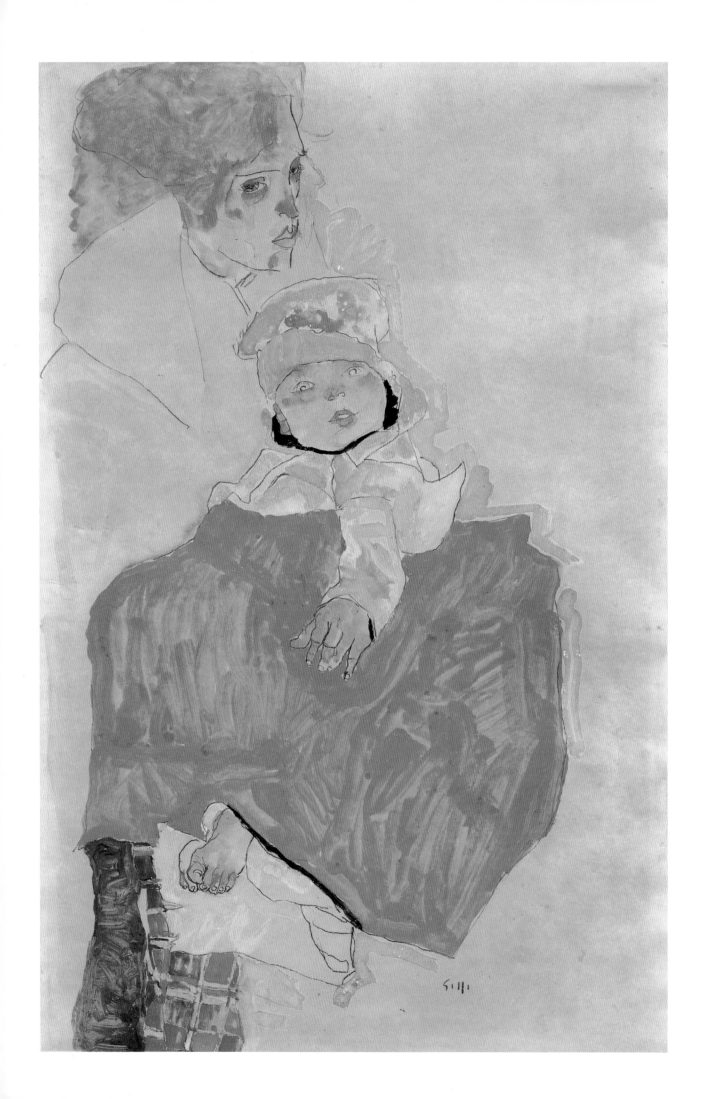

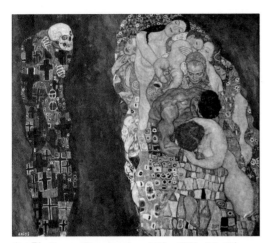

fig. 76. Gustav Klimt. *Death and Life*. 1911–15. Oil on canvas. 70⅛ × 78" (178 × 198 cm). Novotny/Dobai 183. Private collection

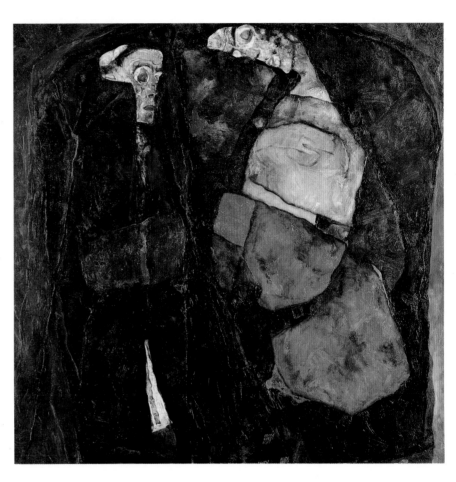

opposite
plate 68. *Mother and Child*. 1911. Gouache and pencil on paper. Initialed "S." and dated, lower right. 21¼ × 13¾" (54 × 35 cm). Kallir D. 751. Private collection

above right
plate 69. *Pregnant Woman and Death (Mother and Death)*. 1911. Oil on canvas. Signed and dated three times, lower center. Verso: inscribed "Schwangere und Tod M.2000" by another hand, on the stretcher, and stamped twice, "Moderne Galerie." 39½ × 39⅜" (100.3 × 100.1 cm). Kallir P. 202. Národní Galerie, Prague; Inv. 0-4396

Pregnant Woman and Death (plate 69) relates directly to three paintings by Gustav Klimt, *Hope I*, *Hope II*, and the slightly later *Death and Life* (fig. 76). The first two Klimt canvases feature a pregnant woman ("hope" or "expectation" commonly evoked the anticipatory limbo of pregnancy) discreetly accompanied by skeletal heads. This eerie combination alludes to the life-threatening potential of pregnancy at the turn of the century, as well as serving as a reminder that we are all, from birth onward, destined to die. *Death and Life* presents the latter message more explicitly by juxtaposing a cloaked death figure with a teeming tower of humanity.

Klimt's pairing—death to the left, life to the right—is reprised in *Pregnant Woman and Death*, though it is not certain that Schiele knew *Death and Life*, a work recently completed in 1911 (it was later modified). As in many of his allegories, Schiele here chose to focus on an emblematic coupling: a confrontation between the flesh and an otherworldly power. In the roughly contemporaneous Self-Seers paintings (see plate 53 and fig. 72), the artist appears inspired as well as haunted by a ghostly double that is both a life and a death force. His pregnant woman, by contrast, encounters death passively, in a sort of stupor. (Preliminary studies depict various models, including Schiele's mother, asleep.) Like the "dead mother" (see plate 67 and fig. 75), she has already fulfilled her mortal purpose; the future—all that counts—lies in her womb.

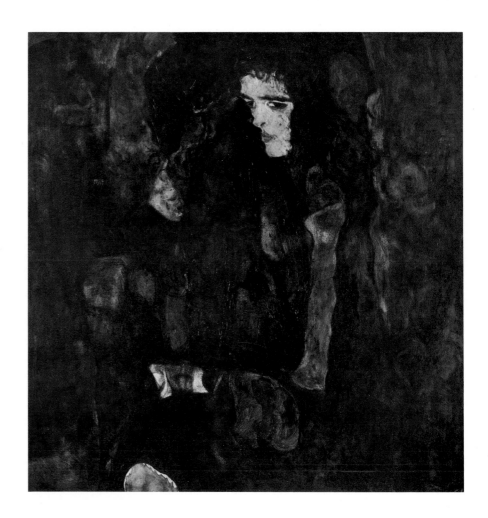

fig. 77. *Black Girl (Girl in Black)*. 1911. Oil on canvas. 39⅜ × 39⅝" (100 × 100.5 cm). Kallir P. 200. Present whereabouts unknown

The subject of *Girl with Black Hair*—also known as the "girl in black" and the "black girl" — is the mystery woman of 1911. Appearing in numerous studies and at least two oils (fig. 77 and Kallir P. 196), she is Schiele's most recognizable model that year, but her identity remains in question. Her narrow face and broad mouth suggest the features of Wally Neuzil, who accompanied Schiele to Krumau in May. Yet the "black girl" images are entirely different from the easily identifiable portraits of Wally executed in 1912 and later. Curiously, it is only at that time that Wally emerges with a distinct personality, suggesting that her prior relationship with Schiele was not especially deep. If the girl with black hair is indeed Wally, it may be inferred that the artist got to know his model from the genitalia on up. Given that Schiele was fully capable of capturing the specifics of a human face with a few bold strokes, the Black Girl series seems intentionally evasive: either he did not want to reveal his model's identity, or he simply did not care. In any event, the black girl is not an entirely real creature. She is rather a vessel for Schiele's musings: a sort of angel of death in the large oil, an erotic icon in studies such as *Girl with Black Hair*.

opposite

plate 70. *Girl with Black Hair*. 1911. Watercolor and pencil on paper. Signed "Schiele" and dated, lower right. 22¼ × 14¼" (56.5 × 36.2 cm). Kallir D. 858. The Museum of Modern Art, New York. Gift of Galerie St. Etienne, New York, in memory of Dr. Otto Kallir, and purchase; Inv. 607.83

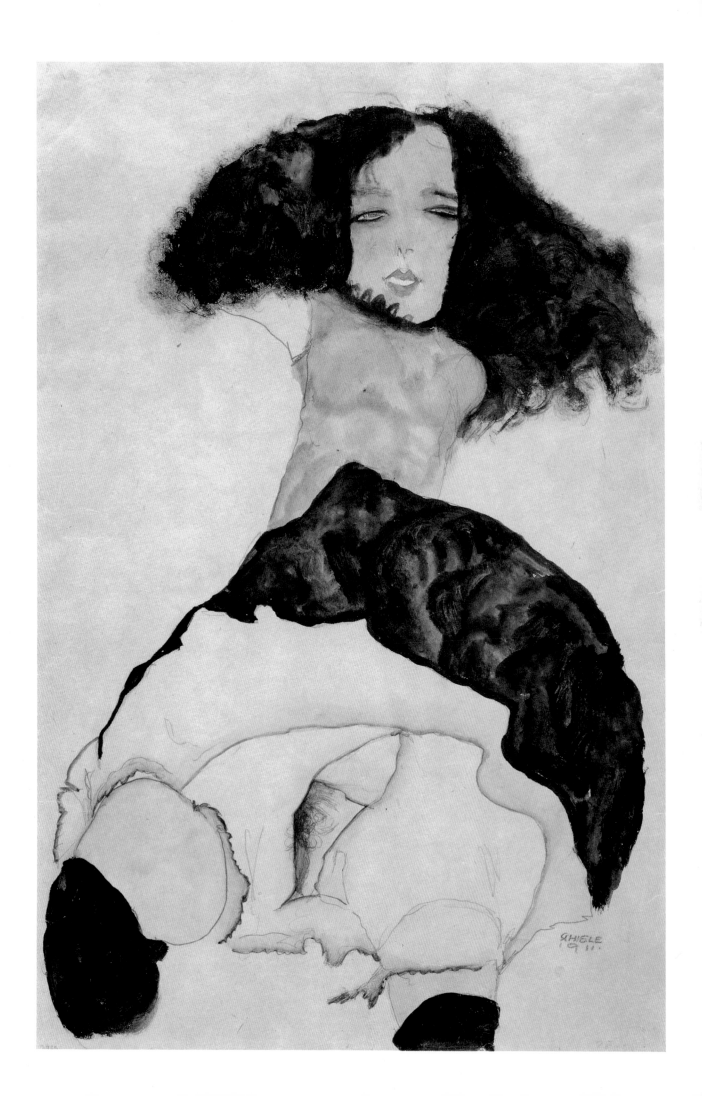

Begun and substantially completed in 1915, *Mother with Two Children III* is the last of three Schiele paintings of that title. The first, which dates to 1914, was based on Gustav Klimt's *Mother with Children* (fig. 78), and a similar compositional arrangement was carried through the entire series. However, Schiele was not really interested in Klimt's idealized conception of maternal bliss. For him, as in his prior works in this vein, motherhood was only one element in a scenario involving life, death, and the creative spirit.

Unlike many of Schiele's earlier mothers, this one is neither dead nor patently doomed. At the time, the artist's relationship with his family was improving, and he was inclined to view his mother (who posed for this painting) more charitably. Furthermore, an infant nephew had now entered his life: the son of his sister Gerti and his best friend Anton Peschka had been born toward the end of 1914 and served as model for both babies in *Mother with Two Children III*. Nonetheless, the painting can hardly be considered a family portrait. Though Schiele's orientation was conditioned by personal circumstances, his allegories were never explicitly autobiographical.

At first glance, the threesome depicted in *Mother with Two Children* seems to constitute a break from the duos that inhabit most of Schiele's allegories. However, it is still the two infants who carry the weight of the picture's message. They are, after all, a prototypical Schiele pairing, representing two antithetical and yet complementary responses to life: the one on the left passive, asleep, sightless; the other active, awake, a "seer." The mother, by comparison, fades into the background. She may not be dead, but she is exhausted. Having already performed her most important function, she survives only to nurture passively the life she has created.

The protracted genesis of *Mother with Two Children III* is an indication of the difficulty Schiele had coming to terms with the composition and its content. Although he exhibited the painting in early 1916, he subsequently continued to fiddle with it, and the 1917 signature reflects the final date of completion. The two prior versions as well as numerous sketchbook entries attempt to reconcile the artist's desire to balance the babies with a need to distinguish them typologically. In his ultimately symmetrical solution, facial characteristics rather than poses are the defining elements. The decorative patterning of the clothing and blankets further unifies the picture. The bright coloring—suggestive of a folk art influence—can be seen in many of Schiele's paintings between 1913 and 1915.

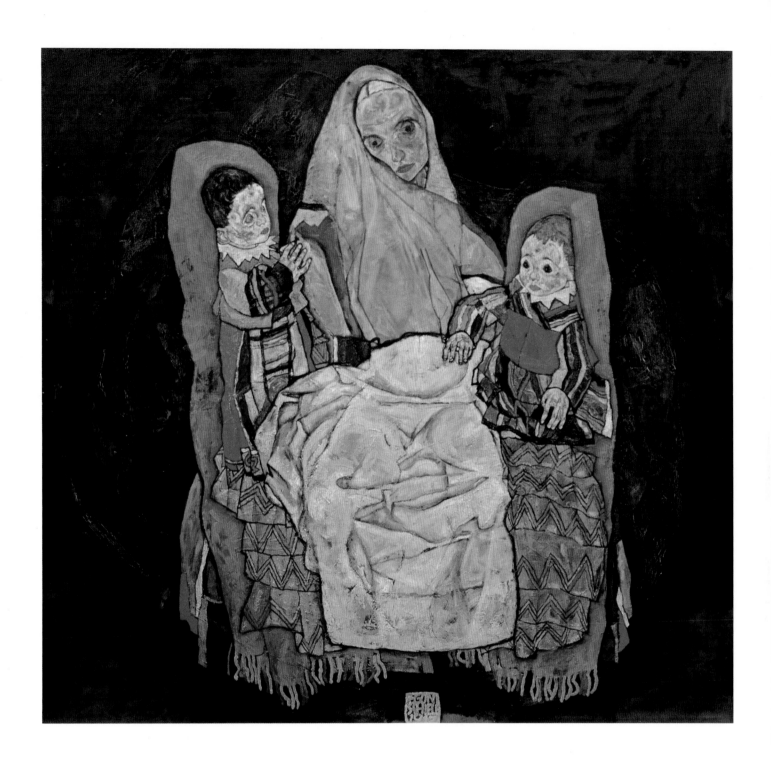

For all his experimentation with allegorically freighted couplings and his near obsession with human sexuality, Schiele evidenced remarkably little interest in mundane male-female relationships before 1913–14. *Reclining Male and Female Nude, Entwined* (plate 72) is very different from his prior depictions of heterosexual couples (to be found almost exclusively among the works on paper). For one thing, the male is no demon lover, nor a boastful self-portrait. In fact, he is the artist Felix Albrecht Harta, and Schiele's attitude to the entire scene is accordingly detached.

If Harta has just made love to his female companion, he betrays no residue of passion. The woman, whose face we do not see, may well be gazing at him in adoration, but he is definitely looking not at her but the viewer. As drawn by Schiele, the woman is scarcely more than an abstract shape. Overall, *Reclining Male and Female Nude* is a more analytically objective presentation of sexuality than has been seen in Schiele's earlier drawings. This attitude would become increasingly pronounced over the remaining course of his life.

By 1914, Schiele had reached the midpoint of his mature career. His approach to his subjects was becoming less subjective and his style more noticeably realistic, but neither development was as yet fully realized.

In *Reclining Nude with Green Stockings* (plate 73), delicately modeled flesh is played off against the more two-dimensional drapery and stockings. With the lightest touch of watercolor, Schiele traced the outlines of his figure, suggesting a bulk and volume that are further augmented by the voluptuous contours themselves. The model is something more than a sex object, something less than a full-fledged person. Her sex organs are clearly on display, nestled between the soft folds of her robe like diamonds in a jeweler's case. Yet the greater realism of Schiele's evolving style has given the model a semblance of autonomy: Schiele controls her body, but not her soul.

opposite above
plate 72. *Reclining Male and Female Nude, Entwined.* 1913. Gouache, watercolor, and pencil on paper. Signed and dated, lower left. 12⅜ × 18⅜" (31.3 × 46.7 cm). Kallir D. 1453. Graphische Sammlung Albertina, Vienna; Inv. 26.669

opposite below
plate 73. *Reclining Nude with Green Stockings.* 1914. Gouache and pencil on paper. Signed and dated, lower right. 12 × 18" (30.5 × 45.8 cm). Kallir D. 1486. Kunsthaus Zug, Collection Armin Haab

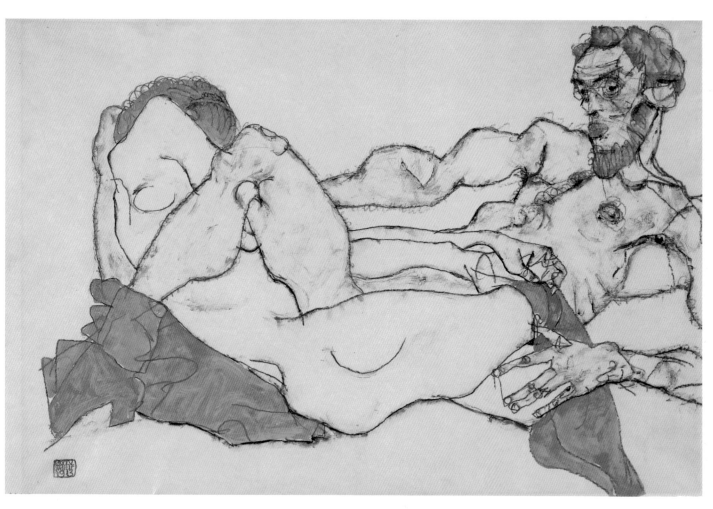

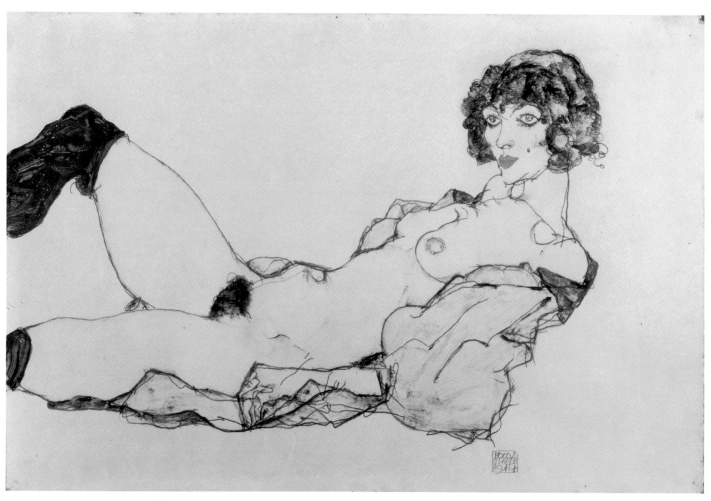

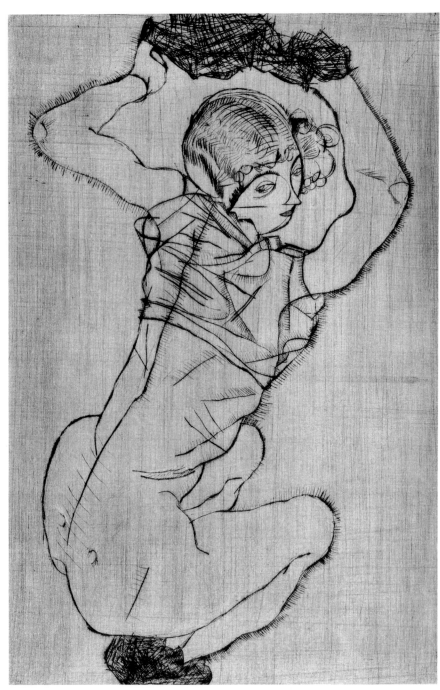

fig. 79. *Squatting Woman*. 1914. Drypoint etching.
19 × 12⅝" (48.3 × 32.2 cm). Kallir G. 6. Courtesy
Galerie St. Etienne, New York

opposite
plate 74. *Model Disrobing*. 1914. Pencil on beige wove
paper. Signed and dated, lower right. 19⅛ × 12⅛"
(48.5 × 30.8 cm). Kallir D. 1551. The Metropolitan
Museum of Art, New York. Bequest of Scofield Thayer,
1982; Inv. 1984.433.305

Though conditioned by an overriding thrust toward greater verisimilitude, some of the
experimental techniques of 1914 appear superficially radical. This is certainly true of the wild
hatching that emerged around midyear. These drawings recall the pseudoprimitivism of some of
Oskar Kokoschka's early work. However, Schiele's seemingly erratic lines (unlike Kokoschka's)
are actually busy defining three-dimensional volumes.

The bizarre seams and scars that punctuate Schiele's figure drawings in 1914 may derive from
his contemporaneous experiments with etching (compare fig. 79). Since Schiele, who had little
patience with printmaking and gave it up after a few months, never learned the more complex
techniques for transferring tone to the plate, he had to make do with line alone. Hatching is the
tried and true way to embellish an etched line and model richer forms. It cannot be determined
whether this approach—evident in Schiele's etchings—influenced his drawings, or vice versa.

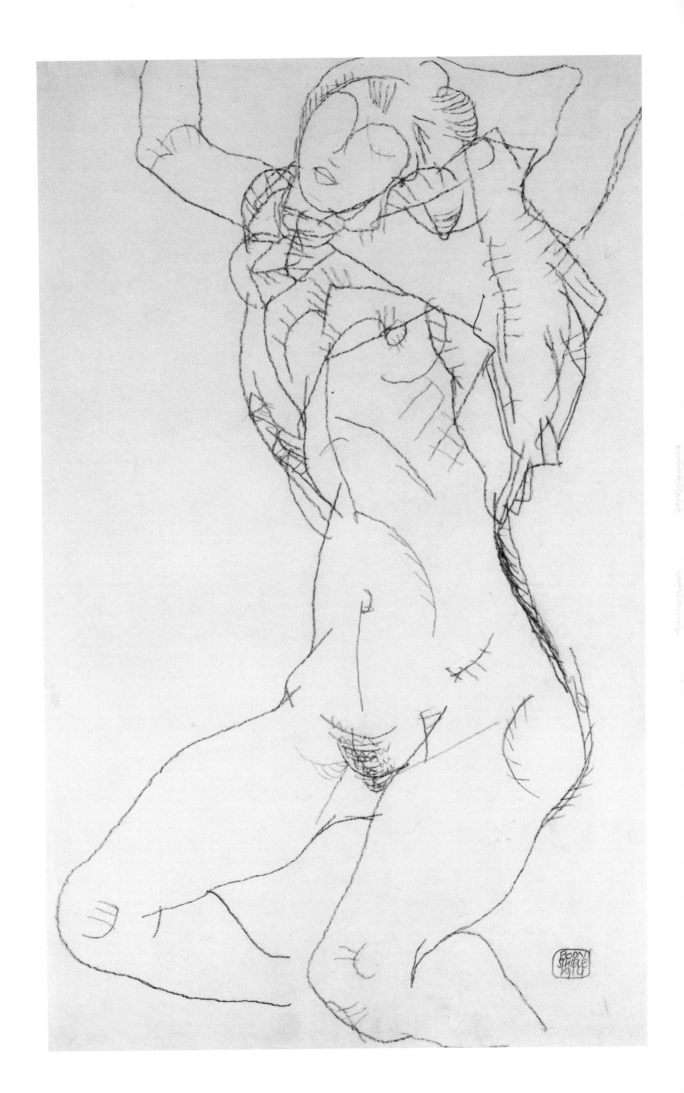

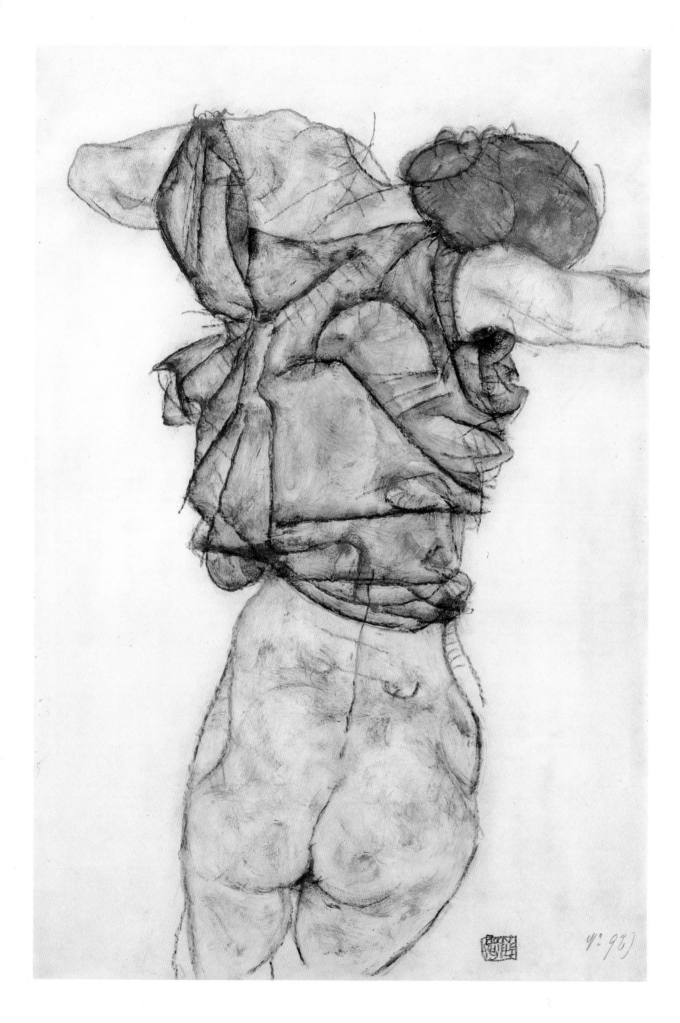

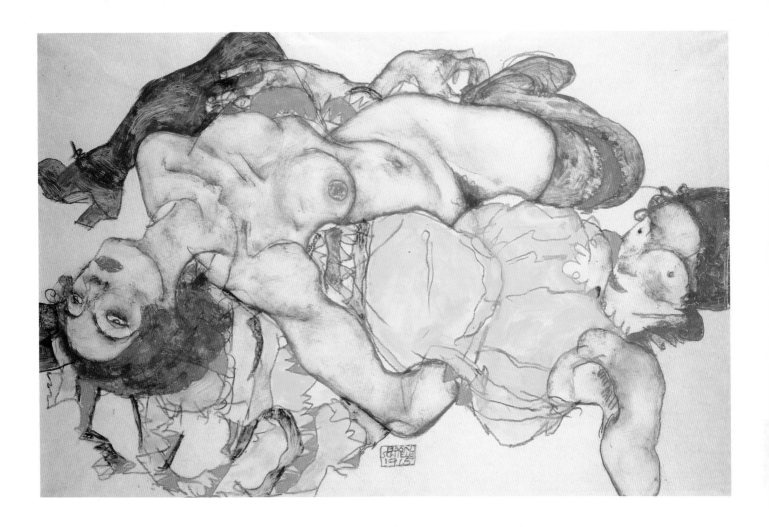

plate 75. *Woman Undressing*. 1914. Gouache and
pencil on paper. Signed and dated, lower right.
18½ × 12¾" (47 × 32.4 cm). Kallir D. 1554. Private
collection, New York

above

plate 76. *Two Girls, Lying Entwined*. 1915. Gouache
and pencil on paper. Signed and dated, lower center.
12⅞ × 19⅝" (32.8 × 49.7 cm). Kallir D. 1743.
Graphische Sammlung Albertina, Vienna; Inv. 31.173

Between 1913 and 1915, the concept of blindness permeates much of Schiele's work (see plate 64). As mooted in his description of the never-executed pendant to *Encounter* (see plate 62 and fig. 74), blindness is first and foremost an accusation hurled at a philistine public. The mother who fails to nurture her offspring is blind, as are Schiele's hypothetical disciples, whom he must lead to the light. But, increasingly, it is Schiele himself who is blinded: a humble aspirant rather than a true seer. As he attempted to emerge from the solipsism of adolescence, blindness became a metaphor for a lingering inability to establish meaningful contact with others.

It is significant that Schiele at this time was struggling toward more mature sexual relationships. Distancing himself from Wally (who, as his model and illicit lover, was by the standards of the day scarcely better than a prostitute), he was preparing to marry a bourgeois "good girl," Edith Harms. In the process, he was succumbing ineluctably to the prevalent double standard: women were sex objects or people, but not both. Yet while Schiele on one level accepted this stereotype, he did not immediately embrace it. Especially during this period, his depictions of women are extremely ambiguous.

Depicted singly, the button-eyed or eyeless nudes created by Schiele between 1914 and 1915 (see plate 74) suggest an effort to depersonalize female sexuality. On the other hand, like the blind self-portraits, these doll-like figures may symbolize a failed struggle to make human contact. Yet a third reading is suggested by *Two Girls, Lying Entwined* (plate 76). Here it is the clothed model who appears as the limp and lifeless rag doll, while the nude is fully fleshed out, vibrantly alive. What then did Schiele really want? If the bold, sensual Wally was more "real" than the chaste, genteel Edith, was he about to make a big mistake?

Seated Couple is perhaps the most poignant of all Schiele's "blind" self-portraits. The subjects are very obviously not allegorical figures but Egon and his bride, Edith. For all the stylization of her features, this Edith is a real person, with living, seeing eyes, whereas Egon lies limp and lifeless in her arms. Her embrace is one of unrequited passion, his pose that of numbed indifference or incomprehension. Significantly, Edith is fully clothed, while Egon is naked from the waist down. Is he perhaps masturbating? There is, in any case, no sexual intimacy between the two, and no tenderness beyond Edith's clinging embrace. It is Schiele's ultimate depiction of blindness as metaphor for sexual and personal alienation.

plate 77. *Seated Couple (Egon and Edith Schiele).* 1915. Gouache and pencil on paper. Signed and dated, lower center. 20⅝ × 16¼" (52.5 × 41.2 cm). Kallir D. 1788. Graphische Sammlung Albertina, Vienna; Inv. 29.766

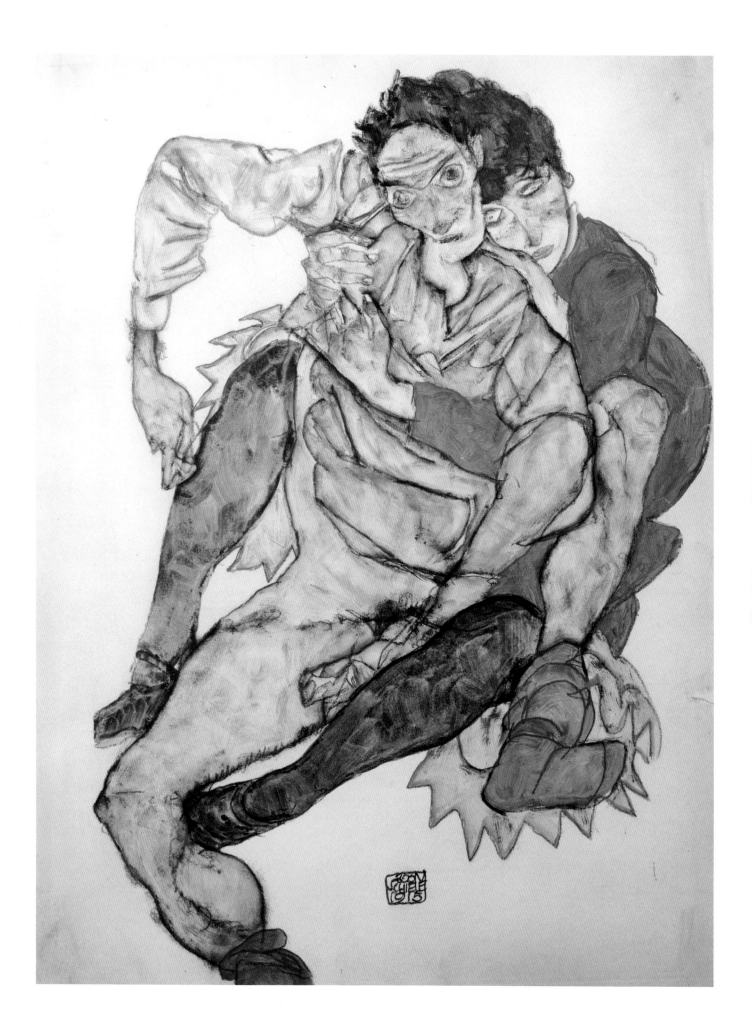

As Schiele's orientation became more objective and his style more realistic, his nudes lost something of the frenzied intensity seen earlier on. He drew a vast number of nudes during the last two years of his life, and some observers have attributed their occasionally slapdash quality to his avaricious wife, who allegedly encouraged the artist to create these works for the marketplace. This theory, however, ignores two important facts. For one thing, Edith was jealous of the naked women with whom Egon regularly associated and tried to limit such encounters. Furthermore, a full roster of models, far from being lucrative, was a costly luxury that Schiele could afford only toward the end of his life, when he for the first time experienced sustained professional success.

At long last, Schiele had attained the stature of his idol Gustav Klimt, whose harem of ready models was legendary. Like Klimt, Schiele saw the female nude as raw material necessary to the construction of his allegories. And, like Klimt, he executed sheets and sheets of studies in order to generate pictorial ideas and compositions. The results, as well as Schiele's overriding intentions, are visible in the late allegories, virtually all of which depict nudes. If the studies seem impersonal, it is because Schiele now perceived the female nude as his allegorical "everywoman."

In tandem with his changing attitude toward the female nude, Schiele had since 1914 been evolving a more representationally accurate style of rendering. His lines, formerly jagged and searching, became smooth and sure, capturing the curves of the body with unswerving accuracy. The complicated retracing, hatching, and scrolled embellishments seen in his earlier drawings were replaced by single, perfect strokes.

Color always followed line in Schiele's work. He habitually began with a base glaze of ocher or brown, which defined the principal volumes. Over this he superimposed brief dabs of brighter gouache, mapping out salient bulges and concavities and describing key protuberances, such as knuckles or cheekbones. The relatively three-dimensional approach used for the flesh and drapery contrasted with the bolder stylization of hair and stockings. In the latter areas, the flow of Schiele's brush through dense paint still shaped the surface.

The increased realism of Schiele's late work seemed to demand more conventional compositions. However, the artist was loathe to abandon the spatial transpositions that had always defined his unique approach to the recumbent model (see plate 10). As a result, there developed a disturbing tug between his voluptuous nudes and the flat, self-contained picture plane. Though the orientation of Schiele's signature commands respect, it is hard to resist viewing *Reclining Woman with Green Slippers* (plate 79) as a horizontal.

Although Schiele stressed pose and gesture at the expense of personality in many of his 1917–18 nudes, this was by no means always the case, particularly when the artist had a closer personal relationship with his model. *Female Nude* (plate 80) is one of several drawings from this period that may depict Edith Schiele. Early in the marriage, Edith had been reluctant to pose and had insisted that Egon disguise her face so that it would not be recognizable by his patrons (to whom she often had to deliver sold sheets). This study, however, contrasts sharply with those earlier drawings in its direct, unswerving gaze and uninhibited genital exposure. Certainly Edith was not happy about being depicted in this manner. This model, unlike most of Schiele's nudes, is not a mere object of delectation, nor did the artist shy away from depicting her evident feelings.

opposite above
plate 78. *Female Nude with Black Stockings*. 1917. Gouache and black crayon on beige wove paper. Signed and dated, lower right. 18⅛ × 11⅝" (46 × 29.6 cm). Kallir D. 1931. The Metropolitan Museum of Art, New York. Bequest of Scofield Thayer, 1982; Inv. 1984.433.316

opposite below left
plate 79. *Reclining Woman with Green Slippers*. 1917. Gouache, watercolor, and black crayon on paper. Signed and dated, lower right. Verso: Austrian export stamp. 18⅛ × 11¾" (45.9 × 29.8 cm). Kallir D. 1925. Private collection, courtesy Richard Nagy, London

opposite below right
plate 80. *Female Nude*. 1917. Black crayon on paper. Signed and dated, center right. 18⅛ × 11⅝" (45.9 × 29.6 cm). Kallir D. 1980. Národní Galerie, Prague; Inv. K-17862

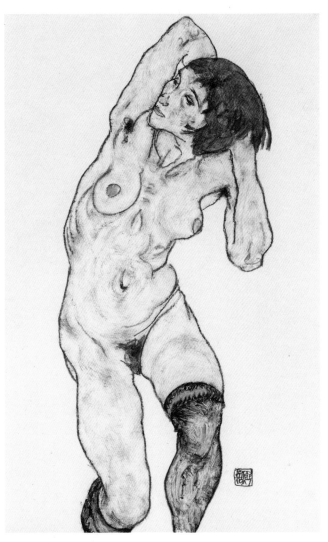

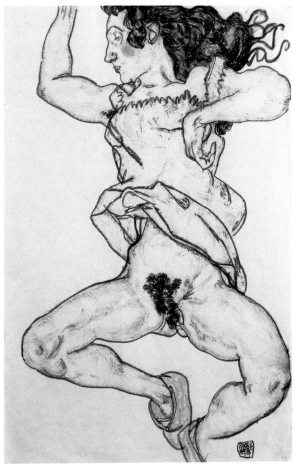

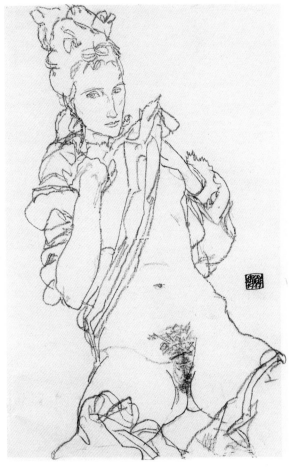

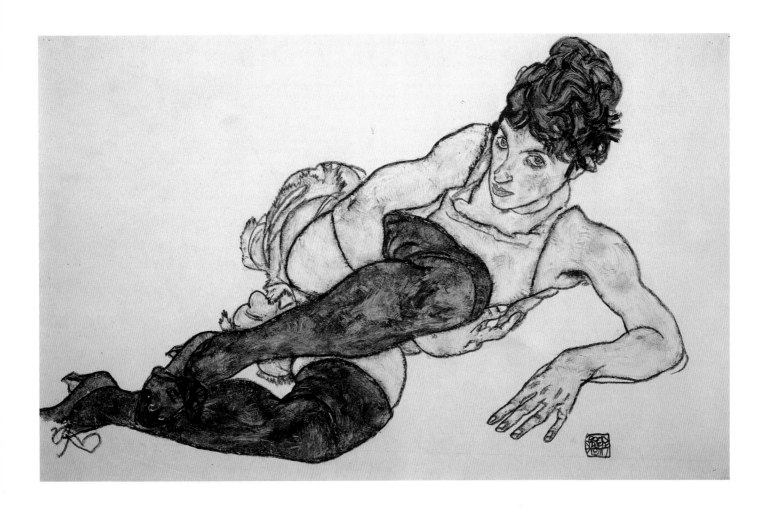

In 1917, after a year as a soldier in the Austrian countryside, Schiele returned to Vienna and resumed contact with many of his old acquaintances. Foremost among these was his sister-in-law, Adele Harms, whom he had once courted. Adele, a notoriously unreliable witness, later claimed to have had an affair with her brother-in-law at this time. There is no doubt that she posed for him.

The similarity between Adele's face and that of her sister Edith sometimes makes it difficult to distinguish the two in Schiele's drawings. Adele's hair was darker, but the artist was not scrupulously accurate about such details. In more conventional portraits (see plate 89), the elder sister is usually differentiated by a squarish jaw and coarser features, but the stylization common to Schiele's nudes and seminudes tends to obliterate such nuances. *Reclining Woman with Green Stockings* (plate 81) has traditionally been identified as a study of Adele Harms. This theory is partly substantiated by a surviving studio photograph (see fig. 28), though it must be remembered that virtually all Schiele's models wore similar undergarments.

plate 81. *Reclining Woman with Green Stockings.* 1917. Gouache and black crayon on paper. Signed and dated, lower right. Verso: Guido Arnot collector's stamp and export stamp. 11⅝ × 18⅛" (29.4 × 46 cm). Kallir D. 1995. Private collection, courtesy Galerie St. Etienne, New York

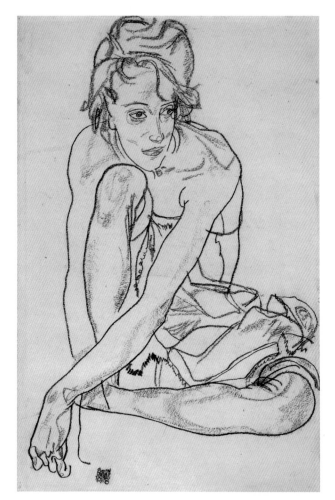

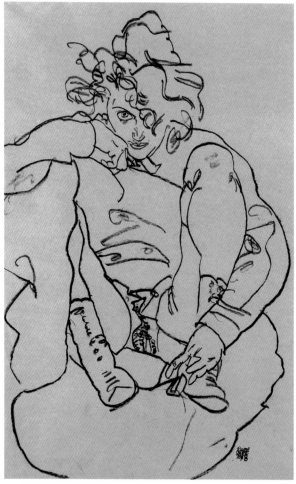

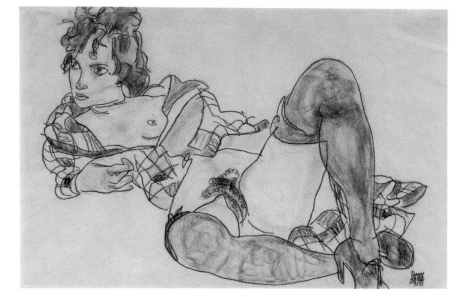

above left

plate 82. *Crouching Woman with Left Arm Forward.*
1918. Black crayon on paper. Signed and dated, lower
left. 17¾ × 11⅝" (45.2 × 29.4 cm). Kallir D. 2409.
Graphische Sammlung Albertina, Vienna; Inv. 23.526

above right

plate 83. *Squatting Woman with Boots.* 1918. Black
crayon on paper. Signed and dated, lower right.
17⅛ × 11" (43.5 × 28 cm). Kallir D. 2418. Private
collection, courtesy Richard Nagy, London

right

plate 84. *Reclining Woman.* 1918. Charcoal on paper.
Signed and dated, lower right. Verso: Schiele estate
stamp. 11⅝ × 18¼" (29.5 × 46.4 cm). Kallir D. 2427.
Private collection, courtesy Galerie St. Etienne, New York

Already in 1917, Schiele had begun to show greater interest in defining interior volumes with
crayon or charcoal. Using short thrusts or little loops, he would delineate the edge of a
collarbone, the bump of a kneecap, and similar details. Over the course of 1918, such
excursions within the contours of his drawings became more extensive. He began, at first
gingerly and then boldly, to mold vast swathes of flesh and drapery with the flat edge of his
drawing implement. At its most extreme, such modeling left no room for color, and Schiele
actually colored few of his 1918 nude studies; he had concluded that color was extraneous to the
business of drawing.

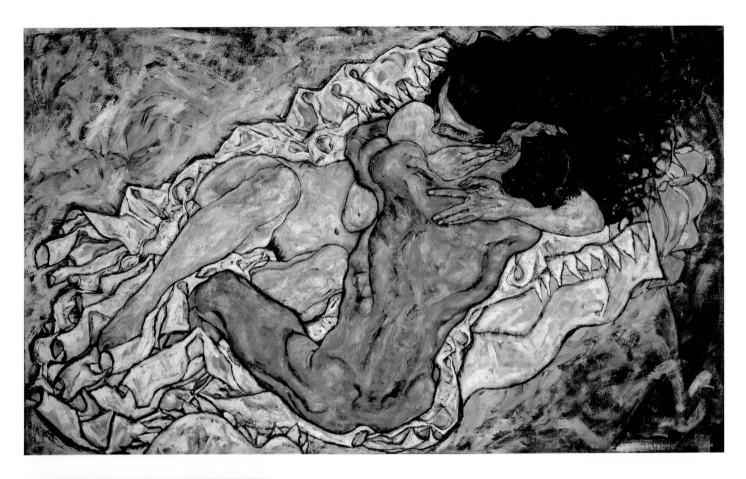

In 1914, Schiele for the first time painted a heterosexual couple unencumbered by allegorical costumes and mystical overtones (*Man and Woman I,* Kallir P. 275). Such subjects had since recurred sporadically in his work, but only in 1917–18 did they become a significant element in the figural oils. *Embrace* (plate 85) is in some ways the most conventional and least ambiguous of Schiele's representations of couples. Recalling Oskar Kokoschka's well-known 1914 painting *The Tempest* (fig. 80), it depicts love as a refuge from the turmoil of external events. The totemic melding of the lovers also brings to mind Gustav Klimt's famous *Kiss* of 1907–8.

The womblike blanket that envelops the protagonists of *Embrace,* like Schiele's theme itself, dates back to about 1914. The blanket serves both a symbolic function—isolating and protecting the central characters—and a structural one—mediating between the realistically modeled figures and a more abstract surround. The figure-ground dichotomy was a central paradox in Klimt's work, and it caused even greater problems for his disciple Schiele. Having dispensed with Klimt's decorative framework, the younger artist had to find a replacement—in essence, to create a new aesthetic world for his allegorical figures to inhabit. Neither the completely blank voids of 1910 (see figs. 56 and 58) nor the various geometric patterns encountered later on (see plate 69 and fig. 64) really seemed to do the trick. The unified painterly treatment of figure and background in *Embrace* is by comparison more successful, and it presages a new phase in Schiele's development.

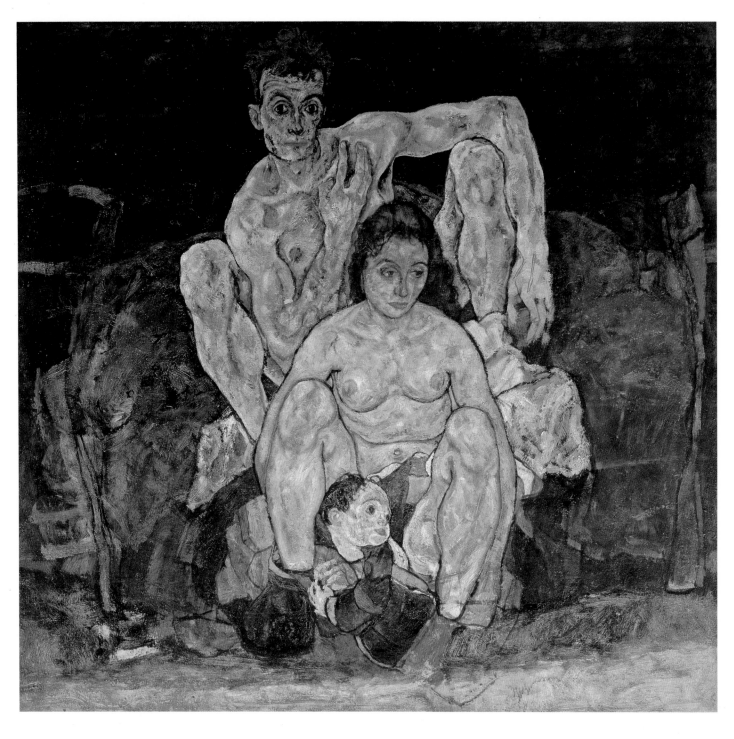

plate 86. *The Family (Squatting Couple).* 1918. Oil on canvas. 60 × 64" (152.5 × 162.5 cm). Kallir P. 326. Österreichische Galerie, Vienna; Inv. 4277

The Family (plate 86) is the culmination of Schiele's lifelong allegorical concerns, embedding as it does the regenerative mother-child cycle (compare plate 71) within a destructive male-female pairing (compare plate 77). As in prior allegories, the man (actually a self-portrait) is both a life-giver and a life-taker. Above all, he is a godlike creator, a "sower of seed." The female, typical of the bland "everywoman" who inhabits the artist's 1917–18 paintings, is an empty vessel, a means to an end. As in Schiele's prior depictions of mothers, it is the infant who represents the creative goal. The nested figures thus evoke an endless sequence of birth, life, and death.

Some have purported to read autobiographical significance into *The Family*, for in 1918 Egon and Edith Schiele were expecting their first child. However, the painting was completed before Edith learned of her pregnancy, and she was most definitely not the model for the woman. This is not a depiction of a real relationship, for there is no contact or rapport among these people. Only the self-portrait is truly animated; the other two figures are wholly symbolic.

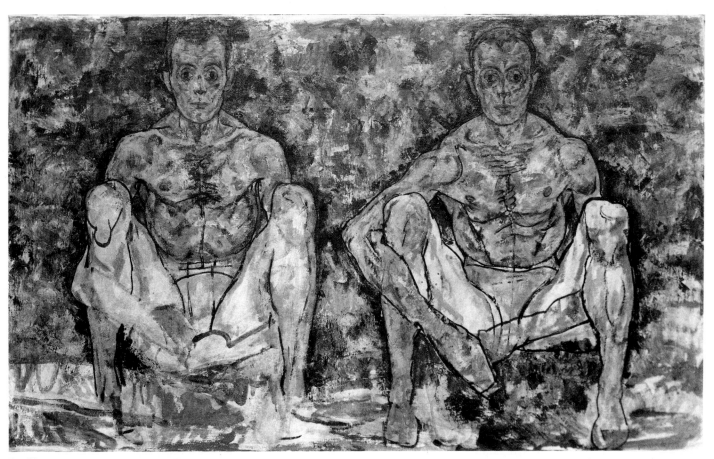

fig. 81. *Two Squatting Men (Double Self-Portrait)*. 1918.
Oil on canvas. 39⅜ × 67⅜" (100 × 171 cm). Kallir P.
328. Private collection

opposite
plate 87. *Crouching Male Nude (Self-Portrait)*. 1917.
Gouache, watercolor, and black crayon on paper.
Signed and dated, lower right. Study for *The Family*
(Kallir P. 326); related to *Two Squatting Men* (Kallir P.
328). 18 × 11½" (45.8 × 29.1 cm). Kallir D. 2123.
Graphische Sammlung Albertina, Vienna; Inv. 31.106

Following his marriage in 1915, Schiele all but abandoned self-portraiture. However, toward the end of his life, he did return to the subject, albeit with less intensity than in his early twenties. He was now no longer concerned with self-exploration but rather with transforming his own image and experiences into universal statements. Over the years, he had been evolving a simplified repertory of poses—standing, reclining (or floating), and crouching—that came to dominate his last allegories. The simian squat of *Crouching Male Nude* (plate 87), which can be traced back to a pair of 1912 watercolors (Kallir D. 1166 and 1167), is the dominant pose of *The Family* (see plate 86) as well as of the unfinished painting *Two Squatting Men* (fig. 81).

Crouching Male Nude derives its fullest meaning only from the context provided by the oil paintings to which it relates. In *The Family*, the pose is protective and encircling, whereas in *Two Squatting Men*, it evokes self-containment and isolation. It is probable that Schiele intended these two paintings, as well as the closely allied *Two Squatting Women* (Kallir P. 327), to be viewed as a group. He was, at the time, working on panels for a self-styled mausoleum; the three canvases in question were probably part of a series depicting "earthly existence." Though Schiele died before the mausoleum could ever be realized, the project encapsulated his new allegorical vision. In these last works, he entirely abandoned the elaborate costume dramas—the cloaked monks and saints—of his earlier period in favor of monumental, emblematic nudes.

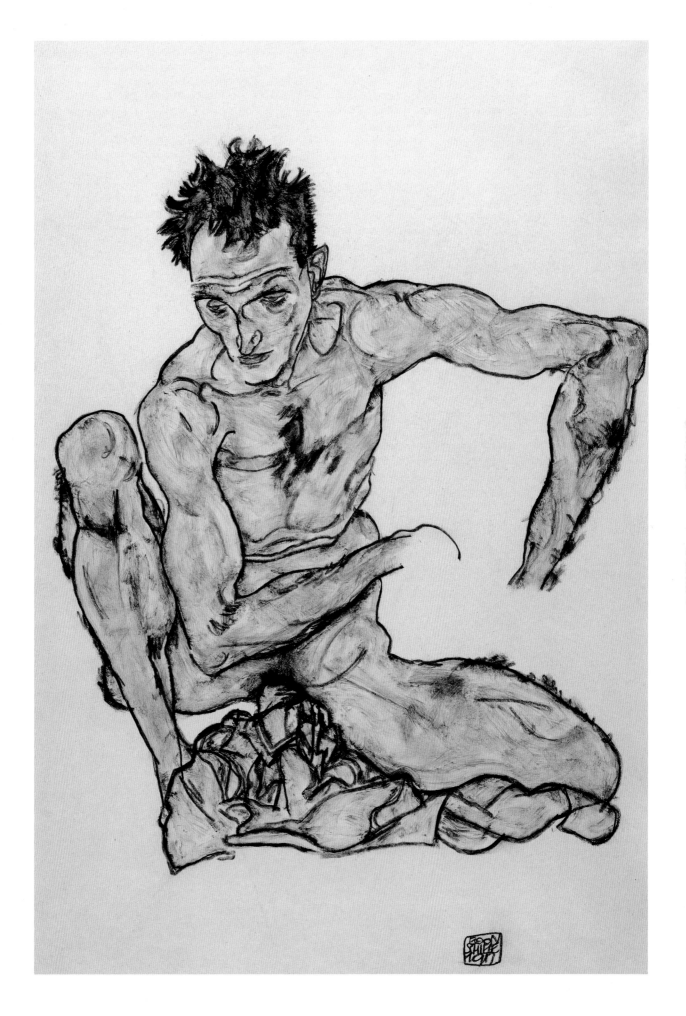

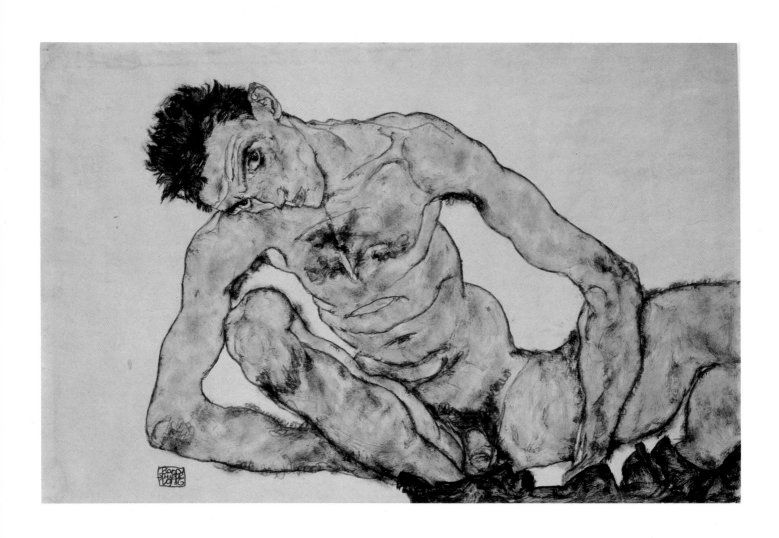

plate 88. *Nude Self-Portrait, Squatting.* 1916.
Watercolor and pencil on paper. Signed and dated,
lower left. Related to *The Family* (Kallir P. 326).
11⅝ × 18″ (29.5 × 45.8 cm). Kallir D. 1855. Graphische
Sammlung Albertina, Vienna; Inv. 31.262

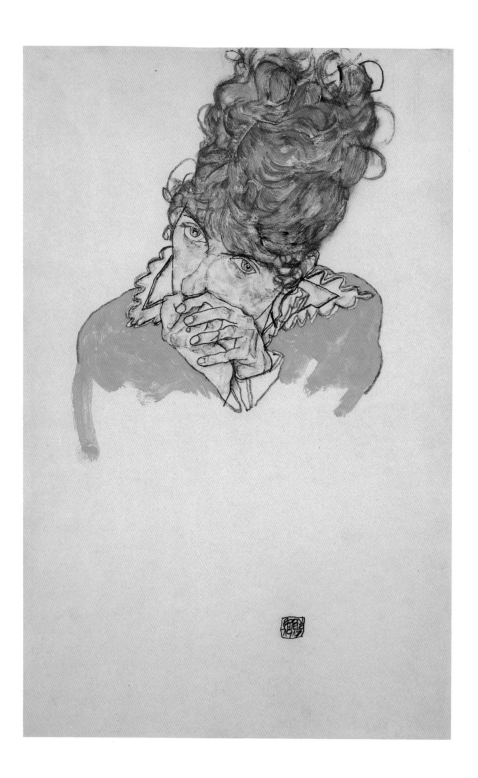

plate 89. *Portrait of the Artist's Sister-in-Law, Covering Mouth with Hands.* 1917. Gouache and black crayon on paper. Signed and dated, lower center. 16⅞ × 11" (43 × 28 cm). Kallir D. 1912. Private collection

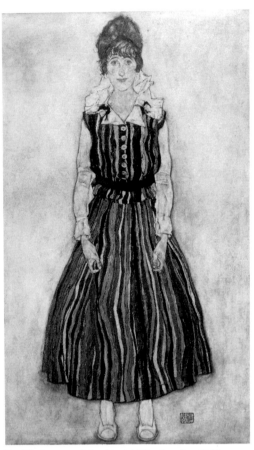

fig. 82. *Portrait of the Artist's Wife, Standing (Edith Schiele in Striped Dress)*. 1915. Oil on canvas. Verso: unfinished 1914 painting (Kallir P. 274). 70⅞ × 43¼" (180 × 110 cm). Kallir P. 290. Gemeentemuseum voor Moderne Kunst, The Hague; Inv. 18-1928

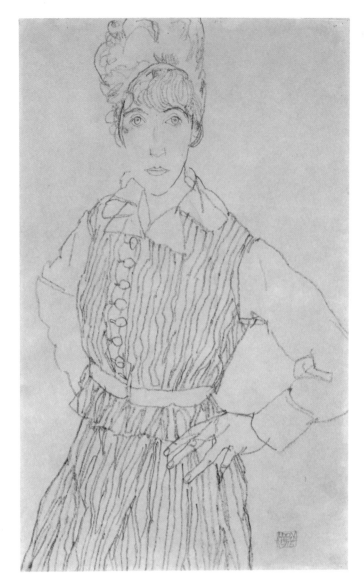

plate 90. *Portrait of the Artist's Wife, Standing, with Hands on Hips*. 1915. Black crayon on paper. Signed and dated, lower right. 18 × 11¼" (45.7 × 28.5 cm). Kallir D. 1719. Private collection

Schiele's first painting of his bride, *Portrait of the Artist's Wife, Standing (Edith Schiele in Striped Dress)* (fig. 82), contrasts sharply with the preliminary studies. As a group, these works document the troubled first months of the couple's marriage. Almost immediately after the wedding, Egon had been inducted into the Austrian Army. Though Edith followed him to basic training in Czech Bohemia, the two naturally had very little contact. The innocent flirtations whereby Edith whiled away her empty hours infuriated her husband, causing him to question her fidelity. He could not help but compare the supposedly chaste "good girl" whom he had married with the loyal Wally, his former illicit lover. It was a strange conundrum, for if Edith was not as virtuous in her outward behavior as Egon might have wanted, neither was she fully responsive in their private sexual encounters.

The vacuous, glazed stare of Edith in the oil portrait—reminiscent of the blind, doll-like beings found in Schiele's contemporaneous drawings (compare plates 74 and 76)—has long baffled observers. Was Schiele in this painting satirizing the bourgeois creature who had replaced his more sexually sophisticated lover? Was he deliberately creating an idealized virgin as a rebuke to his wife's perceived betrayal? Or did he in his heart want to believe that this pretty dolly was really Edith? In any case, the preliminary drawings (plate 90) tell a very different story from the final oil. Here one sees the true Edith: the defiant Edith, who would not be confined to a hotel room while her husband learned to be a soldier, and also the lonely Edith, who begged to be allowed to return home to her family and friends in Vienna. It is to Schiele's credit that, in his art if not in his life, he recognized and honored his wife's sensibilities.

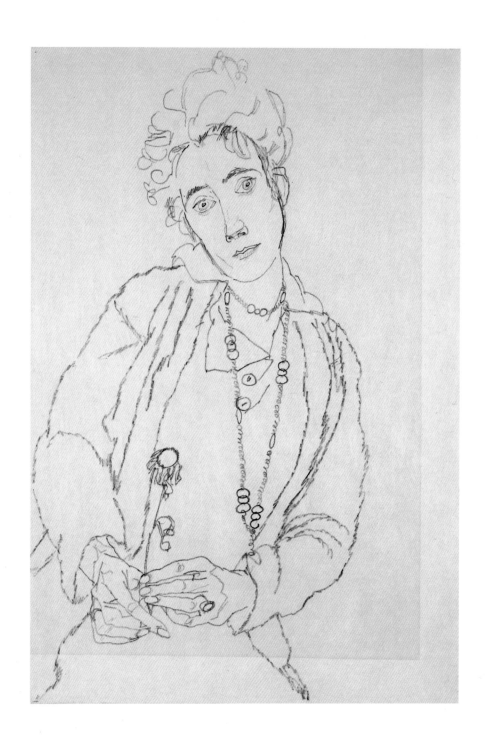

The increased naturalism of Schiele's late drawing style had varying effects on his treatment of women. While the nudes became more remote and impersonal, the portraits became more vibrant and sympathetic. Marriage encouraged Schiele to relate to women on a newly profound level. The humanism emergent in the 1915 drawings of his wife (see plate 90) would soon be evident in all his portraits.

plate 91. *Woman Holding Flower (Edith Schiele?)*. 1915. Pencil on paper. Verso: landscape study, 1915 (Kallir D. 1807). 18¼ × 12⅜″ (46.5 × 31.5 cm). Kallir D. 1715. Private collection, London

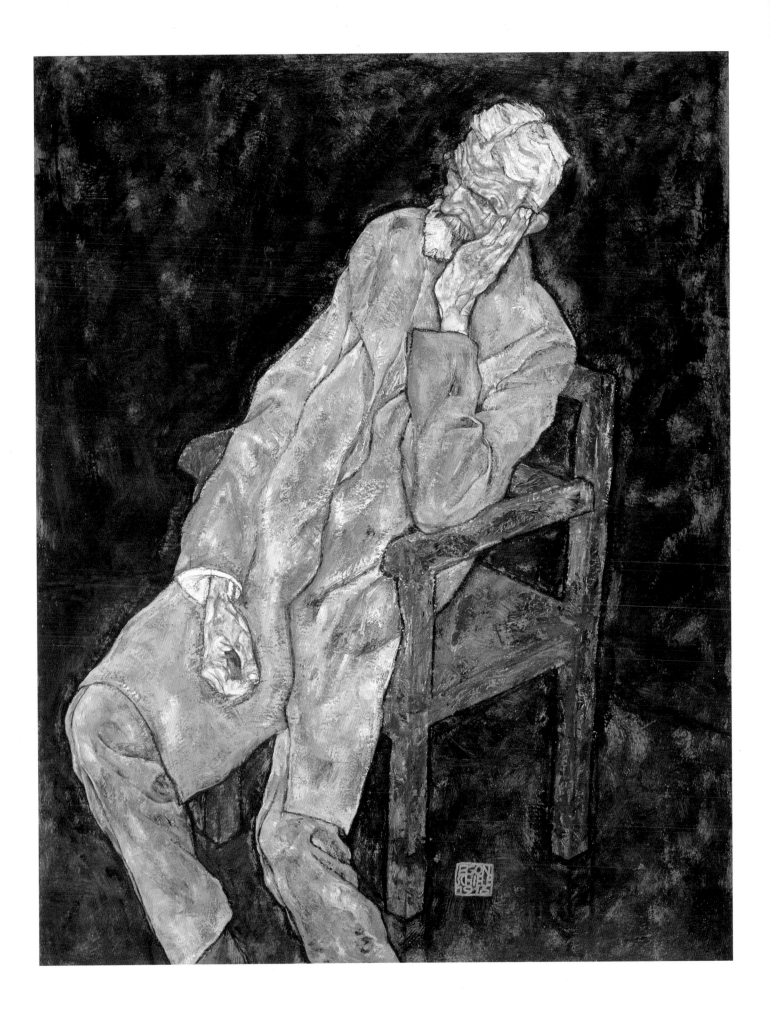

Johann Harms was a machinist with the Austrian railway, and it is noteworthy that Schiele, in marrying his daughter Edith, entered a railroading family not unlike his own. Johann, however, remains a shadowy character compared to his wife, Josefa or Josefine. It was Mrs. Harms who unwittingly brought Egon and Edith together by purchasing the house at Hietzinger Hauptstrasse 114, across from Schiele's studio. Subsequently, it was she who shaped the couple's courtship, first by forbidding the two to meet, and then by attempting to block their marriage. Her husband, though reportedly indifferent to the artist, was by comparison a sympathetic soul.

Schiele was, in any event, fond of his father-in-law, and this affection permeates the portrait. The artist painted only a handful of works in 1916, his most active period of military service. He found time to sketch Harms during the few months, around the beginning of the year, when he was stationed near his Vienna studio. The oil (plate 92), largely completed in April, introduces elements that reappear in many subsequent portraits. The squat studio chair suggests a space far more substantial and real than Schiele's customary background void (compare plate 31), and the sideways, slumping pose is distinctly different from the earlier head-on approach. Combined with the enhanced verisimilitude of the artist's mature style, these elements help to distance the sitter from Schiele's psychic preoccupations. Harms inhabits his own world, upon which we and the artist intrude as spies. Unaware of our presence, he is submerged in his own thoughts and, above all, in the weariness of old age: His meager contact with reality, the chair, is insufficient to hold him. He slides forward, into the abyss and toward the death that will claim him within a year's time. When Harms died in January 1917, Schiele took his death mask.

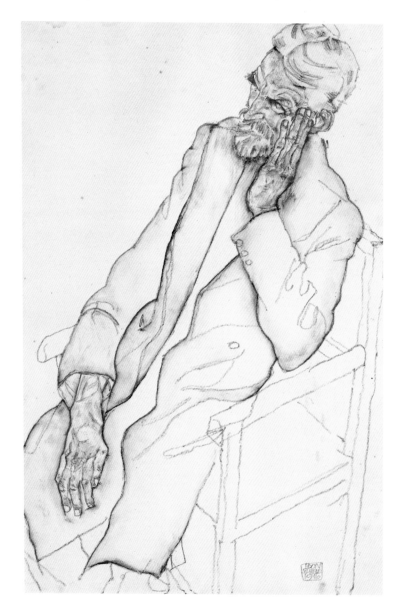

opposite

plate 92. *Portrait of Johann Harms.* 1916. Oil on canvas. Signed and dated, lower center. 54½ × 42½" (138.4 × 108 cm). Kallir P. 300. Solomon R. Guggenheim Museum, New York. Partial Gift, Dr. and Mrs. Otto Kallir, 1969; Inv. 69.1884

plate 93. *Portrait of Johann Harms.* 1916. Gouache, watercolor, and pencil on paper. Signed and dated, lower right. Verso: inscribed "Herr Harms, Schieles Schwiegervater, 10. IX. 16" by Heinrich Benesch. Study for *Portrait of Johann Harms* (Kallir P. 300). 19 × 14⅜" (48.2 × 36.4 cm). Kallir D. 1844. Private collection

The marriage, in 1914, of Schiele's favorite sister and sometime model, Gerti (see plates 3, 4, and 7), to his best friend, Anton Peschka, was a minor watershed in the artist's life. It was no coincidence that in the wake of this event, he stepped up his courtship of Edith Harms, marrying her within a year. The birth of the Peschkas' first son, Anton, Jr., likewise prompted Schiele to think more seriously about family and his future.

Schiele had always liked and identified with children (see plates 12–16), though after his prison ordeal (see plates 55 and 56) he seldom drew or painted them. He therefore naturally welcomed the opportunity to return to this favorite subject within the safety of his own family; almost immediately after his nephew's birth, Schiele began drawing and painting the infant (see plate 71). Military service then temporarily separated Schiele from his sister's orbit, and when he returned to Vienna in 1917, he found that Anton, Jr., had become a strapping toddler. The present work is the most complete extant study for an oil portrait that Schiele did not live to finish (Kallir P. 318). The dress worn by the little boy has caused some confusion among modern-day viewers, but it was in fact customary in Schiele's time to dress very young children of either gender alike.

plate 94. *Portrait of Anton Peschka, Jr., the Artist's Nephew.* 1917. Gouache, watercolor, and black crayon on paper. Signed and dated, lower right. 15 × 10¼" (38 × 26 cm), sight. Study for *Portrait of a Boy II (The Artist's Nephew, Toni)* (Kallir P. 318). Kallir D. 1881. Private collection

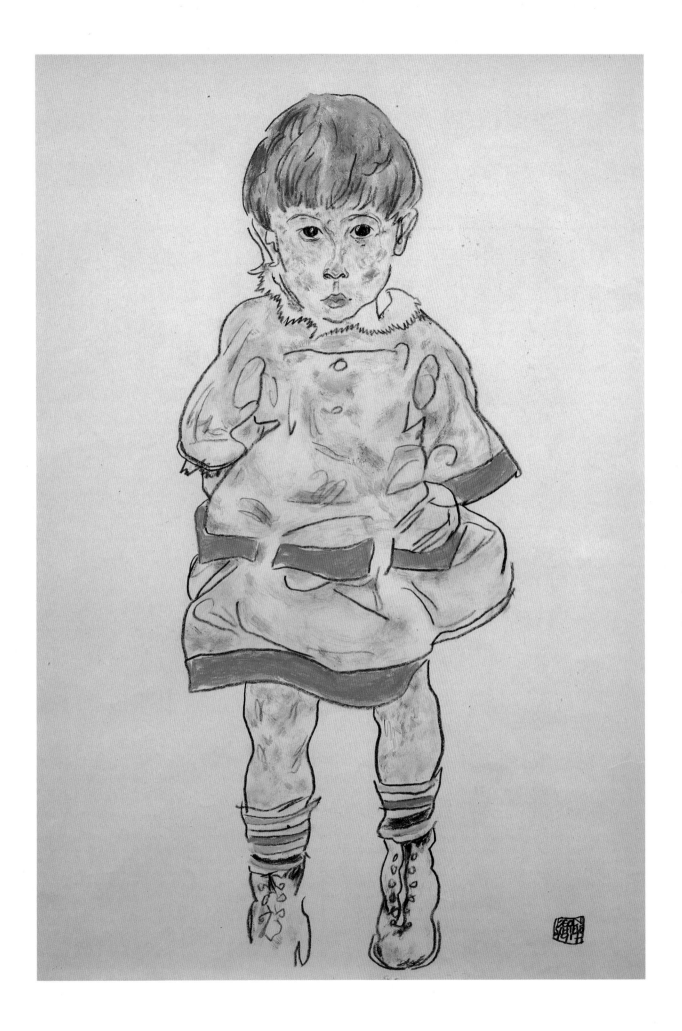

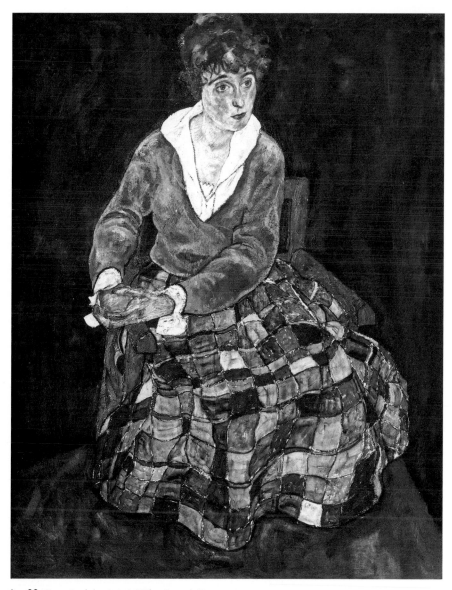

Schiele may have begun work on his second and final oil portrait of his wife (plate 95) in early 1917. Purchased at his March 1918 Secession exhibition by the dealer Gustav Nebehay and subsequently resold to the Staatsgalerie (today Österreichische Galerie), it became the first Schiele painting to enter an Austrian museum. The museum's director, Franz Martin Haberditzl, who had earlier bought a selection of the artist's drawings, suggested that certain modifications be made to the canvas. The originally checkered skirt (fig. 83), which Haberditzl supposedly found too decorative, was painted over, and at the same time Schiele added the feet and altered details such as the collar.

Though one can only imagine the overall effect of the rejected portrait, the patterned skirt suggests a direct link to Schiele's first painting of Edith (see fig. 82). The more subdued palette of the revised version, on the other hand, recalls the portrait of the subject's father, Johann Harms (see plate 92). As a result of the changes, Edith's face becomes the focal point and animating spirit of the finished painting. Several years of marriage had attuned Schiele to the workings of the female psyche, and this painting, like all the artist's late portraits of women, is comparatively dignified and notably cognizant of personality.

opposite
plate 95. *Portrait of the Artist's Wife, Seated*. 1918. Oil on canvas. Signed and dated, lower left. Inscribed "Egon Schiele, Wien XIII 'Bildnis E. Sch. 1918' Privatbesitz," on the stretcher. 54⅞ × 43" (139.5 × 109.2 cm). Kallir P. 316. Österreichische Galerie, Vienna; Inv. 1991

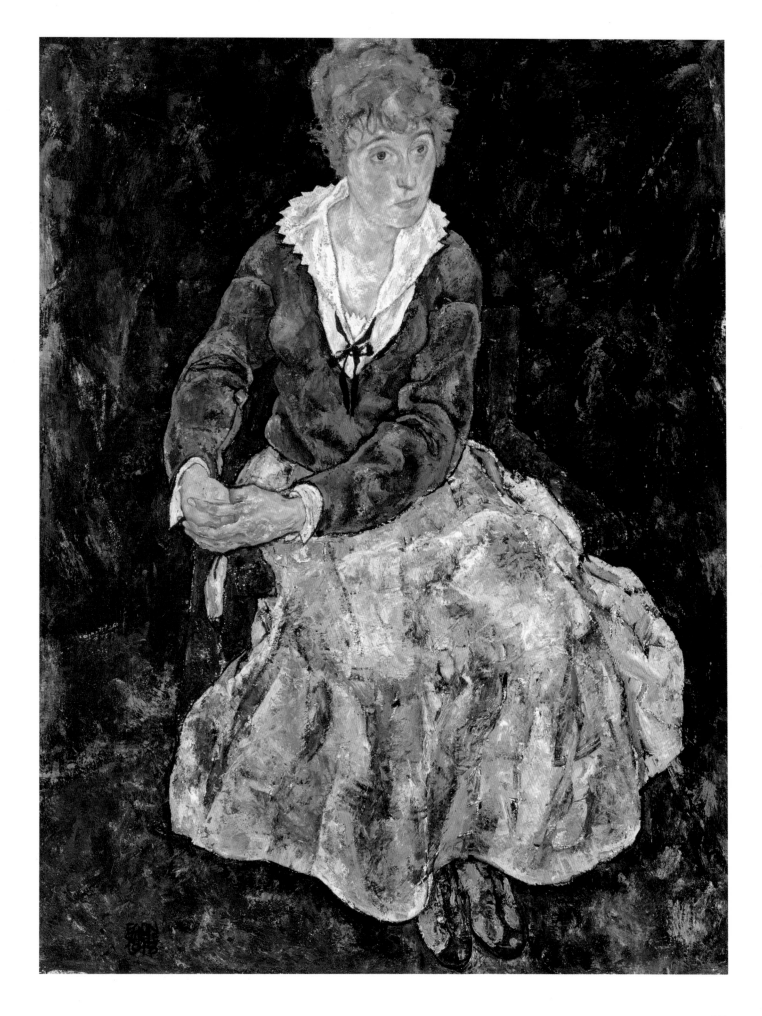

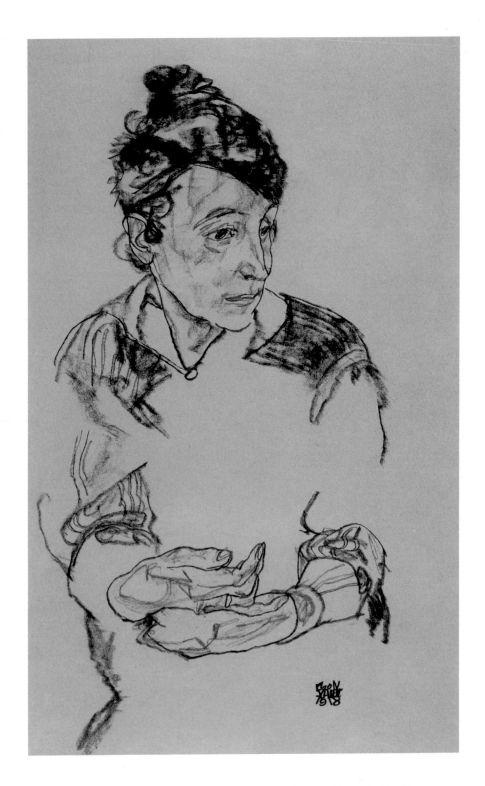

Schiele's relationship with his mother apparently improved toward the end of his life. For one
thing, she definitely approved of his nice bourgeois marriage, calling Edith "a daughter-in-law
such as I had dreamed of."[1] Furthermore, as Egon began to achieve a modicum of success—
and, not coincidentally, to aid her financially—she became more tolerant of his professional
vocation. Marie Schiele (who in truth had a good deal in common with her daughter-in-law) was
a relatively shallow and pedestrian woman, but certainly not the personification of evil that
Schiele had previously imagined. His ultimate portrait of her (plate 96)—done in the heavily
worked charcoal typical of his very last drawings (compare plate 84)—is bluntly honest but not
unsympathetic.

[1] Marie Schiele, in Christian M. Nebehay, *Egon Schiele, 1890–1918: Leben, Briefe, Gedichte* (Salzburg:
Residenz, 1979), no. 1003.

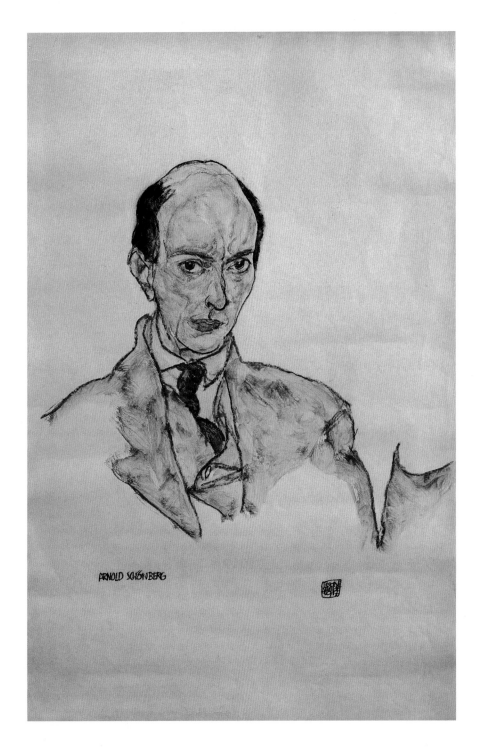

plate **97.** *Portrait of Arnold Schönberg with Left Arm Raised.* 1917. Gouache, watercolor, and black crayon on paper. Signed and dated, lower right. Inscribed "Arnold Schönberg," lower left. 18⅛ × 11⅝" (46 × 29.5 cm). Kallir D. 2086. Private collection

For the first time in 1917, Schiele began to assume a genuine leadership position within the Viennese art community. With an eye to the looming postwar era, he hoped to found a Kunsthalle, which he envisioned as a multifaceted venue for the display of contemporary art, the performance of modern music, and the publication of literary works. Though this venture quickly foundered for lack of financial support, Schiele managed to enlist some illustrious collaborators, among them Gustav Klimt, Josef Hoffmann, the poet Peter Altenberg, and the composer Arnold Schönberg.

Schiele's portrait studies of Schönberg (of which four are known; see plate 97) undoubtedly originated as a result of their Kunsthalle discussions in March 1917. It is likely that Schiele suggested the sittings, for Schönberg could not afford to commission a portrait and never owned any of the drawings. Furthermore, it appears he was a reluctant subject, for later Schiele had to urge him to resume posing. Whether or not he acceded to this request is unknown. Sketchbook notations suggest that Schiele wanted to paint an oil, but matters never progressed to that stage.

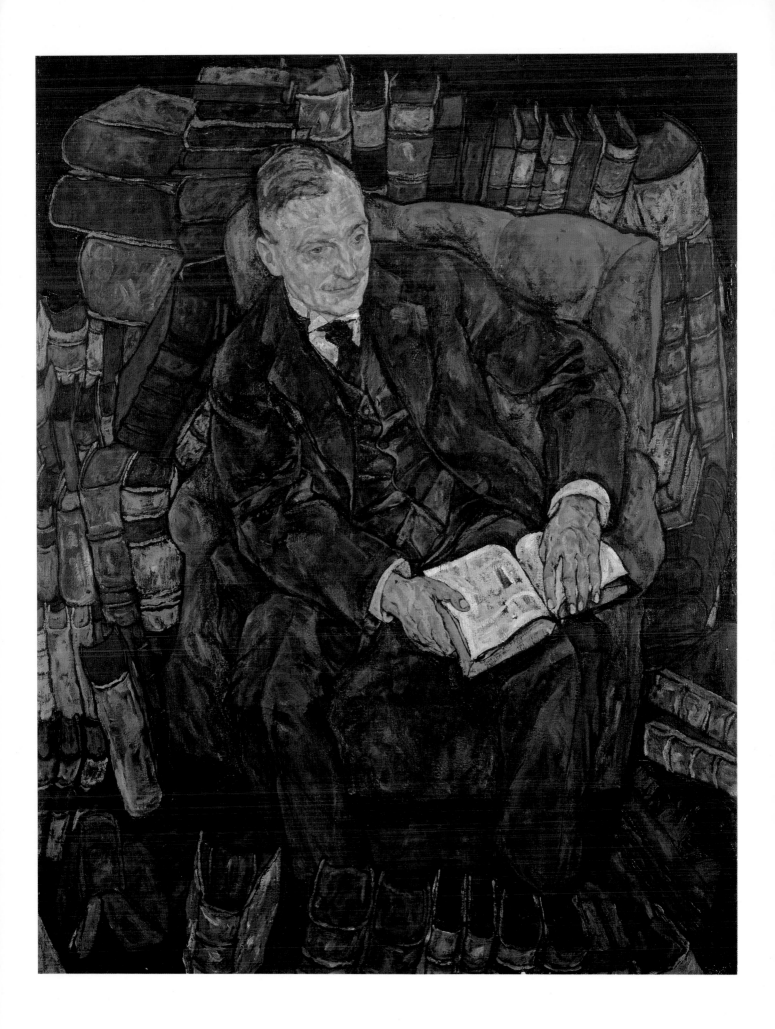

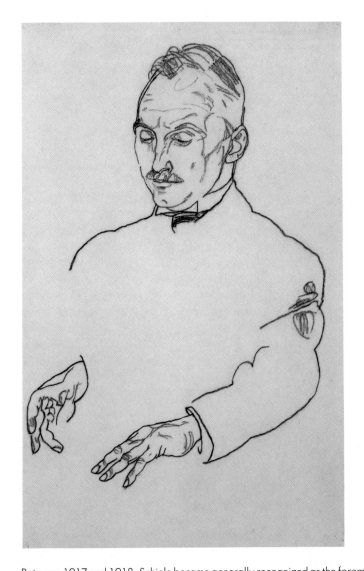

plate 98. *Portrait of Dr. Hugo Koller.* 1918. Oil on canvas. Inscribed "Egon Schiele, Wien XIII 'Bildnis Dr. K.' 1918" and, by another hand, "Dr. Hugo Koller, Privatbesitz, Wien IV, Argentinierstr. 26" on the stretcher. 55¼ × 43⅛" (140.3 × 109.6 cm). Kallir P. 320. Österreichische Galerie, Vienna; Inv. 4296

plate 99. *Portrait of Dr. Hugo Koller.* 1918. Black crayon on paper. Verso: inscribed "Ich bestätige, daß die umstehende Kreidezeichnung von Egon Schiele als Vorstudie für das Porträt meines Vaters Dr. Hugo Koller (Österr. Galerie) geschaffen wurde, 28. 12. 57, Rupert Koller," by the sitter's son. Study for *Portrait of Dr. Hugo Koller* (Kallir P. 320). 18⅝ × 11¾" (47.2 × 29.8 cm). Kallir D. 2468. National Gallery of Art, Washington, D.C. Rosenwald Collection; Inv. 1964.8.1532

Between 1917 and 1918, Schiele became generally recognized as the foremost artist then living in Austria, yet the professional options open to him were not substantially better than they had been at the beginning of the decade. Vienna still did not have a robust network of galleries specializing in contemporary art, and Schiele was—despite or because of his experiences in that vein—categorically opposed to the capitalistically motivated interventions of the commercial dealer. So it was that, to the end of his days, he preferred to maintain direct contact with his patrons, and as he became increasingly well-established, his portrait commissions multiplied accordingly.

Hugo Koller was a wealthy industrialist and an erudite scholar whose wife, Broncia Koller Pinell, was one of the best female artists of her day. (Her early work can easily hold its own next to that of such better known Secessionists as Carl Moll and Koloman Moser.) During the summer of 1918, Schiele frequented the Kollers' summer home in Oberwaltersdorf, where he drew their two children, Silvia (also an artist) and Rupert. The painting of Hugo, however, was probably substantially completed in May and June.

Like all Schiele's late portraits, the Koller painting (plate 98) is characterized by a greater objectivity and realism than can be found in the artist's prior work. A direct descendant of the Johann Harms portrait (see plate 92), it has the same skewed profile pose, averted glance, and mediating chair (in this case, Koller's own rather than a studio prop). In his last works, Schiele was increasingly driven to furnish the background void (one sees this as well in *The Family*, plate 86). Here, he reconstructed Koller's favorite ambiance by virtually burying him in an avalanche of books. Once again, one has the sense of peering into the sitter's private world, catching him unawares. The resultant impression of emotional distance is characteristic of Schiele's commissioned portraits.

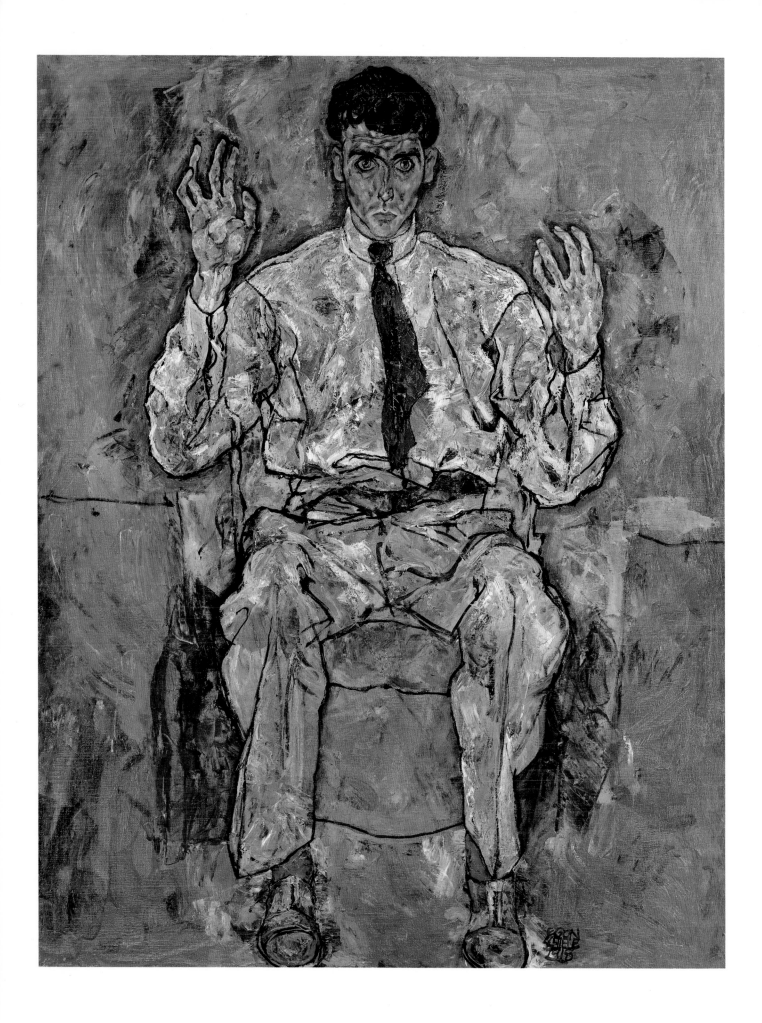

As Schiele's drawings came to rely more on contour and tone, his painting style became, paradoxically, less linear. Although an armature of line is visible to the last, it is overshadowed by an increasingly robust network of expressive brushstrokes. Schiele was finally fully capable of exploiting the traits intrinsic to oil. Rather than thinning the paint down in an attempt to mimic watercolor or pushing it around like gouache, he wielded buttery impastoes masterfully. It could almost be said that at the very moment he was becoming a classical realist in his drawings, Schiele was, for the first time, becoming a genuine Expressionist in his paintings.

In truth, many conflicting directions are suggested by Schiele's late works, and it is impossible to know which he would have pursued had he lived. *Portrait of the Painter Paris von Gütersloh* (plate 100), one of Schiele's last paintings, was probably begun in the spring of 1918, at the same time as a related lithograph (Kallir G. 16). Thought by some to be unfinished, the portrait invites several interesting hypotheses regarding the artist's aborted development.

Unlike Schiele's commissioned portraits, which can be a bit staid, the Gütersloh painting—of a longtime friend and colleague—is brimming with vitality. The direct stare of the early portraits, largely absent in Schiele's oils since 1915, here returns. As a fellow artist, Gütersloh recalls Schiele's visionary alter ego. He is a man possessed, whose trembling fingers, held aloft like those of a surgeon preparing to operate, constitute the key to his supernatural powers. If Hugo Koller (see plates 98 and 99) was portrayed in a world of books, Schiele has created for Paris von Gütersloh a self-contained world of paint. This is not the customary background void but an all-embracing painterly fabric out of which the sitter organically emerges. One can only wonder whether the pictorial abandon of the Gütersloh portrait is merely the hallmark of a work in progress or whether this brighter, bolder, almost abstract approach might have heralded Schiele's ultimate destination.

Selected Bibliography

Unless otherwise indicated, all quotes accompanying the plates are by Egon Schiele, as transcribed by Christian M. Nebehay in *Egon Schiele, 1890–1918: Leben, Briefe, Gedichte* (Salzburg: Residenz, 1979). Translations from the German are by Jane Kallir.

Works by Schiele reproduced or discussed herein have been referenced according to Jane Kallir's catalogue raisonné, *Egon Schiele: The Complete Works* (New York: Abrams, 1990). The prefix "P" refers to the catalogue of the paintings, "D" to the drawings and watercolors, and "G" to the graphics.

Benesch, Heinrich. *Mein Weg mit Egon Schiele*. New York: Johannespresse, 1965.

Clair, Jean, ed. *Vienne 1880–1938: L'Apocalypse Joyeuse*. Exhib. cat. Paris: Centre Georges Pompidou, 1986.

Comini, Alessandra. *Schiele in Prison*. Greenwich, Conn.: New York Graphic Society, 1973.

———. *Egon Schiele's Portraits*. Berkeley: University of California Press, 1974.

———. *Egon Schiele*. New York: George Braziller, 1976.

Des Moines Art Center, Iowa. *Egon Schiele and the Human Form: Drawings and Watercolors*. Exhib. cat. 1971.

Friesenbiller, Elfriede, ed. *Egon Schiele, "Ich ewiges Kind": Gedichte*. Vienna: Christian Brandstätter, 1985. Translated as *Egon Schiele, I Eternal Child*. New York: Grove, 1988.

Hofmann, Werner. *Egon Schiele: "Die Familie."* Stuttgart: Philipp Reclam, 1968.

Institute of Contemporary Art, Boston. *Egon Schiele*. Exhib. cat. 1960.

Kallir, Jane. *Egon Schiele, The Complete Works: Including a Biography and a Catalogue Raisonné*. New York: Harry N. Abrams, 1990.

Kallir, Otto. *Egon Schiele: Oeuvre Catalogue of the Paintings*. New York: Crown; Vienna: Paul Zsolnay, 1966.

———. *Egon Schiele: The Graphic Work*. New York: Crown; Vienna: Paul Zsolnay, 1970.

Künstlerhaus, Vienna. *Traum und Wirklichkeit: Wien 1870–1930*. Exhib. cat. 1985.

Leopold, Rudolf. *Egon Schiele: Gemälde, Aquarelle, Zeichnungen*. Salzburg: Residenz, 1972. Translated as *Egon Schiele: Paintings, Watercolors, Drawings*. London: Phaidon, 1973.

Marchetti, Maria, ed. *Le Arti a Vienna*. Exhib. cat. Venice: Edizione La Biennale and Mazzotta, 1984.

Mitsch, Erwin. *Egon Schiele, 1890–1918*. Salzburg: Residen2, 1974. Translated as *The Art of Egon Schiele*. New York: Hudson Hills, 1988.

Nebehay, Christian M. *Egon Schiele, 1890–1918: Leben, Briefe, Gedichte*. Salzburg: Residenz, 1979.

———. *Egon Schiele: Leben und Werk*. Salzburg: Residenz, 1980.

———. *Gustav Klimt, Egon Schiele und die Familie Lederer*. Bern: Galerie Kornfeld, 1987.

———. *Egon Schiele: Von der Skizze zum Bild*. Vienna: Christian Brandstätter, 1989. Translated as *Egon Schiele: Sketchbooks*. New York: Rizzoli, 1989.

Powell, Nicolas. *The Sacred Spring: The Arts in Vienna 1898–1918*. Greenwich, Conn.: New York Graphic Society, 1974.

Roessler, Arthur, ed. *Briefe und Prosa von Egon Schiele*. Vienna: Richard Lanyi, 1921.

———, ed. *In memoriam Egon Schiele*. Vienna: Richard Lanyi, 1921.

———. *Erinnerungen an Egon Schiele: Marginalien zur Geschichte des Menschentums eines Künstlers*. Vienna: Carl Konegen, 1922; rev. and enl. ed., Vienna: Wiener Volksbuchverlag, 1948.

———, ed. *Egon Schiele im Gefängnis: Aufzeichnungen und Zeichnungen*. Vienna: Carl Konegen, 1922.

Schröder, Klaus Albrecht, and Harald Szeeman, eds. *Egon Schiele und seine Zeit*. Munich: Prestel, 1988. Translated as *Egon Schiele and His Contemporaries*. Munich: Prestel, 1989.

Solomon R. Guggenheim Museum, New York. *Gustav Klimt and Egon Schiele*. Exhib. cat. 1965.

Varnedoe, Kirk. *Vienna 1900: Art, Architecture, and Design*. Exhib. cat. New York: The Museum of Modern Art, 1986.

Vergo, Peter. *Art in Vienna 1898–1918*. London: Phaidon, 1975.

Whitford, Frank. *Egon Schiele*. London: Thames and Hudson, 1981.

Index

T

Photograph Credits

The authors, Art Services International, and Harry N. Abrams, Inc., wish to thank all of the institutions, galleries, and individuals that supplied photographs for this book, many of whom are the proprietary holders of the works. Several were provided by the authors and through the courtesy of the Galerie St. Etienne, New York. Plates 66, 74, and 78 are copyright © 1993 The Metropolitan Museum of Art, New York.

We also wish to acknowledge the photographers of the reproductions. Those for whom we have information are listed below:

Dean Besom, Washington, D.C.: pl. 99; Geoffrey Clements, Staten Island, N.Y.: fig. 79, pls. 16, 65; Susan Einstein, Los Angeles: pl. 2; Foto Hinz, Basel: fig. 30; Fotolabor Fayer, Vienna: pls. 3, 28, 48, 52, 87; Fotostudio Fan, Vienna: pl. 27; Fotostudio Otto, Vienna: pls. 26, 42, 85, 95; Dr. Franz Glück, Neulengbach, Austria: fig. 42; Eric Pollitzer, New York: pls. 11, 23, 60, 94; Rudolf Stepanek, Vienna: fig. 60; Jim Strong, Inc., New York: pls. 18, 21, 24, 34, 38, 39, 44, 48, 50, 54, 63, 68, 84, 90; Martina Urban, Hamburg: pl. 101.

Checklist to the Exhibition

NGA: National Gallery of Art, Washington, D.C., February 6–April 24, 1994
IMA: Indianapolis Museum of Art, May 29–August 7, 1994
SDMA: San Diego Museum of Art, August 27–October 30, 1994

Plate 1. *Schiele, Drawing a Nude Model before a Mirror*: NGA
Plate 2. *Danae*: NGA, IMA, SDMA
Plate 3. *Nude Girl with Folded Arms (Gertrude Schiele)*: NGA
Plate 4. *Seated Female Nude with Raised Right Arm*: IMA, SDMA
Plate 5. *Standing Girl in Plaid Garment*: NGA